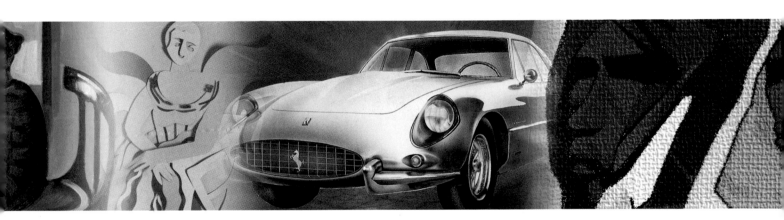

ALL

about techniques in

ILLUSTRATION

The Changing World of Illustration

Modern illustration really began with the invention of the printing press. It was then that it became possible to publish all kinds of information (literary, artistic, scientific, technical) or to decorate and illustrate texts. Since that time, different styles of illustration have developed alongside technical advances in image reproduction. As for illustrative style, the tendencies of each period have coincided with changes in artistic trends, as illustrators have adapted these trends to the graphic styles of their time.

THE ORIGINS OF ILLUSTRATION

The origins of illustration as we know it today can be found in the miniatures that medieval artists used to decorate manuscripts. These illustrations are closer to many present-day illustrations than the engraved illustrations of the Renaissance. In fact, as creative works (generally hand-painted in watercolor), their effect is very similar to modern techniques of reproduction that give a perfect fusion between text and image. Among the most impressive examples of medieval illustration are the capital letters of the Irish gospels (including the famous *Lindisfarne Gospel* from the 10th century, one of the oldest in Europe). These

Martyrs Book of Usuardo, c. 1400. Diocesan museum of Girona (Spain). Medieval illustration spanned the creation of the manuscript in its entirety from typography to the smallest decorative detail.

Illustration belonging to the Blessed of Liébana, Codex of the Monastery of Saint Peter of Cardeña (Spain), c. 1180. In the Middle Ages there was no distinction between the style of an illuminated manuscript and that of an art painting (altar-pieces or murals). Both tasks were usually carried out by the same artists.

miniatures were often highly detailed works, painted with supreme skill, and were often considered true works of art.

ENGRAVING: A MEDIUM FOR BROAD DISSEMINATION

After the invention of the printing press, engravings were always made on wood, and they incorporated image and text on the same wooden plate. Until the 19th century (when new methods of engraving on wood made this medium popular again), the wood cutting technique did not allow for fine detail. Precision in detail was achieved by engraving on metal (from the 16th century onward), which required image and text to be printed separately. This started the fashion for full-page, stand-alone illustrations, and large-scale illustrations. This technique

heralded in the golden age of engravings (realistic portraits, geographical maps, scientific images, etc.). It is a technique that is still used today (drypoint, etching, aquatint, etc.), although nowadays it is usually used by artists other than illustrators. The next great innovation was the lithograph (created in 1798), which allowed colors to be printed. This was unlike previous engraving techniques in which coloring had to be done by hand. The lithograph was the forerunner of modern techniques of photoengraving.

SATIRICAL ILLUSTRATIONS

In the 18th century there was a huge boom in book illustration, thanks to the widespread dissemination of illustrated writings by French and British intellectuals. The boom also spread to magazines and periodicals, which were much more concerned with current affairs than with cultural topics. In England, the genre of political and social satire was born, which soon became one of the most popular forms of illustration in the modern world. One great English satirist was William Hogarth (1697–1764), whose magnificent

Illuminated Capital: *Scriptorium of the Abbey Allerheiligen in Schaffhausen, end of the 11th century. Schaffhausen State Library (Switzerland). Intricately illuminated capital letters for hand-written gospels are among the earliest examples of illustration.*

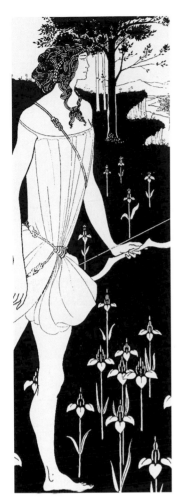

engravings caricatured the vices and miseries of urban English society and the English political system in the 18th century. His French counterpart was Honoré Daumier, who found himself in serious trouble with the law a century later for satirizing Louis Philippe of Orleans in a series of famous caricatures. Both were great painters, but in their own time they were especially known for their work as illustrators.

ILLUSTRATORS IN THE 19TH CENTURY

The second half of the 19th century witnessed the golden age of narrative illustration. It also marked the apogee of poster illustration and all types of visual propaganda. Many writers consider the art of poster design to have originated in France in the middle of the 19th century, at the hands of Honoré Daumier (1808–1879) and Édouard Manet (1832–1883). The style of these two artists and their imitators would influence the aesthetics of what was to become decorative Modernism. In illustration, this style is distinguished by its stylized forms and influence of Japanese prints, with silhouettes and curved lines that define

This delightful illustration by Aubrey Beardsley is highly representative of his style: a decorative drawing with stylized shapes in black and white, and a symbolic literary subject.

Théophile-Alexandre Steinlen, Conversation with Angela *(illustration for the weekly illustrated magazine Gil Blas). Illustrations like this one made Steinlen the most renowned magazine illustrator of his time. His influence can be seen in the early works of artists of the stature of Picasso or Bonnard.*

outlines without giving volume. Modernist illustration is characterized by bright colors, curving lines, everyday subject matter, and a clear suppression of details in favor of flat blocks of color.

The evolution of illustration towards the end of the 19th century reached one of

its high points with the work of Toulouse-Lautrec, many of whose posters are among his most famous works. Bonnard (1867–1947), Steinlen (1859–1923), Gustave Doré (1832–1883), and Aubrey Beardsley (1872–1898) are other artists whose posters, magazine illustrations, and plates for literary works are hallmarks of the aesthetic of the period that favors spirals and stylized forms of plants and flowers.

IMPRESSIONISM AND SYMBOLISM

Two vitally important artistic movements co-existed during the final decades of the 19th century: Impressionism and Symbolism. The former favors realism, everyday subject matter, and a rapid, sketchy style. In contrast, Symbolism features fantasy-based and literary subjects in a style that is highly refined and decorative. Both tendencies were represented by top-class illustrators, whose influence can be felt even today.

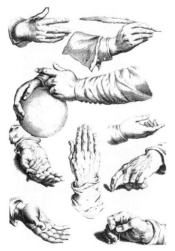

Gérard de Lairesse, plate for the treatise The principles of drawing. *Metal plates allowed illustrations to be reproduced independently of the text. This technique offered the possibility of achieving far greater detail than that obtained with woodcuts.*

Gustave Doré, illustration for the poem The Rime of the Ancient Mariner *by Coleridge. Doré was one of the most famous illustrators of his time. His finely detailed style created images that we still recognize, with characters like Don Quixote or characters from Jules Verne's novels.*

THE 20TH CENTURY

Prior to the 20th century, illustrators generally followed the tradition of humorous realism established by the great Victorian artists. The central core of that tradition was rigorous, academic drawing, even when the illustration was decorative, comic, or designed for children. This trend continued into the early decades of the 20th century (and can still be found today). Some of the best examples can be seen in the wonderful silhouettes by the English illustrator Arthur Rackham (1867–1939).

Nevertheless, in the twenties and thirties a certain type of stylization became fashionable among editors and publicists. It sprang from the new vocabulary created by avant-garde painters and sculptors. Commercial expansion after the war gave the more experimental illustrators the chance to work using more modern, expressive forms: this was a type of illustration calculated to capture and promote, as well as criticize, the spirit of the new era—the era of mass communication, new media, and consumerism.

In technical terms, the new type of illustration dispensed with the obligatory pre-eminence of faithfully figurative drawing. It opened the way for illustrators to explore the possibilities of brush-stroke, color, texture, and exclusively visual interplay in a way that was closely related to abstract art. It also saw the arrival of photomontage and

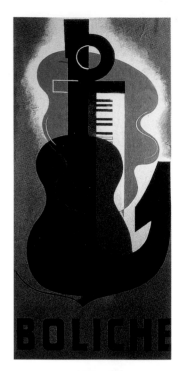

Antoni Clavé, poster for the bar Boliche. Private Collection. The forms in this poster are inspired by the pictorial style of the early decades of the 20th century, specifically Cubism. Examples like this one show how avant-garde artistic movements were reflected in contemporary illustrations.

of new techniques stemming from modern instruments such as the airbrush, opening up new possibilities for large-scale illustrations and more highly refined representations of machines and engines.

POPULAR CULTURE

Toward the middle of the 20th century, artistic trends focused their attention on movements of urban popular

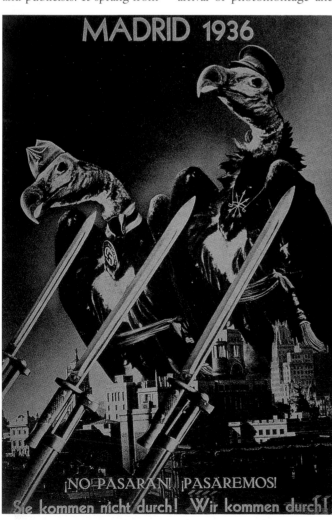

John Heartfield, photomontage for a poster of the Spanish Civil War. *IVAM-Marco Pinkus collection, Valencia (Spain). Photomontage proved to be one of the illustrator's most effective resources for creating a strong visual and psychological impact.*

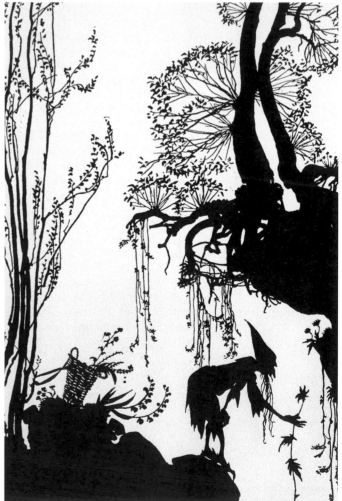

Arthur Rackham, illustration for the story Sleeping Beauty. *Rackham is famous for his silhouette-based illustrations for children's books. He produced very strong, visual images which achieve their objective by surprisingly simple means.*

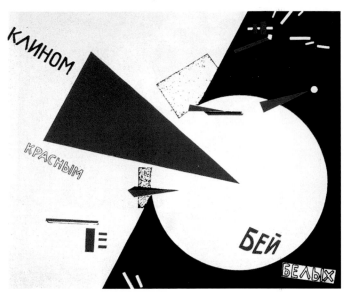

Eliezer Markovitch Lissitzky, Beat the Whites with the Red Wedge!, *Private Collection. This is one of the pioneers of the visual style that developed during the Russian revolution. It is an entirely avant-garde style, and one that continues to be current even today, although completely integrated in the aesthetic of our times.*

Alexandre de Riquer, Salon Pedal, *Museum of Modernist Art, Barcelona (Spain). This poster shows the unmistakable stamp of Modernism (or Art Nouveau), a style that sparked off the profound graphic renovation of the 20th century.*

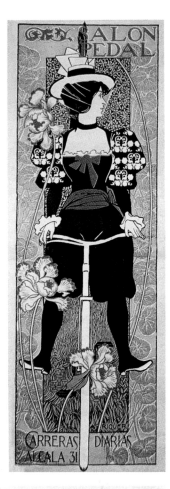

THE EVOLUTION OF GRAPHIC DESIGN

Graphic design and illustration move in separate but parallel spheres, with the result that trends in one area always impact on the other. This is logical since both disciplines inevitably co-exist on the same printed page. Illustrators have to be able to read the tendencies of the day, not just in illustrations produced by their contemporaries but in the specific aesthetic of graphic design, in typography, use of space, colors, and so on.

culture or, rather, on the products of the consumer market that constituted the visual landscape of contemporary life. This was the movement known as Pop Art. The painters and sculptors who were part of this trend used popular images as subjects, for example characters from the movies or comic strips. Many of the most famous artists of this period (including the American artist Andy Warhol and the English artist Peter Blake) moved from commercial illustration to Fine Art with hardly a change to their style or representation. This had an effect on the world of illustration, because it led to a reevaluation of themes and styles that were commonly associated with less recognized genres. The new illustrators began to create versions of these popular forms and to experiment with formulas and techniques from other periods: old street advertisements, ancient typography, children's stories, old movies and old photographs, and so on.

periodicals are the ones that offer the greatest opportunity for experimental or avant-garde work. They are constantly in demand of new images and experienced illustrators. Every topic imaginable can appear on the pages of these magazines and newspapers, and illustrators can let their imagination run free, limited only by their professional ability and the criteria of editorial directors. One only needs to glance at the illustrated magazines that have a broad circulation to see the plethora of styles and techniques currently in use. Each period has its own trends and fashions (which generally change dramatically every ten years or so), and illustrators should keep up to date in order to ensure that their work stays current with new developments. Within these trends, however, are hundreds of personal variations and all of the technical combinations imaginable.

NEW DIRECTIONS

Of all the areas that require illustrators, magazines and

Alexander Rodchenko, Kino-Glaz. Kunstgewerbemuseum, *(Zurich). Photomontage was one of the great novelties that illustration engendered in the 20th century. This propaganda poster clearly shows the influence of cinema and photography.*

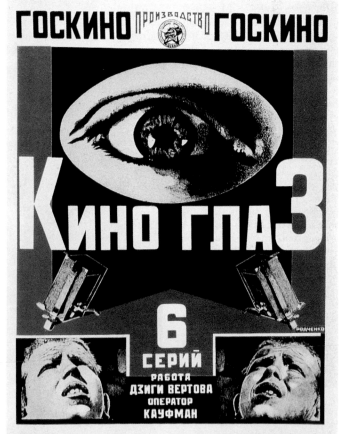

days, the technique of animation involves the use of computers.

CHILDREN'S ILLUSTRATION

There are many types of children's books, from the simplest ones aimed at very young children, to highly involved stories that can be compared to adult literature. There are also pedagogical children's books, which need as much detail in their illustrations as the most exacting technical works.

Children's illustration covers a huge area in which the age of the reader is key. In general one can say that these illustrations must offer a clear, easily understood interpretation of the subject or theme, and must always be in tune with the type of work involved (narrative, pedagogical, activities-based, etc.). They must be attractive to children, even though the parents are the ones who buy the illustrations, not the children. Also, it is not the person who commissions the illustration who must like it, but the publisher. The illustrations must not be condescending to young children.

On the contrary, they must take the narrative framework established by the publication seriously, and look for ways to attract the reader's attention visually. They must also be attractive to adults, who read these books and actually buy them. Illustrators of children's works are usually specialists in the field, and have a versatile style that spans all of the requirements for the genre.

COVER ILLUSTRATIONS

Cover illustration is the most demanding discipline for an illustrator, whether the illustrator has complete freedom of expression or must work within parameters established by the editor. Cover illustrations must fit in with the overall design of the book. Often they spread over the entire outer cover, and affect the general design of the publication. Cover illustration can also require the insertion of text or typographical elements. The complexity of the illustration usually depends on the size of the particular cover (which may be for conventional books, compact discs, coffee-table books, novels, children's books, etc.)

Children's illustrations are a challenge for illustrators. They require a special talent for producing charming, attractive results, as the genre demands. This work by Anna Llorens is a magnificent example of expressiveness and subtlety.

This children's illustration, in the typical silhouette style of Arthur Rackham, conveys the rhythm and vitality of the scene rather than a particular facet of the story. The visual intention dominates all other considerations.

POSTER DESIGN

Creating posters is very similar to illustrating book covers (sometimes the cover of a book is used to create publicity posters), although posters demand greater visual brilliance than covers, because they have to compete with lots of other visual stimuli. Nowadays, posters based on conventional illustrations are very rare, since photography and illustrative techniques using computers have taken over the tasks traditionally performed by painters and illustrators.

John Heartfield. Cover for a novel (detail). IVAM-Marco Pinkus collection, Valencia (Spain). Photographic montage is one of the options available to the illustrator for summing up the spirit (rather than the plot) of a work of fiction.

ILLUSTRATION IN ADVERTISING

Illustration in advertising is designed to accompany or give form and personality to a commercial brand or product, or to announce an event. Often what distinguishes this type of illustration from others is a simple question of format. For example, most publishers enlarge and alter the design of book covers for use as promotional posters. In any case, what is essential in advertising illustrations is its immediacy and effective visual impact.

FASHION ILLUSTRATION

Fashion illustration has not been supplanted by photography, since its use relies on the inspiration of a designer to express a characteristic style pertaining to fashion catalogues, magazines, and adver-

tising in general. Fashion illustration is very stylized and usually commissioned from specialists who know how to represent the qualities and textures of textiles and how they drape and form folds in a way that is both spectacular and sophisticated. Fashion illustration usually uses a rapid design technique that demands a skillful mastery of the materials. Flowing lines and colors (drawn with ink, pencils, watercolor, or felt-tipped pens, most frequently used in combination) are the most common techniques used in this genre.

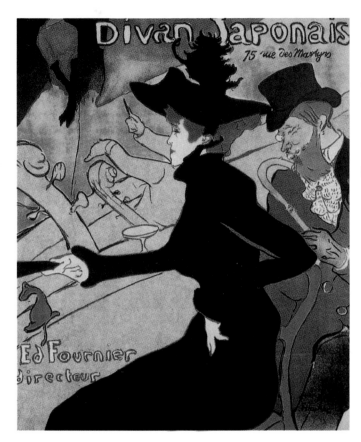

Henri de Toulouse Lautrec The Japanese Sofa. *Musée Toulouse-Lautrec, Albi (France). This is one of the many posters that Lautrec created for Parisian cabarets and commercial products. Their incomparable visual appeal, handling of color, use of silhouettes, and typography established them as classic works in poster design.*

PACKAGING

Illustrations such as those for commercial containers of consumer goods and packaging convey a universal brand image and are used with small variations on the different types of wrapping, packaging, and accessories that constitute a brand's public image (labels, food product lines, shops and outlets, etc.). There is no specific style in this genre. Companies usually commission illustrations that fit in with their brand image, and in the event that there is no brand image, they work with graphic designers and illustrators to create one.

This splendid advertising illustration by Miquel Ferrón incorporates different product lines of the brand being advertised and, at the same time, creates an image that is both suitable and attractive from a commercial viewpoint.

Fashion illustration created by Marina. The figures in the illustration are usually stylized models.

Drawing in Illustration

The work of the graphic illustrator relies on drawing. This is the most fundamental graphic technique. Whether the illustration is a realistic one or otherwise, mastery of drawing is a basic necessity for all illustrators. Every professional has a personal characteristic way of drawing, either painstaking or spontaneous, but it must always be able to express the general idea or theme of the illustration clearly and effectively. Normally an illustrator needs to have the versatility of representing any type of subject matter, and must be ready to take on commissions of a greatly varying nature. For this reason, the illustrator must be suitably flexible in this discipline.

ILLUSTRATOR'S DRAWINGS

Dexterity in drawing is as important in illustration as in any artistic expression of painting or drawing. Sometimes illustrations in black and white, for example, are based entirely on the accuracy and clarity of the drawing rather than on other complementary technical factors. The only aspect that differentiates illustrative from artistic drawing is that the latter does not have a specific purpose or use, as is usually the case with illustration. Today, however, there are many examples of illustrations that are closer in style to modern art than to concrete, objective representations of technical subjects. Learning to be an illustrator is no different from learning to be a painter in terms of drawing: you have to understand techniques of line and shading and be able to depict both stationary and moving objects, as well as have a basic understanding of perspective and composition.

SUPPORTS FOR DRAWING

Paper is the most universal medium for drawing. For pencil drawings, it is best to use paper with a slightly coarse surface. For ink drawings, on the other hand, smoother, harder surfaces are more suitable. The smoother the surface, the easier it is to draw a clean, precise line. In contrast, coarse-grained surfaces create more textured, diffuse tracings.

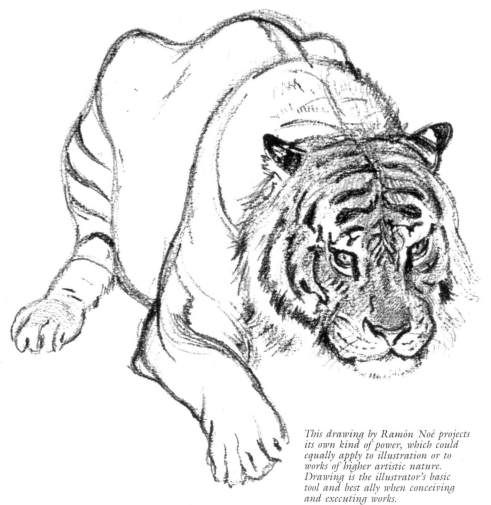

This drawing by Ramón Noé projects its own kind of power, which could equally apply to illustration or to works of higher artistic nature. Drawing is the illustrator's basic tool and best ally when conceiving and executing works.

Mastery of form in drawing is the foundation on which an illustrator's artistry is based. As this work by Ramón de Jesús illustrates, it provides a starting point for developing a personal style.

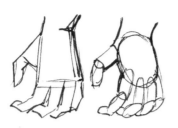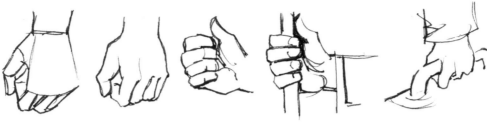

This sequence shows the process in developing a form (in this case the hand) from simple sketches. These steps are the same whether the result is realistic, stylized, or a caricature.

DRAWING MEDIA

The most common media used by illustrators are graphite pencils and ink. Graphite pencil is a universal tool. It can be erased easily and is used for sketching figures and objects in illustration before adding color or even before retracing with ink. There are many types of ink, from traditional Chinese ink (opaque, glossy black) to colored inks, as well as the different kinds of ink—both soluble and insoluble—for felt-tipped pens and technical pens (pens with sealed ink reservoirs, which produce precise lines of consistent thickness).

Certain types of illustration are made with a brush and Chinese ink. The technique needed for this type of work— now falling into disuse—is very exacting, as it obliges the illustrator to control the stroke by varying the amount of hand pressure on the brush.

COMIC AND GRAPHIC HUMOR

Comic illustrations and visual humor generally require a high degree of dexterity. Illustrators who specialize in these genres usually use pen and ink or brush and ink to create a drawing that is direct, spontaneous, and fresh, and which can be quickly understood by the reader. They generally describe a situation in a succinct way. The technique for this type of work is based almost entirely on rapid, flowing strokes in creating shapes.

Many cartoon illustrators have a personal style that is very close to caricature and can depict a situation involving one or more characters using simple visual outlines devoid of additional details. These works look deceptively simple. In actual fact, they require an expert dominance of the line, form, and movement of human figures and a lot of groundwork in characterizing them, since the reader must be able to recognize them immediately.

The ability to draw the human figure is indispensable in any kind of drawing. Initial sketches must include all the information to be developed later.

From these initial sketches it is easy to complete the physical elements of the characters involved in the illustration.

The fact that an illustration is a caricature does not imply a lack of skill on the part of the illustrator. It is usually the opposite: a quick, schematic, sometimes exaggerated illustration normally requires a firm understanding of the basics of drawing. This is a work by Pedro Rodríguez.

THE HUMAN BODY

The basis for most illustrative techniques is drawing and the basis of drawing lies in the ability to represent the human body. By doing so, the illustrator acquires the ability to represent any other subject properly. In all drawing schools, drawing of the human body is an obligatory subject, since this is where the skill of the illustrator is most clearly shown.

DRAWING STYLES

Each type of illustration requires a different drawing style. As has already been mentioned, illustrations in comics are based on free, personal styles. This is also the case with children's illustrations. Here the pleasing spontaneity of the illustrator cannot be replaced by other techniques. In general, illustrations that are going to be painted should have simpler lines than ones in which line and blocks of color constitute the main technical elements. For painted illustrations, an outline drawing is usually enough to define the form and outline spaces to be colored. For technical illustrations (painted by airbrush, for example), the drawing has to be extremely precise, with no margin for personal whim. It should outline each of the details of the illustration in such a way that when painting, no doubts arise about what each of the forms looks like. Professional illustrators are capable of varying the type of drawing based on the demands of the pictorial technique they need to use.

The style of a drawing usually depends on the result the illustrator wants to achieve with the illustration. In this case, the drawing is extremely simple, in order to allow color to dominate in the finished illustration. Illustrations by María Rius.

In technical illustrations, the drawing must be as detailed as possible, no matter what technique is going to be used to complete it. In this case, it is a drawing that will be painted by airbrush.

Even though this type of illustration is extremely time consuming, it is necessary to complete the drawing as accurately as possible. Illustrations by Miquel Ferrón.

In illustrations that are going to be painted with strong colors, the drawing should be limited to showing the contours, providing structure for coloring in, and outlining the different areas for color. Illustrations by Almudena Carreña.

This is the illustration (painted in acrylics) made from the previous drawing.

SCALE ILLUSTRATIONS

In technical illustration, scale drawings are usually used which are based on photographs or plans. Making a drawing to scale is usually quite laborious, and precision and meticulousness are more important than artistic ability. Many illustrators project photographs onto the paper in order to achieve as accurate a representation as possible. These days, illustrations on computers have made it easier to calculate scale when making more complex technical illustrations.

DRAWING IN INK

This is almost a separate specialty within the complex world of illustration. However, the large-scale use of color in all printed media has reduced the traditional predominance of this technique, which almost always uses Chinese ink. Ink drawing is the generic name for many different techniques: using a pen with a nib, a reed, a fountain pen, a brush, or a technical pen, among others. Expert illustrators use these media without drawing an initial sketch in pencil. At most, they use a pencil to trace the basic lines of the design.

Almost all the media above are readily responsive to the amount of hard pressure exerted, thus varying the thickness of the line. This means that line takes on an incomparable vitality, and one that is impossible to imitate with any other medium. Along with this characteristic, a typical feature of drawing in ink is the texture that can be achieved in shading, which ranges from opaque black to transparent washes made up of cross-hatching. A great deal of practice is necessary in order to master the surprisingly wide range of possibilities ink-drawing tools offer.

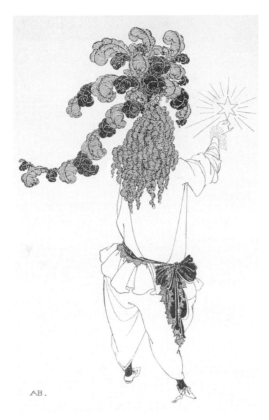

A magnificent example of an illustration made with pen and ink (by Aubrey Beardsley), entirely based on the grace and accuracy of its fine lines.

Here Vicenç Ballestar used ink with both a reed and a brush. This type of drawing looks best when done with speed and energy, in order to bring out the pure contrasts between the black of the ink and the paper.

TECHNICAL PEN

Of all the tools for ink drawings that are available, the technical pen is the most modern. It achieves results that are identical to a modern, fine-pointed, felt-tipped pen, with the difference that rotary pens are made in very precise sizes that give a thickness of line that is always consistent (from 0.1 mm wide). They are usually used for technical drawing, or when an illustration is going to be colored in and requires perfectly visible outlines.

In this illustration by Vicenç Ballestar, blocks of color fulfill a basic role. The forms are defined by changes in the tone of the ink, avoiding a need for precise outlines.

The reed pen is an excellent tool for illustrations that require energy and detail at the same time. Illustration by Fransesc Llorens.

An Illustration in Ink

Illustrations in ink (with brush, pen, or reed pen) are quick to produce but require careful preparation, especially if the work is going to be made with spontaneous strokes which are difficult to correct. This is the case with the illustration shown on the following pages. The task requires illustrating an article with a drawing whose visual power comes from the characteristics of the medium being used, especially from the strength of the strokes. The following pages show the complete, step-by-step process used to complete the project. It is a process that requires research for reference material, conceptualization of the layout, completion of sketches, and a final decision concerning the finished appearance of the illustration.

CHARACTERISTICS OF THE PROJECT

The project requires an illustration for an article on the fight for survival that eagles face nowadays. It is not an entirely scientific article, nor is it literary. Instead it is an informative text for an illustrated, general interest, weekly magazine. The editor has given the illustrator, Vicenç Ballestar, complete freedom to interpret the subject in his personal style. In situations like this, the only constraint for the artist is how the work will fit on the page. This information usually comes from the designer or art editor responsible for the visual appearance of the publication. The illustrator must bear in mind the size of the area where the image will fit and adapt the size of the work to it. It is logical that the original should be larger than the

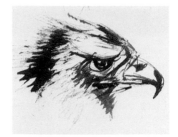

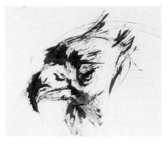

The head of an eagle is the most significant detail in the illustration. The artist does some practice sketches in order to capture the characteristic expression of the bird.

printed image, since the visual quality always diminishes when a small original is reproduced on a larger scale, but not the other way around. Since this is an illustration with pen and reed pen, it cannot be very large as such an illustration would be awkward to produce.

REFERENCE MATERIAL

All experienced illustrators have an archive of models of all types that can be useful in researching a project. Ballestar has consulted his files and has found a few extremely spectacular press photographs of eagles and other birds of prey, both standing still and in flight. Professional illustrators usually combine features of different photographs to create the right image. What the photographs do not show can be filled in by the imagination and skill of the illustrator. For this project the illustrator did not have to leave the studio to find the model he wanted, nor did he have to get in touch with the editor. His archive had a good selection of animal photographs.

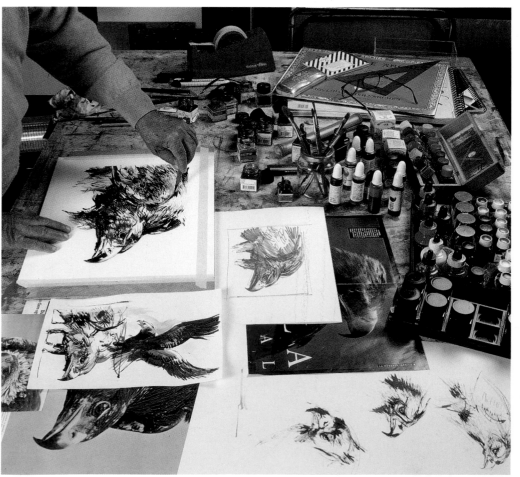

The illustrator's workbench is covered in material: photographs for the project, paper for sketches, and a large number of bottles of ink, both black and colored.

MATERIALS

The question of technique and style is entirely up to the illustrator. Ballestar has chosen a technique using black and colored Chinese ink, drawn with steel nibs and reed pens. Colored inks are very transparent, and can be mixed together. It is also possible to dilute their brightness with a little water. Combined with black ink, the result has a powerful visual effect. The strokes of the pen or reed evoke the eagle's feathers and give the drawing vitality and spontaneity. Strokes of different thickness are alternated by combining different steel nibs and reeds. Reed pens always give much thicker lines than steel nibs and are very useful for retracing the essential lines in the illustration. The coloring is limited to black, burnt sienna, and blue (a blue that is highly diluted with water).

APPROACHING THE SUBJECT: NOTES AND SKETCHES

Using the photographs as sources of inspiration, Ballestar has begun by drawing a few sketches of the animal in different positions and from different angles. In this way, he not only tries out different compositional solutions, but also the possible visual effect produced by combining inks and varying the thickness of the strokes using different steel nibs and reeds. It is a good idea to make sketches using the same paper that will be used for the final illustration. Only in this way can you judge accurately the visual effect you can expect from the illustration. The best paper for drawing with pens is smooth or glossy paper.

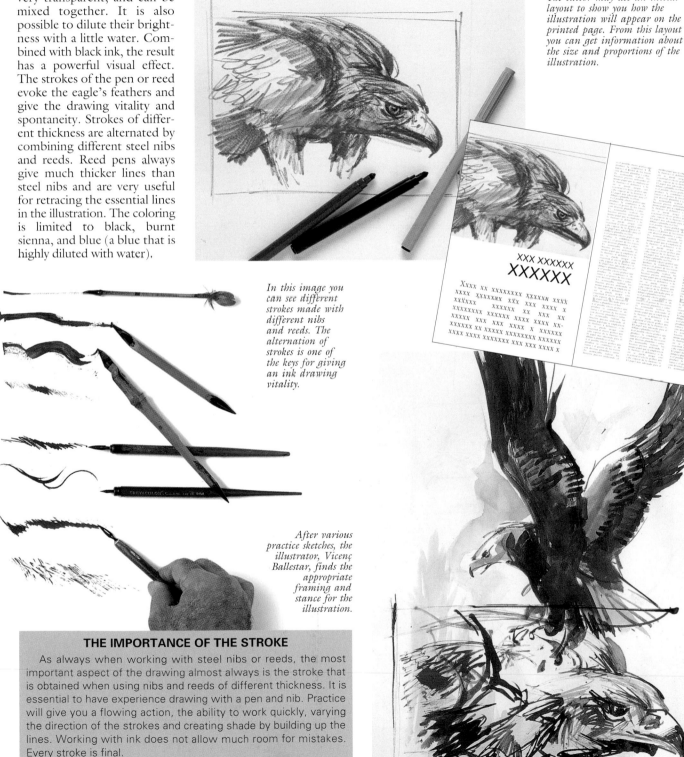

The editor may use an initial layout to show you how the illustration will appear on the printed page. From this layout you can get information about the size and proportions of the illustration.

In this image you can see different strokes made with different nibs and reeds. The alternation of strokes is one of the keys for giving an ink drawing vitality.

After various practice sketches, the illustrator, Vicenç Ballestar, finds the appropriate framing and stance for the illustration.

THE IMPORTANCE OF THE STROKE

As always when working with steel nibs or reeds, the most important aspect of the drawing almost always is the stroke that is obtained when using nibs and reeds of different thickness. It is essential to have experience drawing with a pen and nib. Practice will give you a flowing action, the ability to work quickly, varying the direction of the strokes and creating shade by building up the lines. Working with ink does not allow much room for mistakes. Every stroke is final.

METHOD

The size of the drawing will be about 12 × 16 in. (30 × 40 cm). The support is a very fine-grained paper (not completely smooth) attached to a drawing board with strips of adhesive paper. It is not essential to attach the paper in this way, but Vicenç Ballestar usually works like this (regardless of the technique he is using) to ensure that the

paper does not slip by accident while he is drawing.

The time taken to make the drawing is relatively short (a little less than an hour), but this is an illustration that has to be correct the first time, with no possibility of making corrections or additions. Despite having made various initial notes and sketches there is no guarantee of success, but there is no question that they help the artist approach the work with confidence.

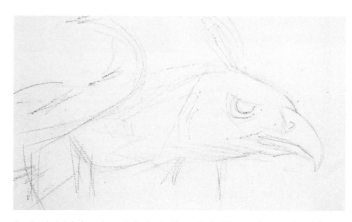

1. An initial drawing of the basic lines of the illustration made with pencil can act as a reference point. It serves to determine the proportions of different parts and to make sure the drawing fits easily within the format of the paper.

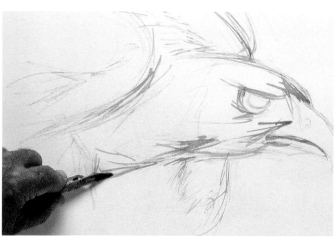

2. The first lines are still very provisional. They are made with blue ink diluted with quite a lot of water to reduce the color. The somewhat thicker stroke of the reed pen is useful for establishing the general outlines of the eagle clearly.

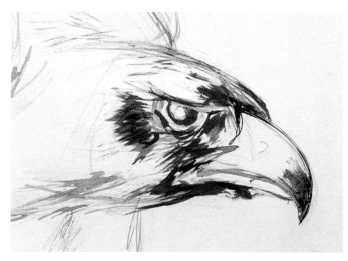

3. Here is the blue drawing with the first marks made with sienna, using a steel nib. The number of strokes in a given area will determine the shading and shape of the volume. It is logical to start with lower density strokes and then thicken them.

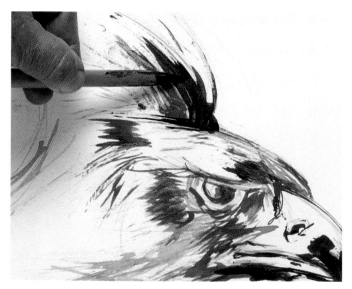

4. The application of black Chinese ink with a reed pen at the base of the wing highlights the shape and relief of the head. Here the side of the reed pen is used instead of the point, to produce a block of color instead of a line.

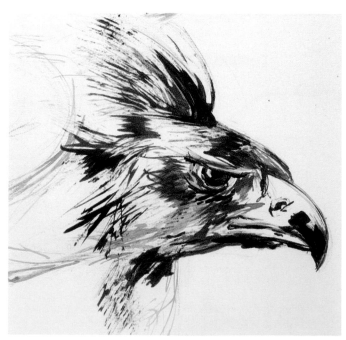

5. Just as important as its direction, length and thickness are the starting point of the stroke, because this is where strokes show the relief of feathers. In the picture you can see how the choice of color has proved a good one from a visual point of view.

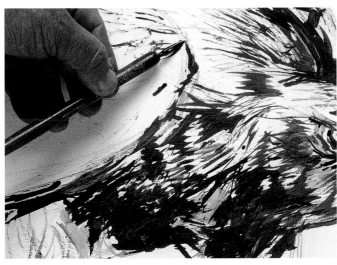

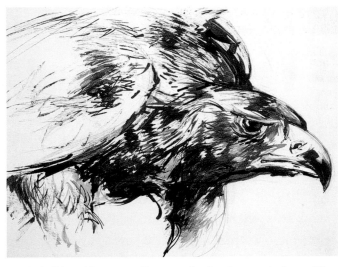

6. *Here you can see how the character of the stroke made with a steel nib can vary substantially when the widest part of the nib is pressed to the paper. The stroke becomes an elongated block of color which gives variety to the lines and reinforces their intensity.*

7. *The buildup of interwoven lines actually gives shape to the form while clearly suggesting the texture of the eagle's feathers.*

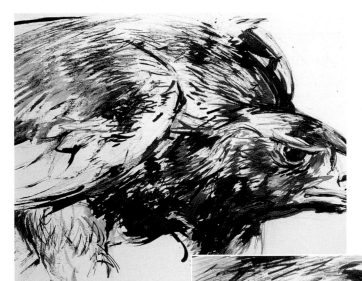

8. *In this image you can see the chromatic effect obtained by adding multiple blue and sienna strokes (suitably diluted with water) in the lighter areas. The resulting effect suggests the reflection of light on the feathers.*

9. *These are the final touches and highlights made with light strokes of the pen. The work is almost finished.*

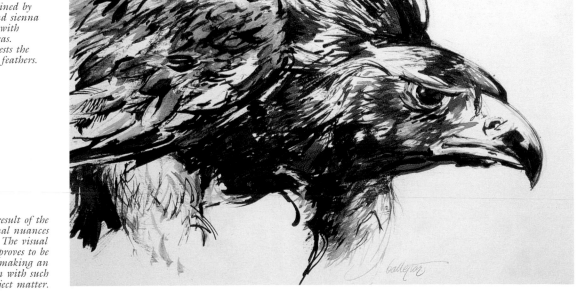

10. *This is the result of the work once the final nuances have been completed. The visual power of the ink proves to be the best choice for making an illustration with such an energetic subject matter.*

Illustrating with Watercolor and Gouache

Watercolor and gouache are the two most frequently used media found in illustrations. They are both extraordinarily versatile media that can be used for very gentle, impressionistic tones as well as for works with solid, opaque, highly detailed colors. In addition to the advantages inherent in these media themselves, there are also endless possibilities for combining them with many other pictorial processes. They are also ideal for retouching finished technical and scientific illustrations. They are used in simple and direct fashion, and do not need to be applied with special tools.

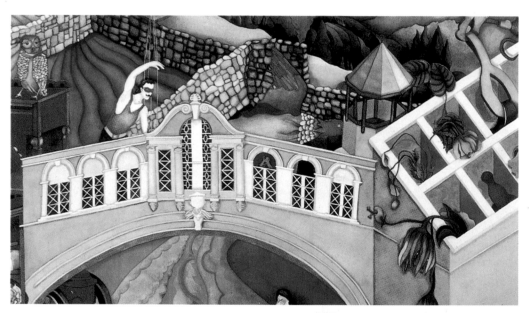

Beth Shadur, Don't Burn Your Bridges Behind You. *Private collection. This work was made with both watercolor and gouache. The two media can be combined easily, and in fact most illustrators often use them simultaneously.*

This illustration by Anna Llorens makes use of the properties of watercolor to create a suggestive watery environment.

THE CHARACTERISTICS OF WATERCOLOR

Watercolors are available in small trays or pans containing semi-damp tablets of color which are easily diluted by moistening with a damp paintbrush. They are also available in tubes containing paste-like pigment. Regardless of their format, watercolors are water-soluble and transparent. Their brightness depends on the degree to which they are dissolved in water. They mix together perfectly and have a fundamental advantage that distinguishes them from all other pictorial media: their tonal richness does not just depend on mixing different colors, but also on the amount of water contained in these mixtures. Since there is no white watercolor (the whiteness of the support paper stands in for the color white), colors do not lose brightness or chromatic quality when they are lightened with water. Watercolor dries quickly and does not need to be used with solvents or other special substances. All you need are the colors, a water container, and a paintbrush.

SUPPORTS FOR PAINTING WITH WATERCOLOR

The usual support for watercolor is paper. There are three basic types of paper: fine-grained, medium-grained, and coarse-grained. For watercolor, especially when working on large-scale works, the best choice is medium- or coarse-grained paper, since these enable the use of a lot of water without warping or deforming the paper. Fine-grained paper brings out the brilliance of the tones that are applied, but colors dry out more quickly. Medium-grained paper is easier for single illustrations. Coarse-grained paper has a very pronounced textured surface which makes it ideal for pictorial techniques without a high degree of detail. Card, cardboard, or even wood can also be used.

The transparency and brilliance of watercolors mean they are one of the most common media used by illustrators. Watercolor's versatility allows the illustrator to produce works in all styles, from realist to imaginary.

This illustration by Agustí Asensio is based on simple blocks of color spread freely over the support. The illustrator only needs to control the water added for the result to be entirely convincing and highly spontaneous.

SUPPORTS FOR PAINTING WITH GOUACHE

As with watercolor, the most common support for painting with gouache is paper. It should not be too rough, as this makes it more difficult to spread blocks of colors completely uniform. In general, the quality and finish of the paper is not so important when painting with gouache, and many professionals work on normal card, cardboard, or a wide variety of supports to which this medium will stick without problem.

Gouache is an opaque medium that is easy to handle. If it is used dissolved in sufficient water, it creates effects very similar to watercolor.

THE CHARACTERISTICS OF GOUACHE

Like watercolor, gouache is a water-based paint. But the essential difference between the two media lies in the fact that gouache colors are opaque. This makes gouache a less subtle medium than watercolor. Nevertheless, it has certain advantages for the illustrator: it permits the illustrator to make all types of corrections or alterations (something that is difficult with watercolor, which shows up any corrections). Colors are lightened not by adding water but by mixing with white. Gouache finishes are uniform and velvety and, if the illustrator wishes, all trace of brush strokes can be eradicated. These characteristics make gouache an ideal medium for making posters in which areas of color can be clearly delineated and painted in solid tones. Because gouache is less subtle, it makes it easy to make printed reproductions that are faithful to the original colors.

As a medium for retouching, there is almost no substitute for gouache in any type of illus-

tration, especially ones that demand a high degree of finish and a great deal of detail. Gouache is sold in tubes of creamy-textured pigment, and in containers with a slightly thicker consistency. Gouache that comes in trays is of lower quality, suitable for school use and little else. Manufacturers offer somewhat wider ranges of gouache colors than of watercolor. Since it is easier to make high quality opaque colors than it is transparent ones, commercial makers can offer illustrators the exact color desired, without needing to mix other tones.

The ranges of gouache colors are very extensive, but many illustrators only use a few tones for obtaining the desired mixtures.

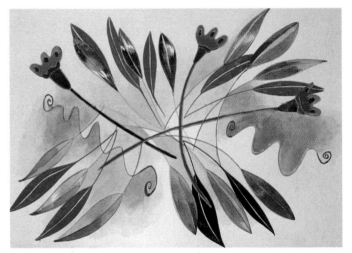

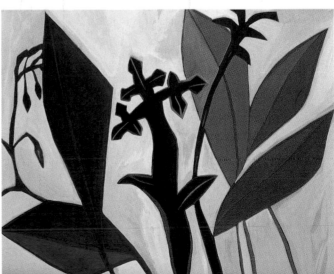

Because of the opacity and smoothness of gouache colors, it is possible to achieve areas of color that are completely smooth as well as areas where brush strokes are visible, as in this work by Almudena Carreño.

USING DIFFERENT MEDIA FOR ILLUSTRATION

WORKING WITH WATERCOLOR

In illustration, watercolor is usually used differently than in the traditional and more genuinely pictorial way of watercolor artists. For them, brush stroke and blocks of color are the most important element, while illustrators use watercolor as a medium for coloring and filling in forms that are already clearly delineated. For this reason, the process for any watercolor illustration begins with a properly detailed drawing, generally made using fine pencil lines. The pencil should not be too soft. Next the light tones are colored in, diluted with plenty of water, as it is difficult to lower the intensity of a color once it has been painted on the paper and has dried. Little by little, the areas of the illustration are painted, applying graded colors over the wider areas as a base. Gradations are achieved by lightly moistening the area to be painted before applying the color, and then extending the block of color gradually, so that it mixes with the water and progressively lowers in intensity. Finally you can highlight details or intensify tones by superimposing a fresh layer of colors over the areas of the illustration that are already dry. The colors lose a little of their brightness when they dry, and it is only when the work is completely dry that the necessary retouches can be made (for which other pictorial media might be used, such as gouache, colored pencils, pastels, felt-tipped pens, etc.).

1. All watercolor works begin with a general application of color to establish the bases of the colors onto which highlights and details will be applied. This and the subsequent images show the process of making a watercolor illustration, by Vicenç Ballestar.

DRYING TIMES

Watercolors dry fairly quickly (especially when working on paper or smooth card). If the area to be covered is rather large, it is better to use larger brushes, which enables working rapidly and avoids leaving visible brush strokes. If it is necessary that the areas of color remain damp longer, a few drops of a retardant (most commonly ox bile) can be added to the water. The rhythm of work depends on the time needed for the areas of color to dry. Only practice will accustom the illustrator to this.

WORKING WITH GOUACHE

The technique for painting with gouache is not very different than that used with watercolor. The distinctive characteristic of gouache is that the illustrator does not need to begin with light tones and then gradually increase their intensity. Being an opaque medium, the illustrator can work from light to dark or from dark to light indiscriminately, and can make all kinds of corrections and alterations. The colors are solid, but they also lose intensity a little when they dry. For this reason, it is not advisable to use too much white to lower a tone, as when it is dry the illustration may have a floury tone, lacking in contrasts. This is one of the reasons why manufacturers offer such a wide variety of different colors: By using them straight from the tube, the illustrator saves the effort of mixing them, which requires the use of white. It is very easy to add retouches with gouache, and these corrections are barely visible in the finished work. As with watercolor, illustrations made with gouache can be enriched or given nuance with other pictorial media: watercolors, felt-tipped pens, colored pencils, etc.

2. Once the base color is dry, all types of detail can be added using small brushes.

3. Watercolor allows for extremely detailed finishes and for a perfect blending of color.

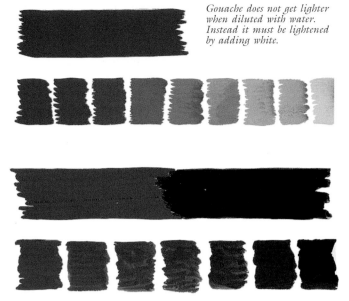

Gouache does not get lighter when diluted with water. Instead it must be lightened by adding white.

Black is not generally used with watercolor, as it dirties the effect of transparent washes. When painting in gouache, though, it is one of the tones most commonly used for achieving grayish coloring.

TRANSPARENCIES USING GOUACHE

By diluting them with lots of water, gouache colors can be used as transparencies, although their tones are not as delicate or luminous as with watercolor. Many professional illustrators use watercolors to provide transparent backgrounds for works that will then be painted in gouache. But once opaque colors have been applied, they cannot be retouched with subsequent transparent washes. This disadvantage is compensated by the perfect homogeneity and saturation of tone offered by gouache which cannot be achieved with watercolor.

This illustration by Cristina Picazo was made with the tonal ranges of greens (lightened with white and darkened with black) that are shown above left.

Watercolor can help the illustrator create interesting effects of light, using a background of soft layers of transparent color which contrast with thicker, denser color. Illustration by Agustí Asensio.

USING DIFFERENT MEDIA FOR ILLUSTRATION

METHODS AND EFFECTS USING WATERCOLOR

The intrinsic properties of watercolor paint make it an invaluable medium which can be applied to various different types of support and combined with other media. Illustrators explore the capabilities of a medium as much as, or more than, artistic painters, and can find all the possibilities for visual expression a given medium offers. The uses to which watercolor can be put are best seen in conceptual and decorative illustrations, which do not demand that the illustrator makes a minutely detailed, graphic depiction of the object being illustrated. Spots, smudges, droplets, scratch-marks, and abstract blocks, textured or otherwise, are some of the many visual effects that can be used with watercolors. Almost all of them make full use of the essential quality of the medium: its transparency. And in addition to these alternatives, there are also the different results that can be obtained by using supports other than paper.

It is impossible to give a complete overview of all the effects achievable, since illustrators are constantly developing new methods and effects. These pages show some brilliant examples of illustrations in which personal

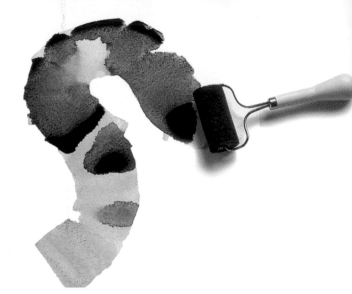

The incomparable brilliance and luminosity of watercolors is useful for covering large areas with liquid color. Effects like this one are impossible with other media.

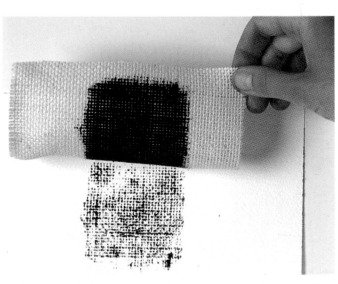

With watercolor it is very easy to achieve stains or textured areas of color by pressing a rough surface loaded with color onto the paper. This is a useful method for covering backgrounds.

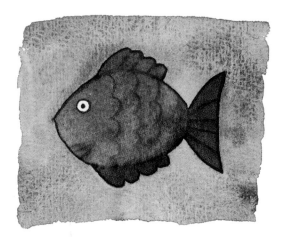

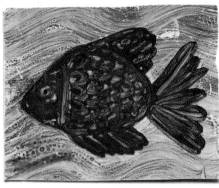

This illustration by M. Àngels Comella was made by adding a little liquid soap to the mixtures. The brush strokes appear particularly visible and vivid, although this does make it difficult to show a high degree of detail.

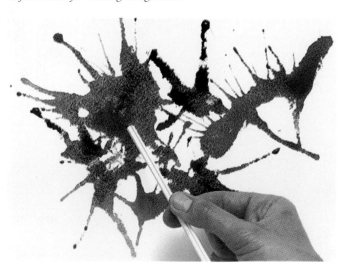

These colorful patterns were made using a straw to blow droplets of color dripped onto the paper.

COMPATIBILITY WITH OTHER TECHNIQUES

Watercolor is compatible with all drawing techniques (principally ink, pastels, and colored pencils) and also, of course, with gouache. The traditional combination is for illustrators to enrich areas of watercolor by coloring in with colored pencils in order to add minute shading and details that would be difficult to achieve with a brush. Because of its delicate consistency, watercolor is always used first. Then this base can be used to add the above-mentioned media, and any others that the illustrator discovers through experimentation.

One style of pointillism can be achieved by flicking on color with the help of a toothbrush covered in watercolor. To control where the color falls, masks are used (cutouts of paper or card), which make it easier to separate clearly the different areas of color.

Attractive effects can be achieved with the simplest methods, such as the pointillism shown in this picture. It is a time-consuming technique which creates very attractive results.

The nature of the support provides one of the most common assets available to illustrators today. This is a watercolor by Montserrat Llongueras, painted using an entirely conventional technique on a wood support to give it its attractive finish.

The luminosity of watercolor is what makes it ideal as a basic medium for illustration. The soft finish of this work by Irene Bordoy is the result of a very delicate, but simple, use of the medium.

Creating variegated effects like this is very straightforward. You just need to "paint" the outline with plenty of clean water and then add brush strokes of different colors before the water dries.

In this illustration by M. Àngels Comella the watercolor was painted on an illustration made with a white wax crayon (the blue is the color of the watercolor, and the white is the color of the wax crayon). The wax repels the watercolor, which collects in small droplets.

creativity is allowed to express itself freely.

METHODS AND EFFECTS USING GOUACHE

Gouache can be used more dynamically and with greater determination than watercolor, and can be used in combination with many more materials and techniques. Because of its opaque nature, gouache colors are commonly used to add nuance to all types of illustrations, to go over details or areas of color, to create textures, to add outlines to colors, to give a pointillist effect, or simply to correct certain areas by going over them with new tones. The thickness of these colors allows the illustrator to imitate the textures and finishes of acrylic paint (for which it can almost always be substituted) or even of oils. However, it is better not to use gouache to make thick impasto (in other words, thick applications of solid color) as it tends to crack and come off the paper. For the same reason, paper painted with gouache should never be rolled, as cracks can develop even on works painted with fine layers of color. These pages show some samples of gouache in illustration by the illustrator M. Àngels Comella.

Illustrations like this one show the simple but effective chromatic power of gouache. The colors cover one another, and can be superimposed without losing intensity. Being opaque, colors are not affected by underlying ones.

This picture shows a simple textured effect achieved by painting multi-colored dots on areas of solid color.

Gouache colors are opaque and much less bright than watercolors. They are particularly useful for achieving completely homogenous and contrasting areas of color. As with watercolor, they can also be used for spraying and spotting.

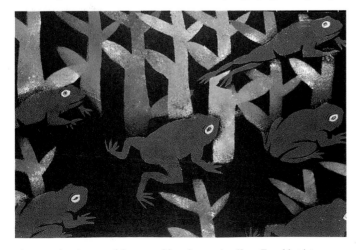

A sponge has been used here to add a chromatic effect. For this picture, the illustrator has used templates (cards with the silhouette of the object cut out) for the shapes of the frogs.

This illustration was made on a sheet of acetate (flexible but hard-wearing plastic) which was first painted in different colors, and then painted in black. The lines are drawn with an engraving tool, revealing the colors of the base below the layer of black.

The crazed effect of this surface has been achieved by spreading gum arabic over the finished illustration. The resulting effect is reminiscent of ancient paintings made on wood.

The textures in this illustration were made by applying very thick gouache with a sponge. The perfectly straight edges were achieved by protecting each area with a card mask.

Gouache colors allow you to create very pure chromatic combinations, especially when the illustration is conceived as a series of simple, two-dimensional forms.

This charming illustration was done by drawing the fish on a separate sheet of paper. The silhouette of each fish was cut out and stuck onto a base of color made with gouache diluted in quite a lot of water and applied with a natural sponge.

USING DIFFERENT MEDIA FOR ILLUSTRATION

A Historical Illustration Using Watercolor

Watercolor is the most handy medium used by illustrators. It is easy to handle, does not need many tools, and offers a high degree of detail, while at the same time it can be easily used for coloring large areas attractively. Furthermore, watercolor can be combined with other media, such as pastels, colored pencils, or gouache, when the artist wants to add nuances, contrasts, or special coloring to the illustration. For intricate, detailed tasks, such as the one below, watercolor is the ideal medium, being both easy and amenable.

THE CHARACTERISTICS OF THE PROJECT

This project consists of creating a historical reconstruction of life in a medieval village. Josep Torres, a specialist in this type of work, is the artist. The illustration is for a textbook on the history of civilization. The illustrator must paint a scene containing several characteristic figures from this period of history in a daily life scene in which one can clearly observe details of architecture, clothes, customs, and tools from the period. It is not necessary to reconstruct a specific location but rather to portray plenty of visual information in a scene that suggests actual human activity. It has to be a double-page illustration with a small space left for an explanatory text to be inserted.

REFERENCE MATERIAL

This type of project requires a lot of reliable documentation, since it is easy to commit a historical error or inconsistency, which can affect the reputation enjoyed by both publisher and illustrator. Both must cooperate in the search for relevant visual documentation covering the style of clothes of the period, work tools, buildings, and so on. This research can be done by consulting encyclopedias, specialist historical works (for example a history of clothing), or pictorial works from the period, which are very useful for reconstructing landscape and architecture.

MATERIALS

Tubes of watercolor paste will be used for this project, with a register of colors that includes 15 different tones: Bearing in mind that watercolor is very versatile and can be used to make multiple mixtures, this is an adequate selection. The watercolorist's palette is substituted by a series of metal recipients (jam jar lids) which can be particularly useful. Given that in this type of illustration the emphasis lies more on detail than on spectacular chromatic effects (the mixtures never require a great deal of color), the use of these small recipients is ideal. A fine, pointed, round sable paintbrush and two medium-sized flat synthetic brushes will be used.

PROCEDURE

In this illustration it is very important to plan the scene that you wish to represent. To a certain extent it is a combination of landscape, figures in different attitudes, and buildings. All the elements in the scene must relate coherently to one another. The usual procedure consists in sketching the individual figures and shapes taken from the documentary material and then altering their sizes so as to integrate them in a unified whole which meets the demands of the project. The illustrator has first made a general sketch which lays out the scene spatially. From this initial sketch he then has rendered these scenes more specific in successive versions until arriving at the definitive composition, which will be traced onto the final support.

To research this subject, the illustrator has consulted encyclopedias and other specialist historical textbooks from which it is only possible to get specific details and not an overall vision (which would be plagiarizing another work).

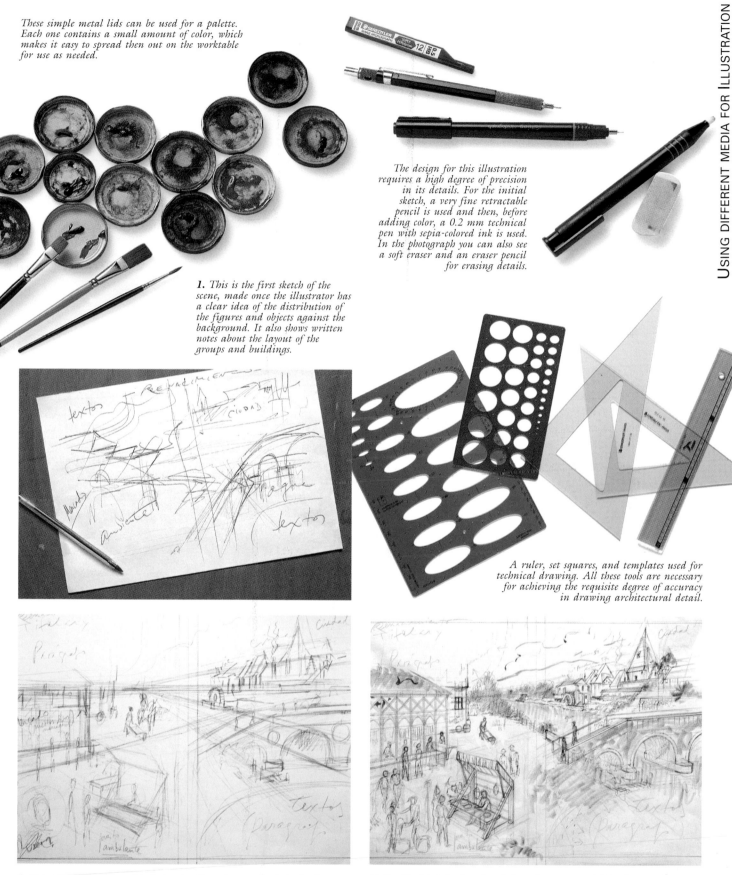

These simple metal lids can be used for a palette. Each one contains a small amount of color, which makes it easy to spread then out on the worktable for use as needed.

The design for this illustration requires a high degree of precision in its details. For the initial sketch, a very fine retractable pencil is used and then, before adding color, a 0.2 mm technical pen with sepia-colored ink is used. In the photograph you can also see a soft eraser and an eraser pencil for erasing details.

1. This is the first sketch of the scene, made once the illustrator has a clear idea of the distribution of the figures and objects against the background. It also shows written notes about the layout of the groups and buildings.

A ruler, set squares, and templates used for technical drawing. All these tools are necessary for achieving the requisite degree of accuracy in drawing architectural detail.

2. A second sketch, more detailed as to dimensions and points of reference of the scene. In this sketch, the illustrator has already defined the general layout of the main groups of figures, the landscape, and the areas reserved for text (the bottom left corner).

3. In this third sketch, a lot of the reference material has been used to define the outlines and architectural elements which dominate the drawing. This sketch will then be traced onto the chosen paper, to give a general outline of the finished composition.

4. *A final sketch, made by tracing over the last one, is used to define the detail of the figures in the groups which were roughly drawn in the previous sketch.*

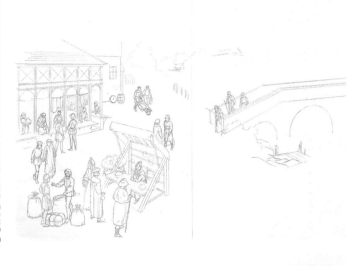

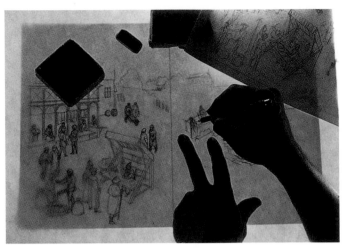

5. *With the help of a light box, the final sketch is made, combining in detailed fashion all the information from the previous sketches. The final sketch combines the scenery and the characters from the two previous sketches.*

TEMPLATES

Technical templates are common tools used in drawing outlines (although they have become obsolete due to computer design programs). As this process shows, they are very useful for detailed illustrations which include various architectural forms. There are templates for all types of flat geometrical forms. The templates of ovals used here are especially useful for semi-circular or curved arches (which are typically medieval) seen in perspective.

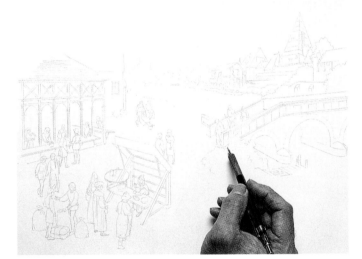

6. *The final details are added to the initial sketch based on the documentation that has been gathered. The pencil lines have to be very finely drawn so as not to affect the addition of color later.*

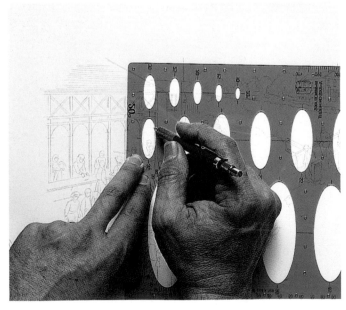

7. *The arches and arcades of the buildings and the bridge are drawn with the help of templates, in order to ensure that the curves are all smooth.*

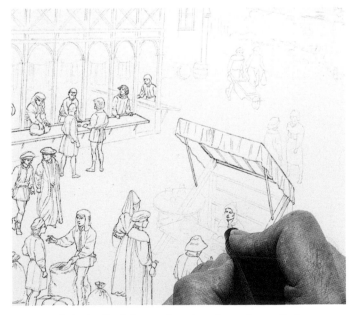

8. *Once all the details of the scene have been drawn in pencil, the illustrator goes over the lines using a technical pen with sepia ink. Sepia is used instead of black to avoid outlines that stand out too much once the figures and buildings have been colored in.*

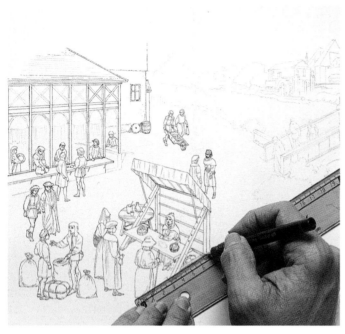

9. *In general, all straight or curved lines should be drawn with a ruler or template to avoid ambiguity in the shapes of objects or buildings.*

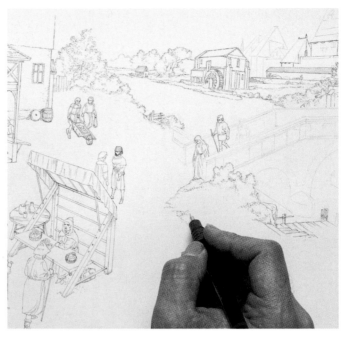

10. *Additional details (plants, rocks, and other small objects) can be added at the end, relying on documentary evidence, in order to fill in areas that seem too bare or undetailed.*

11. *If the curves drawn with pencil are accurate, they can be gone over by hand with the technical pen.*

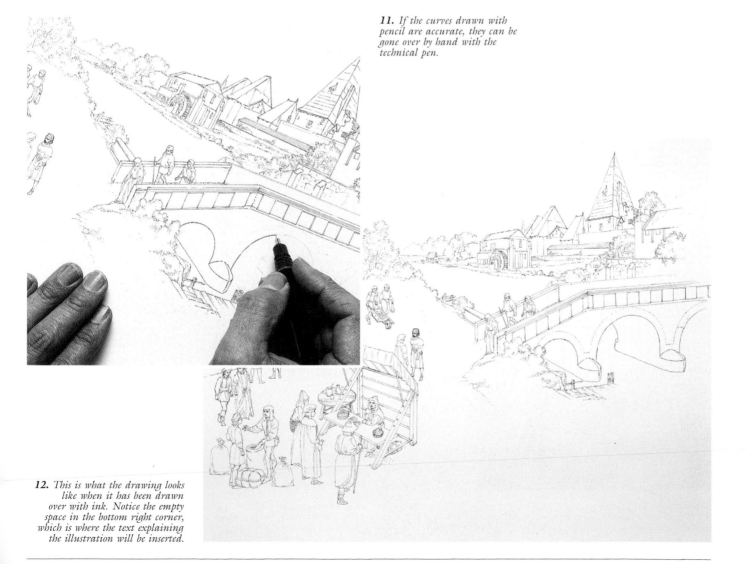

12. *This is what the drawing looks like when it has been drawn over with ink. Notice the empty space in the bottom right corner, which is where the text explaining the illustration will be inserted.*

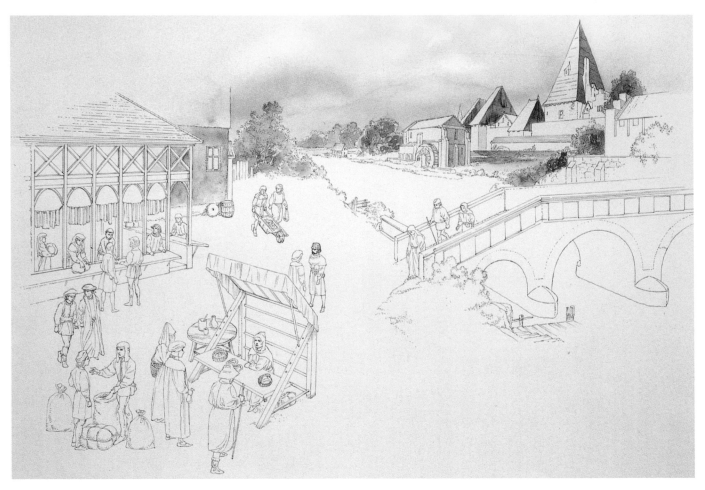

13. *The background of the drawing is colored in first, using very diluted colors. Light and shade is not fully defined until the illustrator has a more complete vision of the coloring of the whole.*

TECHNICAL PENS

The technical pen is another tool that is falling into disuse thanks to the arrival of the computer. It consists of a precision nib, between 0.1 and 1 mm thick, fed by a replaceable ink cartridge which is generally black, although other color cartridges can also be used.

14. *The areas where there are no details are colored with dilute washes of color using a medium-sized synthetic flat brush. The amount of water used should be carefully adjusted so as not to flood the paper and spoil the work.*

15. *The illustrator should be very careful when applying different tones so as not to stray over the contour of each shape. In some areas (such as the bridge, for example) a base wash of lightly shaded color is laid down to which detail can be added once dry.*

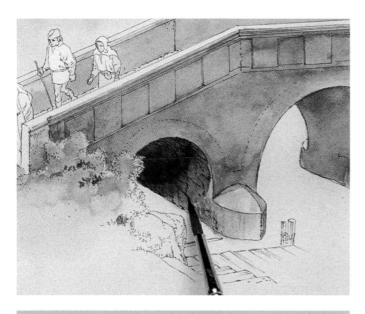

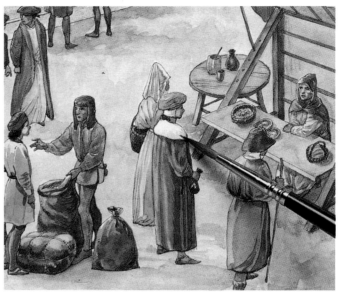

16. *Here you can see how the detail and shading is added to the shapes once a soft, balanced chromatic whole has been achieved. Shade should be darkened little by little, or in other words, not too much work should be completed on some areas of the illustration without doing the same on others.*

KEEPING THE WORK CLEAN

In illustrations that are as time-consuming as this one, it is vital to ensure that the illustration remains clean at all times and to avoid any spillage that could ruin several hours of work. Always work with clean hands and have cloths and absorbent paper ready for drying the paintbrushes after each rinse to avoid accidental droplets falling onto the paper.

17. *The final task consists of fully defining all the details: the shadows in the bridge's stonework, the different hues of vegetation, the cracks and outlines of the architecture, and the details of the people's clothing. The information available should reflect rigorously the reference material.*

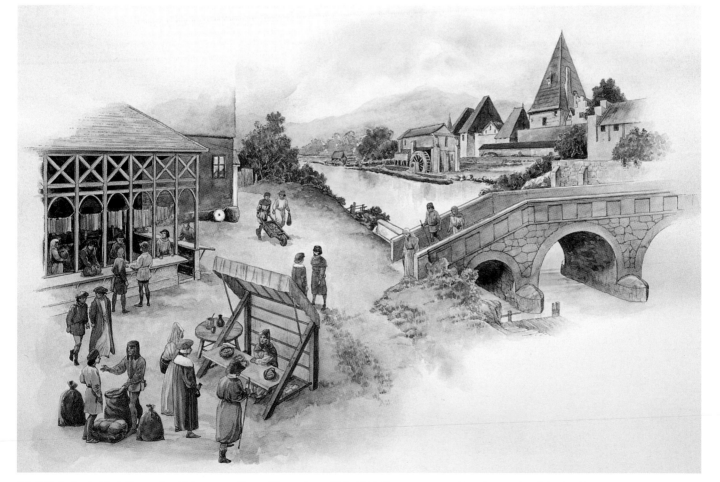

18. *This is the finished illustration. It is a magnificent illustration, which faithfully reconstructs a historic scene in all its detail: not how it actually was, but how it could have been.*

A Naturalistic Illustration Using Watercolors

Watercolors can be used for illustration in ways that few artistic painters are aware of. Watercolorists are used to getting a series of chromatic results from the medium, based on blocks of color, transparencies, and the expressiveness of the paintbrush. In this way, they expect to create works that are realistic, light, and coherent. But as professional illustrators know, the medium is capable of very different, even contrasting, results. Josep Torres, the illustrator who created the following work, uses watercolor as a medium for strictly realistic, highly detailed illustrations. As you will see, watercolor is unparalleled in works which demand a high degree of naturalism.

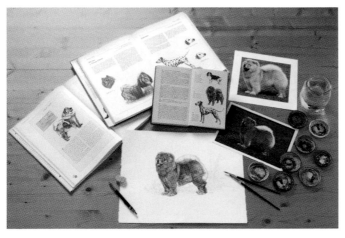

The illustrator will use watercolors and a very fine, round sable paintbrush. The photograph also shows the reference works used for this task: handbooks on dog species, an illustrated encyclopedia on animal life, etc. To ensure the accuracy of the drawing, the outline of the animal is traced in pencil, using a light box.

All the tones of the dog's coat are obtained from these eight colors and their combinations, which are characterized by a predominantly broken, highly nuanced tone.

CHARACTERISTICS OF THE PROJECT

This project consists of making an illustration for a manual on different species of dogs. It is not a scientific publication but rather a book of general interest which illustrates different species of dogs with their characteristics and how they look. Illustrations are usually better for this task than photographs, because the illustrator can depict the characteristic features of each animal to a degree that is unmatched by photography. Furthermore, illustrations give the book a uniform visual style, something that is difficult to achieve with photographs. The illustrator will make an illustration of a Chow which, like the other illustrations in the book, must be highly detailed, and convey with precision details of the dog's anatomy, coloring, and physiognomy.

Before applying the color, the illustrator will make sure that the tone is suitable. For this, he will check it on the same paper as the support for the illustration.

REFERENCE MATERIAL

With this type of commission, the editor usually makes available the necessary reference works. However, experienced professionals usually have illustrated books and catalogues in their libraries, since it is common to receive commissions that demand accurate depictions of animals. Josep Torres will take as his starting point a good photograph of the dog. Nevertheless, the photograph does not show accurately certain details of the head or the flow of its long fur. To obtain this additional information, it will be necessary to consult various specialist books on dogs. It goes without saying that this research must not plagiarize the work of other professionals.

MATERIALS

The illustrator will use tubes of watercolor paste. His palette will consist of various jam jar lids to hold the colors which he will then mix (a simple and easy undertaking). The range of colors is limited to cadmium yellow, ochre, burnt sienna, burnt umber, cobalt blue, cerulean blue, carmine, and English red. He will use a single, very fine, round sable paintbrush.

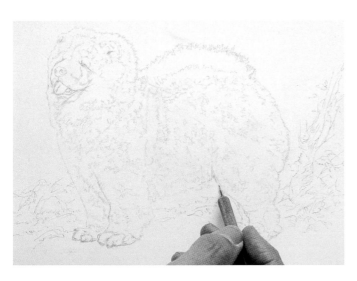

1. The initial drawing must be finely detailed with a hard-leaded pencil, or better still, using a retractable pencil with hard and soft leads which guarantee a fine point at all times. Together with the outline, the drawing should also include all the details of the head and the areas where the coat is darkest.

A NEW PAINTBRUSH

In this work, the paintbrush becomes a veritable high-precision tool. Its tip must be perfect and very pointed, and the shaft must be completely straight. To ensure that the paintbrush is in perfect condition, it is best to buy a new one. Sable brushes are the most reliable, although even their high quality is adversely affected by continuous use. All illustrators have several paintbrushes and save their newer ones for tasks which demand a higher degree of accuracy.

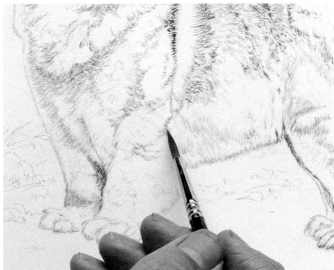

2. Begin painting from light to dark, beginning with the softer tones and then moving on to the darker ones. The first brush strokes are in a yellowish ochre heavily diluted in water.

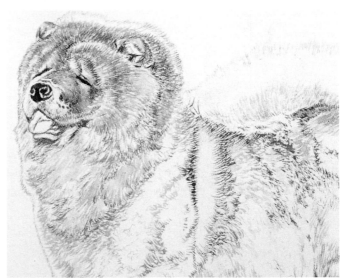

3. This is the first soft coloring made with the ochre mentioned in the previous illustration. All the painted areas are later given nuance using darker tones, but always within the same, warm tonal range.

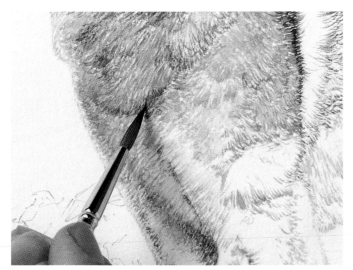

4. The first touches of color have been added to the animal's eyes and snout, meticulously following the lines laid down in the initial drawing. New touches of color are also added to enrich the tones of the rest of the body.

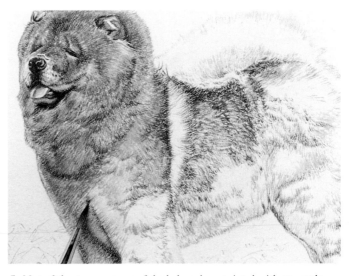

5. Most of the stronger areas of shade have been painted with an earthy color, and now the first tones are completed. These colors should be cold ones, using lightly grayish greens and blues.

38 A Naturalistic Illustration Using Watercolors

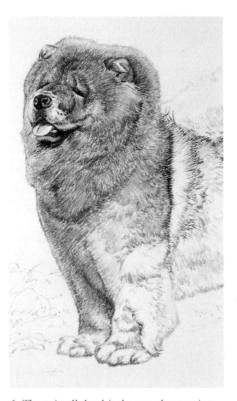

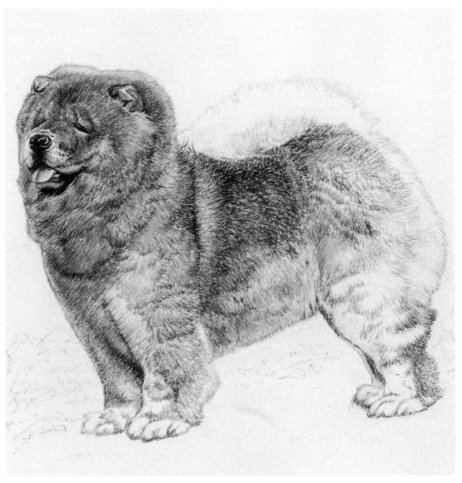

6. *The animal's head is the area that requires the most attention. All the folds should be accurately detailed so as not to create deformities. It is necessary to create detail with each color moving from one area to another rapidly without spending too long over each, to avoid making it too pronounced. The final details of the head relate to work on the snout. To give the correct nuance to its shape and color, it is necessary to include touches of a cold tone (blue) to make it three-dimensional. At the same time, the final details of the mouth and the corners of its eyes are added.*

7. *The darkest areas of the coat are the result of successive layers of color, or rather of successive applications of fine brush strokes which add richness and darken realistically the animal's body naturally.*

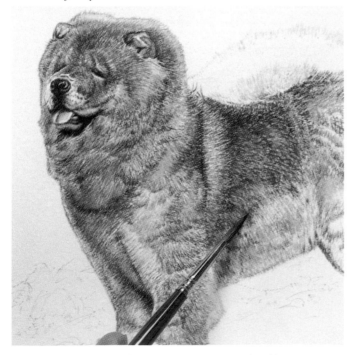

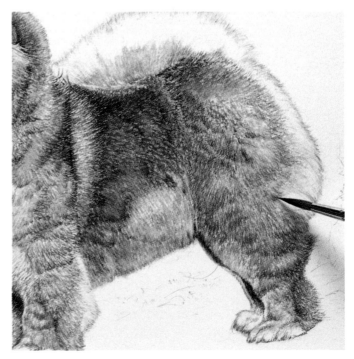

8. *As you can see in this picture, the process consists of working on all areas at the same time, paying attention at all times to the overall appearance of the illustration as a whole.*

9. *The nuances of the tail are extremely delicate and must be painted with very dilute, delicate colors, which are applied through the superimposition of very fine brush strokes.*

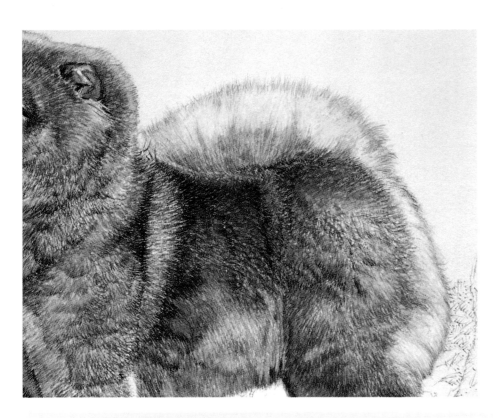

10. *Like the tail, the fur on the thighs is a lightly nuanced white with green and blue tones which need application of light touches.*

11. *The final details are the animal's paws. Here, the interplay of light and shade (warm and cold tones) are what define the complex volume of the paw. They need to be painted with care.*

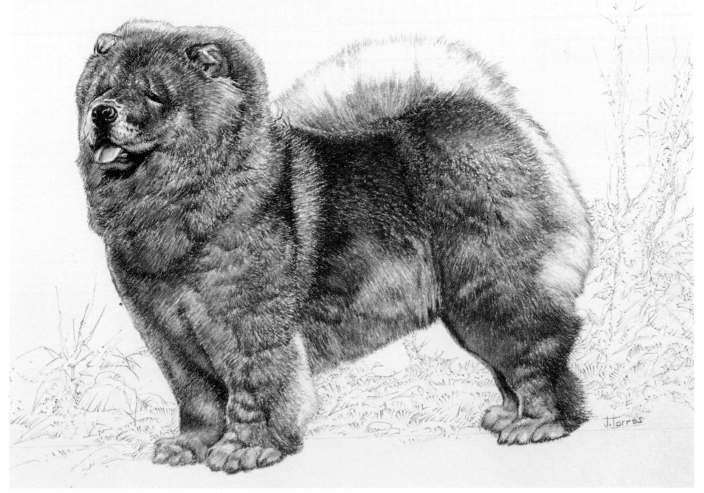

12. *This is the finished illustration. The work is a magnificent example of a naturalist illustration: meticulous, subtle, fully detailed, and highly chromatic.*

A Comic Drawn with Ink and Gouache

Comics are a genre drawn by highly specialized illustrators. As well as visual ability, they require a very specific talent for narrative. In effect, although most comic illustrators work either with scripts written by others or with adaptations of literary works, an illustrator who specializes in comics must be able to preserve the logical continuity of each episode of a story, so that the drawings become a true vehicle for the action. The process of creating a comic is complex and would require an entire book on the subject. The following pages focus on the graphic technique involved in the conception and creation of a page, or, in cinematic terms, of a sequence of the work.

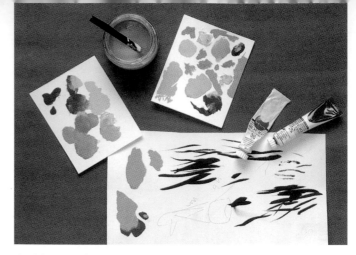

Applying gouache to this work allows the illustrator to create the correct tone: a creamy, fairly light color, a half-tone between the white paper and the black Chinese ink. To get this tone, the illustrator has experimented with various combinations.

CHARACTERISTICS OF THE PROJECT

With a few exceptions, comic illustrators do not work on specific commissions; instead they themselves look for interesting plot lines or link up with scriptwriters who can adapt to their work styles when producing a comic. Of course the editor is a key player, because he or she is the one who ultimately decides on the style of the publication in which graphic stories are published. Nevertheless, the editor will always leave the nature and the graphic style of the story in the hands of the authors, knowing the nature of the work they produce and trusting that the result will adapt itself to fit the requirements of the publication. The comic strip shown in the following pages is the work of illustrator Josep Torres, who is the author of both the story line and the illustrations.

MATERIALS

The paper on which Torres will work is a smooth (non-satin), heavy Scholler paper, which is a quality paper strong enough and perfectly suited for use with Chinese ink and gouache. Errors on this paper can be corrected using a razor blade and without leaving noticeable marks. The illustrator will use a 0.2 mm technical pen and a fine, round sable paintbrush. He will work with a single tone of gouache, which is made by mixing burnt sienna with white. Other materials he will use include retractable pencils, fine felt-tipped pens, an eraser, a razor blade, and a ruler.

REFERENCE MATERIALS

In all realistic comic works, reference materials are a very important element. Streets, clothes, machines, the characterization of people, and so on should all correspond to a specific image of reality (either the present or a particular moment in the past). The imagination of the illustrator cannot interfere with this. However rich or interesting the illustrator's imagination and creations, readers will never accept inaccuracies in how objects or figures familiar to them are represented (unless the comic happens to

The reference material used for this page consists of various photographs and a scale model of a car, as well as fashion photography and urban landscapes from which the illustrator can get all the information needed to characterize the protagonists and locations.

The paintbrush and India ink are basic tools for a comic illustrator. It takes a lot of practice to be able to master the brush stroke and control the thickness and flow of lines, which give a comic drawing its unmistakable character.

be science fiction). Here, the illustrator is using a scale model of a popular car for reference, as well as fashion photography and urban landscapes, in order to characterize the scenes and their characters with utmost precision.

PAGE LAYOUT

For a comic illustrator, a script should be visually translatable instantly: the illustrator should "see" each episode of the script clearly, translated into frames. The graphic story is conceived by page: each page should have its own visual unity and be balanced, legible, and attractive. Too many frames make it difficult to read; too few exaggerate the importance of the scenes unnecessarily and slow down

An example of a page created by Josep Torres, consisting of just two frames. The composition is carefully calculated so that the narrative link between both frames corresponds to the demands of the script. Visually, there is a perfect balance between black and white.

the narrative's rhythm. Each illustrator adopts the layout that best fits his or her visual style. Here you can see pages with two to six frames each.

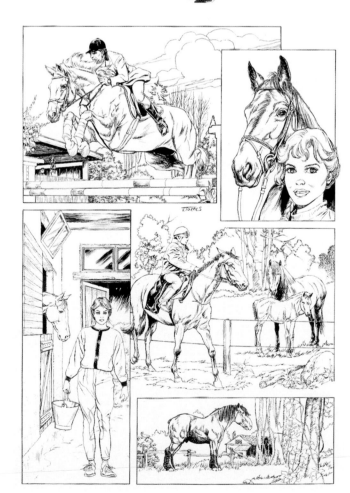

This page shows a clear predominance of line over solid color, and of different size frames that appear to be separate, but which encapsulate a strong sense of narrative.

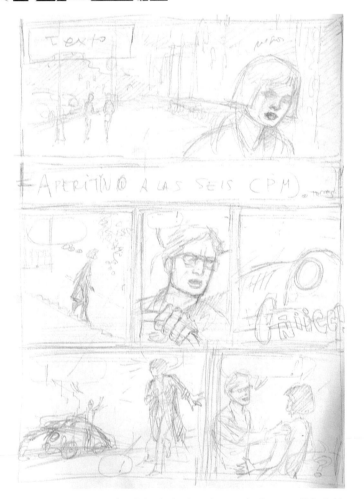

1. *This is the first, freehand sketch showing the way the frames will be laid out on the page. This first version must take into consideration factors such as close-ups, medium shots, and long shots.*

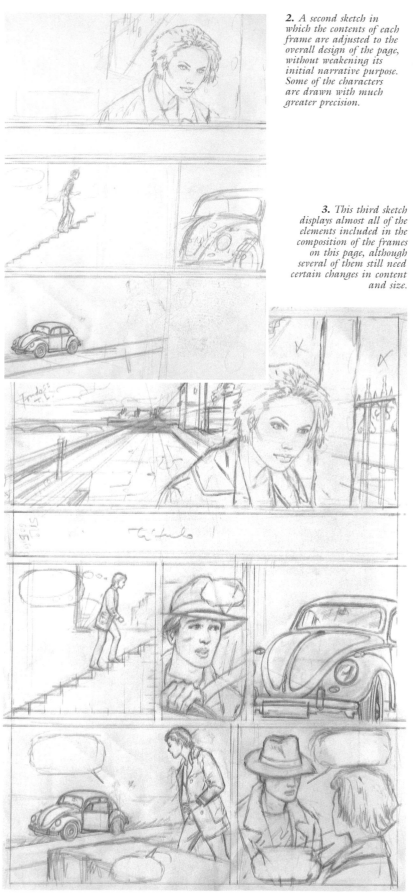

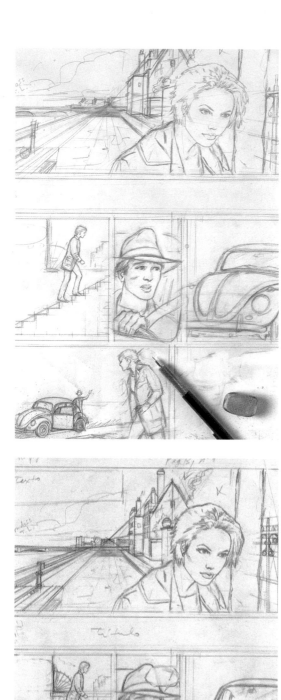

2. *A second sketch in which the contents of each frame are adjusted to the overall design of the page, without weakening its initial narrative purpose. Some of the characters are drawn with much greater precision.*

3. *This third sketch displays almost all of the elements included in the composition of the frames on this page, although several of them still need certain changes in content and size.*

4. *This is a more elaborate version of the previous sketch in which the details to be included are shown in almost final form.*

5. *Finally, the illustrator has achieved the composition he was aiming for, which is complete in almost every detail and in the right shape to convey the story line. The speech bubbles in each frame are summarily outlined.*

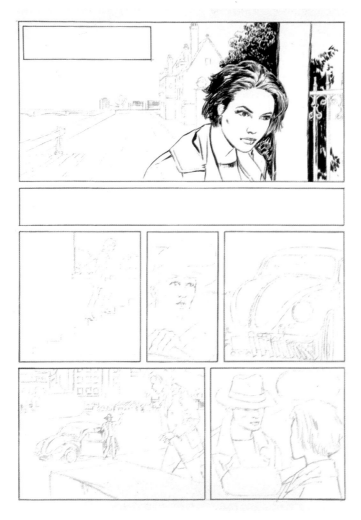

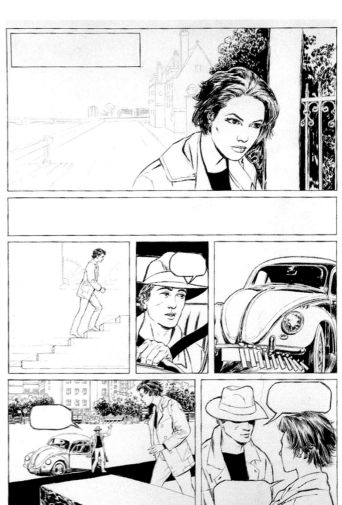

6. *The illustrator has traced the final sketch onto the sheet of paper that will act as the support for the final illustration. He has gone over the edges of each frame and now begins to ink in the whole drawing with a technical pen.*

7. *The black blocks are filled in with a paintbrush, while the details of each drawing and the lines depicting objects and facial details are made with a technical pen. However, not everything in the drawing needs to be inked over. Details found in the reference material are also added.*

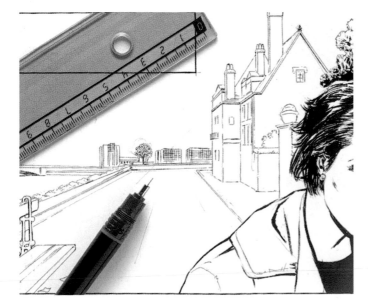

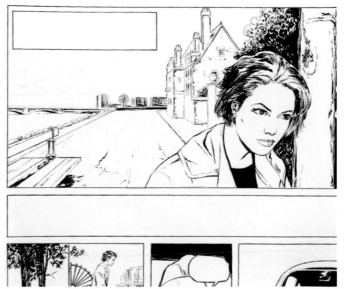

8. *While scenes of the urban landscape are sourced from reference material, the ability to draw perspective without errors or distortions is fundamental. In this case, the perspective was finalized in the last sketch, and all that remains is to ink it in with the help of a ruler.*

9. *Each frame must be inked in with meticulous care. It is important not to overlook the overall balance between blacks and whites, and between highly detailed and emptier areas. Balance is one of the key elements in the visual appeal of the page.*

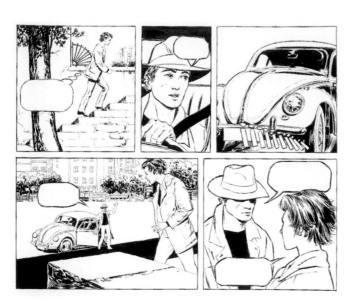

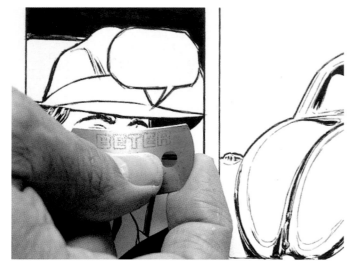

10. In the inked-in version of the bottom half of the page, the balance between empty areas and ones containing more detail, and between blacks and whites, can be readily appreciated, not just for individual frames but also for the page as a whole.

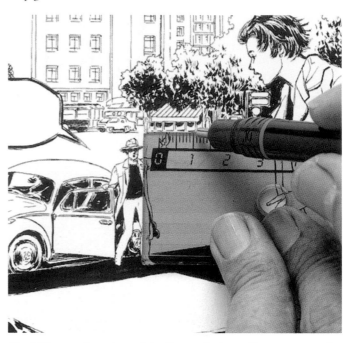

11. Adding small touches and details must be done with extreme care. A ruler is invaluable for defining all the lines in the architectural cityscape.

12. The razor blade is an indispensable tool for correcting errors in the process of inking. This image shows how the illustrator scratches out a small mark where the pen had crossed over the edge of the hat outlined in pencil.

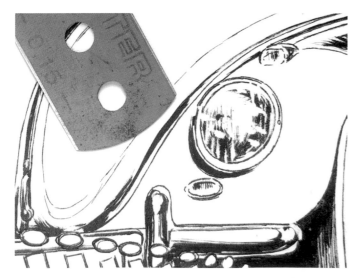

13. The razor blade is also very useful for whitening areas and for adding nuance to areas of brightness. The interplay of light and shadow on the headlight, for example, is much easier to achieve after the inking in is completed.

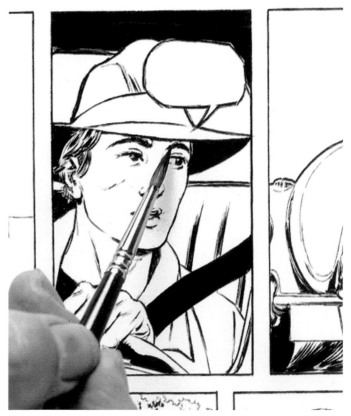

14. When clean, thick lines are required, it is best to go over pen lines with a paintbrush that has a perfectly pointed tip to ensure accurate strokes.

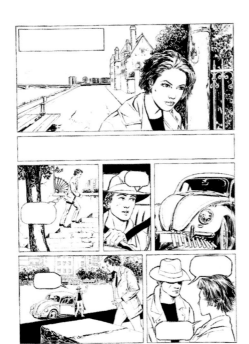

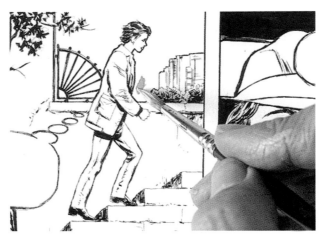

16. *Once the desired tone of gouache is mixed, the areas that will help balance the interplay of blacks and whites are painted in. Gouache is added to individual frames according to the compositional demands of that frame and not to specified areas.*

15. *This is what the page looks like after being inked in. In its current state, everything has been perfectly defined, including the drawing and the spaces left blank for text. The blank spaces should always be large enough to fit the dialogue in the script.*

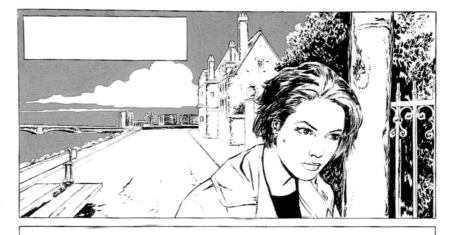

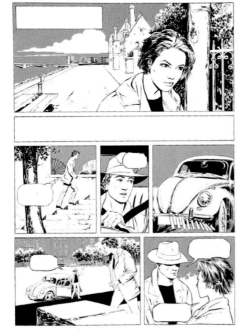

17. *The blank, white areas of the sky are a good place to add the creamy tone of gouache. In any case, color should always be added as a function of the visual balance of individual frames, regardless of which element is being colored in (sky or pavement).*

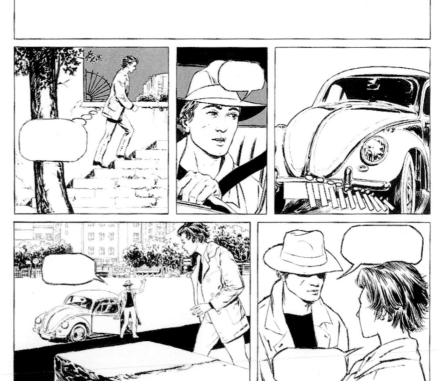

18. *Clarity of images is a basic condition in any illustration designed for narrative purposes. This page of a comic is a good example of how to properly complete an illustration. Success depends on the appropriate use of very simple media and on careful composition.*

Illustrating with Felt-tipped Pens

Illustrators use felt-tipped pens much more than artists do. It is an ideal medium for achieving clean, precise colors, clear outlines, and a finished result that is easy to reproduce by photomechanical means. Of all the pictorial media available, the finish achieved with a felt-tipped pen is the cleanest but also the coldest. For a long time, felt-tipped pens were the medium most commonly used by graphic designers (in the creation of layouts) and by interior designers, since they created an effect that was as close as possible to the appearance of a printed image. Nowadays, computer techniques have replaced these types of uses. However, felt-tipped pens continue to offer interesting possibilities for the creative illustrator who uses them on a textured support or in combination with other media.

TYPES OF INK

Most felt-tipped pens contain water-based or alcohol-based ink. Water-based felt-tipped pens are slower to dry on paper, and colors, even dry ones, blend when superimposed on one another. Some pens make opaque marks that are very similar to gouache and which give good results in works requiring blocks of thick, solid, homogenous color. The most widely used felt-tipped pens are those containing alcohol whose ink evaporates very quickly (quick-drying). Once the color dries, it becomes indelible and, because it is transparent, can be worked over using its transparency to superimpose tones that do not mix or run. If the illustrator wants to blend colors and create a work without noticeable pen strokes, he or she must work quickly and not let the colors dry.

FINE AND BROAD TIPS

The tip of the felt-tipped pen determines the look of the strokes and colors. The tip of the conventional felt-tipped pen (like the one used in schools) leaves a varied trace that thickens with use. Polyester tips are more durable and leave a trace that is consistent in thickness. Polyester-tipped pens come in several different widths, and the professional brands come in two tip sizes, fine and broad, one at each end of the pen. Almost all brands come in both fine-tipped and broad-tipped. The colors that are available vary depending on the manufacturer (Pantone produces as many as 500 different tones).

The professional illustrator usually works with an extremely wide range of colors, thereby eliminating the need for mixing, something which is always difficult with this medium. Individual projects determine which colors will be used. When buying felt-tipped pens, it should be remembered that color charts show only close approximations to the real color. So, it is a good idea to check the tone of each pen on white paper before buying it.

Used in an orthodox and careful way (blending strokes together and working with layers of transparent color), felt-tipped pens can give results as delicate as those shown in this illustration by Jean Naudet.

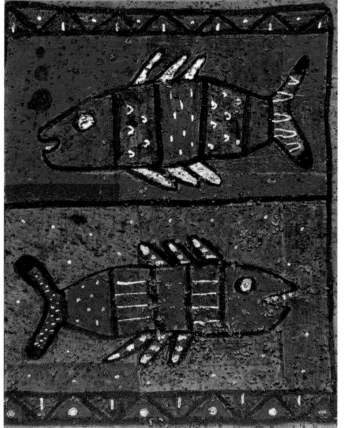

This illustration by M. Àngels Comella was made on cork. The transparent element of the felt-tipped pen allows the support to play a decisive role in the finished effect.

SUITABLE SUPPORTS

Felt-tipped pens can be used on any porous surface, and permanent markers can even be used on impermeable surfaces like plastic or glass. However, the support should not be too porous because the point of a felt-tipped pen can get stuck and the ink absorbed too quickly by the support. The most usual supports are smooth or satin types of paper, film, or even acetates (which are made of rigid plastic emulsion). Because alcohol-based felt-tipped pens leave a transparent trace, the color of the support is important in the finish of the work. The lighter the support, the lighter the work will look.

Felt-tipped pens can be used as a quick medium for producing sketches. This image is part of a page layout or sketch that shows what a photograph will look like once it becomes part of the design. Illustration by Vicenç Ballestar.

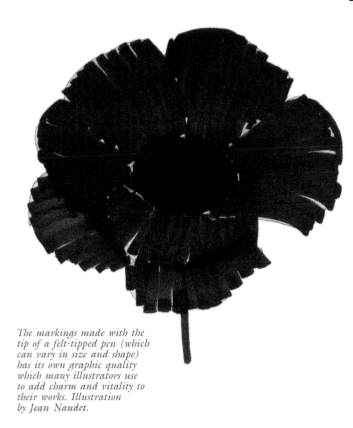

The markings made with the tip of a felt-tipped pen (which can vary in size and shape) has its own graphic quality which many illustrators use to add charm and vitality to their works. Illustration by Jean Naudet.

MIXED TECHNIQUES USING FELT-TIPPED PENS

Felt-tipped pens often yield a finish similar to that of water-color, though they cannot be used as freely. Formats must be smaller and tone mixtures are much more limited. However, felt-tipped pens can provide splendid results when combined with other media, such as pastels or colored pencils (superimposing these on the felt-tipped pen, never the other way around), and even watercolors. Similarly, the different supports that can be used with felt-tipped pens, such as conventional paper, water-color paper, film, silk paper, or even cork, bring about different effects. The color and texture of the support will also be visible and will add a special character to the finished product.

Although it is not common to use rough paper when working with felt-tipped pens, the effect is interesting precisely because of the rough-looking effect of discontinuous colors.

Felt-tipped pens containing water are obviously water-soluble. This illustration by M. Angels Comella has been made on damp paper. Notice how the colors lose their intensity and blend with one another.

Illustrations Using Felt-tipped Pens

Felt-tipped pens are used in a lot of interior design illustrations, layout sketches, and especially architectural designs that do not need to be reproduced to scale and with complete detail. The illustration that follows, by Myriam Ferrón, is an example of this type. It is an architectural view, in perspective, taken from a photograph. This type of illustration is usually done quickly to provide a general impression of the building in full daylight. The objective is to make a project presentation or to show a cityscape.

The illustration will be based on this image. Some professionals project these photographs onto paper to make sure that all of the proportions and measurements of the original remain unchanged.

CHARACTERISTICS OF THE PROJECT

With this kind of project the illustrator usually works from plans, creating the illustration from the information and measurements contained in them. Here the problem is simpler, however, as it involves producing an original from a photograph. It is not necessary to take measurements nor, of course, derive them from plans. It is enough just to use the felt-tipped pen to render the drawing while applying the principles of perspective to the drawing.

MATERIALS

Alcohol-based felt-tipped pens with a bevel tip will be used here. This type of tip allows for making thick lines with the edge of the bevel and fine lines with the tip. The colors are fairly transparent and, thanks to this illustration, will have an interesting, ethereal appearance.

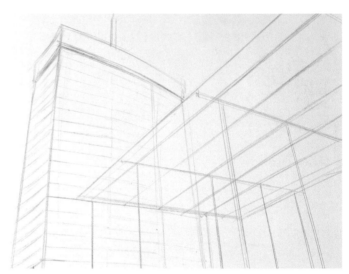

1. The initial drawing should be done with a pencil and with the help of a ruler to make sure the perspective is correct.

2. The pencil lines are drawn over, using a gray-colored felt-tipped pen. This is a neutral color that will easily integrate with the overall chromatics of the illustration.

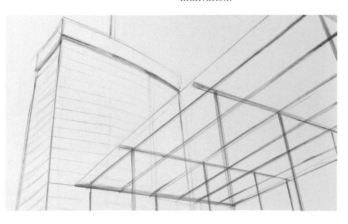

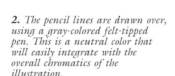

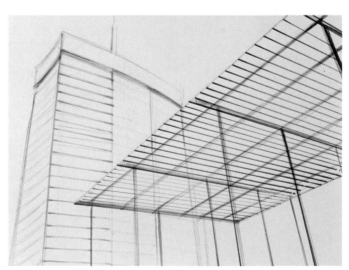

3. All lines must be gone over so that the transparent color will highlight the solid structure, giving the surfaces the appearance of glass lamina.

4. *The flat areas of the roof in the foreground and of the façade's side are traced with a blue felt-tipped pen. The lines should be parallel and straight so that the surfaces show up clearly. The use of a ruler facilitates this task.*

5. *Next, strokes of light green have been added in the same way to represent the illuminated sheets of glass of the larger building.*

6. *The sky is painted with directional pen strokes to contrast with the uniformity of the lines of the buildings and to create a sensation of the surrounding atmosphere.*

7. *The edges and angles in the shade are drawn using a darker gray than the one used to mark out the structure in the drawing.*

8. *Finally, a darker blue has been used to finish darkening the shadows and to create the final contrasts, which highlight the volumes. Working with felt-tipped pens gives a particular luminosity and ethereal quality to illustrations, lightening those that emphasize excessively purely technical subjects.*

Pastels and Colored Pencils

Illustrators rarely rely only on pastels and colored pencils. In fact these are the media most commonly used in conjunction with others (such as watercolors, gouache, acrylics, and felt-tipped pens). Both media consist of sticks of dry color, which are applied by rubbing them over the support. Pastel sticks are much more intense in color and cover the support more thickly than pencils. On the other hand, pencils allow the illustrator to add a certain level of precise detail and nuance that is not possible with a pastel stick.

CHARACTERISTICS OF PASTELS

Pastels are the closest thing to pure color since they consist of pure pigment, the basic coloring substance in all pictorial media. Pastels allow the illustrator to achieve deep, saturated colors. Their colors are thick, with a velvety quality and they require the use of a fixative (a special lacquer, available in aerosol form, which is sprayed over the finished work) for the results of the work to be long lasting. Pastel colors can be hard or soft, with hard pastels allowing for greater detail than soft ones. But because they contain more pigment, soft pastels offer greater quality in tone. All manufacturers sell pastels of different sizes in boxes as well as in single sticks. Most manufacturers offer the same colors in both the hard and soft varieties.

The quality of an illustration's finish always depends on the coarseness of the support. The coarser the support, the less possibility for detailed work, although the final effect can have the special quality of this illustration by M. Angels Comella.

Pastel sticks are available in different degrees of hardness. Softer sticks provide a greater intensity in color, but less possibility for shaping details.

Pastel colors blend together easily on smooth supports and create highly subtle effects of atmosphere or light. Illustration by M. Angels Comella.

SUPPORTS FOR PASTELS

Pastels can be used on any rough surface that will retain the pigment when rubbed on. Watercolor paper and other drawing papers are suitable for working with pastels. One type of paper that illustrators use overall, and which is used particulary with pastels, is Canson card, available in a range of colors. Glossy surfaces are the only ones not suitable for use with pastels.

A box of "all lead" colored pencils; that is, colored pencils without wooden shafts. These are useful for large-scale works, which do not require a high degree of detail. Conventional colored pencils are sold in a wide variety of colors so that there is little need for blending.

SUPPORTS FOR COLORED PENCILS

For the most part, paper or card supports are the only ones that can be used with colored pencils because the faint, narrow lines of the pencils are almost unnoticeable on textured surfaces or non-white supports. Very coarse papers do not allow for a lot of detail or thick areas of color. This is why professionals tend to use smooth or lightly grained papers. Because original works made with colored pencils are usually small in size, in larger illustrations colored pencils are used only as a supplemental medium.

CHARACTERISTICS OF COLORED PENCILS

The main characteristic of colored pencils is that they are easy to use. They are handled just like a regular pencil, but have a less pasty, softer, and glossier finish. The only media needed are the pencils themselves and the paper. Colored pencils are best suited for small-scale works because they are less intense in tone and can cover a smaller support area as compared to other media. The possibility of creating highly detailed illustrations and the permanent, unchanging nature of their colors are the main advantages that colored pencils offer.

Colored pencils can be bought individually. Major brands are available in multiples, and often come in luxurious boxes of between 12 and 140 colors. Some manufacturers make both hard and soft colored pencils. Hard pencils allow greater accuracy because they can be sharpened to finer points. Colored pencils are also available as watercolor pencils, soluble in water. In recent years, colored pencils have appeared on the market as thick sticks of color, more like pastel sticks or wax crayons than traditional colored pencils with cedar lead.

When dealing with works done in colored pencil, contour and coloring should not be distinguishable since both are completed simultaneously. Illustration by Cristina Picazo.

Along with watercolor, colored pencils are one of the media most frequently used by illustrators, especially in children's illustration. Illustration by Luis Filella.

TECHNIQUES AND POSSIBILITIES FOR PASTELS

Pastels can be used for drawing lines and also filling in areas of color. What professional illustrators usually do (given the thickness of the lines) is blend the two together to obtain colored surfaces whose texture reflects the coarseness of the paper. Blending lines or blocks of color means spreading the color over the support with a finger, a cloth, or a paper stump (a pointed stick of absorbent), so that the pigment particles penetrate the paper and emphasize its texture. The grain of the paper is therefore particularly important as it enables the artist to achieve very different finishes depending on how rough the surface is.

Pastel color tones are mixed directly on the support by blending and can be erased with a light rubber eraser. Nuance can easily be achieved by using colors from the same tonal range. The range of colors available nowadays is wide enough to allow extensive tonal gradations from dark to light. Using a stick with a slightly different tone avoids the need to retouch with black or white. Pastel yields better results when the texture of the support is highlighted.

Sanguine is a color stick that resembles pastels more than colored pencils. However, it is used more as a medium for drawing than for painting. Its reddish tone makes it unmistakable. Illustration by Vicenç Ballestar.

The density of pastel color along with the coarseness of the support's surface can create very warm, deep, colorful results.

In this illustration the pastel has been added to a base of watercolor on a very coarse-grained paper. The pastel allows the base below it to show through, creating a rich chromatic effect.

This illustration by M. Àngels Comella shows a layer of gouache color applied onto a dark, glossy support. Various tones of pastel have been blended on top of the gouache, and then scratched with a pointed object to make the lines of the drawing.

Wood can also be used for pastel illustrations which do not need too many color mixes and which are based on simple chromatic surfaces. Illustration by M. Àngels Comella.

Used in moderation, pastels are a good complement to illustrations painted in watercolor. In this example, the pastel colors have been used to create a smudged, ethereal effect. Detail of an illustration by María Rius.

Here M. Àngels Comella has used pastels on wallpaper so that the grain of the support forms part of the texture of the image.

Used straight onto a very light-grained paper, pastels give very harmonious, easily achieved results. All you have to do is blend each area of color slightly to create a pleasant overall effect. Illustration by M. Àngels Comella.

This illustration by Vicenç Ballestar shows the vitality that can be achieved by using pastels directly with hardly any blending or mixing of colors.

COMBINING WITH OTHER MEDIA

Pastels can be superimposed on all types of surfaces painted with watercolor, gouache, or acrylics, provided the layer of color is not too thick (as can often happen in the case of gouache or acrylic), since this would mean painting on very smooth surfaces to which pastel does not adhere well. Painting on washes of Chinese or colored inks can also produce interesting results. Many illustrators use pastel on very rough supports (wood, fine sandpaper, butcher paper, supports covered in plaster, etc.) in order to achieve rough finishes that can create attractive, age-induced effects.

TECHNIQUES AND POSSIBILITIES FOR COLORED PENCILS

Using colored pencils entails a technique that lies halfway between drawing and painting. The intensity of the color depends not just on the color of the pencil itself but also on the amount of pressure that is applied to the point of the pencil. The resulting color can never be as solid as pastel, but it is possible to achieve areas of thick color by holding the pencil lead flat against the paper. Colors do not really blend. Instead, when superimposed, they are seen through their transparency. Therefore, as with watercolors, light colors should be applied before dark ones.

Illustrators who use colored pencils find that the texture of the paper is their main asset, the rougher the paper, the better the results. Some professionals score the support with an engraving tool before coloring it, so that the pencil strokes highlight the grooves and textures of the scoring.

It is a highly usual practice to combine colored pencils with watercolors. Colored pencils are a useful supplement for highlighting, shading, and giving volume to forms that have first been painted with flat colors. This technique is almost universally used by illustrators who can later further enrich the work with touches of gouache or pastel.

There are many types of watercolor pencils available. These are colored pencils which are soluble in water and produce an effect similar to watercolor.

Although lacking complexity, colored pencils are a medium that offers great possibilities in illustration. This work by Miquel Ferrón is a magnificent example of the degree of accuracy that can be achieved with colored pencils using crosshatched strokes.

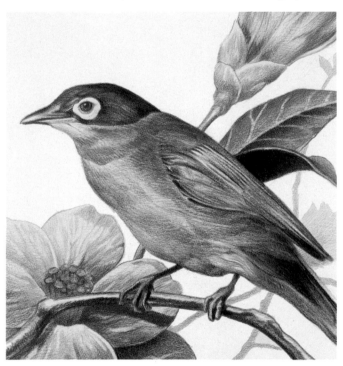

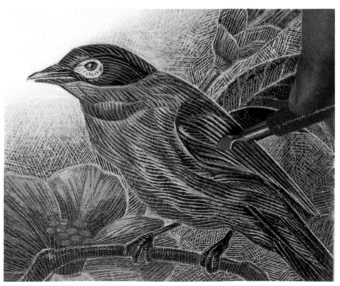

As in the previous example, an engraving tool has been used here to highlight the work's most important outlines and details. The more detail that is added to the illustration, the more the engraved lines stand out.

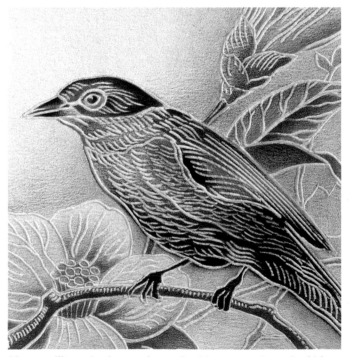

The same illustration in a version made with an engraving tool, which allows the paper to be scored so that the outlines stand out in bas-relief. This is a traditional technique used with colored pencils.

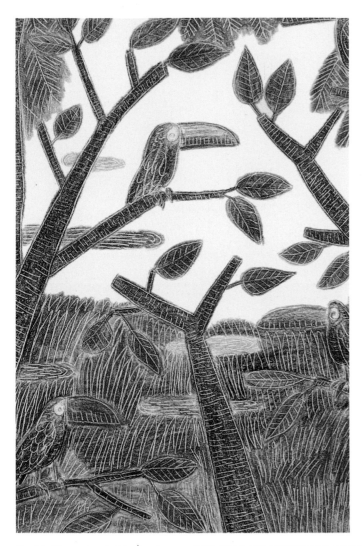

Colored pencil design lends itself to simple applications and this can create very attractive illustrations, like this one by M. Àngels Comella. Here the colors are suggested more than filled in.

In this illustration by M. Àngels Comella, an engraving tool has been used to create visual interest in some parts of the work, in contrast to the areas of color where the pencil stroke is visible.

COMBINING WITH OTHER MEDIA

Colored pencils lend themselves to be used in conjunction with watercolors, creating the most delicate and subtle combinations available to the illustrator. In the case of watercolor pencils, the combination is such that it is impossible to see where one medium ends and the other begins. However, because they are not very opaque, colored pencils do not stand out easily against most pictorial media, which are very strong.

Colored pencils are a common complement to watercolor illustrations. Light nuances in colored pencil can easily enhance forms painted in watercolor.

OIL PASTELS

Better known as wax crayons, oil pastels are characterized by their high level of organic agglutinate (wax or oil), which makes them thicker and more adhesive than conventional pastels. As with stick pastels, they are rubbed onto the support, and can be mixed and superimposed on one another fairly easily. Since they are an oil-based medium, they can be dissolved using organic solvents like turpentine or white spirit. They give a thick, solid, extremely dense line, and can be blended together if they are rubbed with a finger or if heat is applied.

Wax crayons are not a suitable medium for illustrations that need accuracy or a high degree of realism, as the colors easily smudge and it is not possible to keep a stick sharp for very long. However, their brightness makes them ideal for certain types of children's illustrations in which the purity of primary colors and simple lines is more important than the realism of the representation.

The thickness of oil pastels means they can be used like paste, laying down a layer of thick color, for example, and engraving it to reveal the underlying color.

Oil colored pencils can be diluted with white spirit in the same way as oil paints.

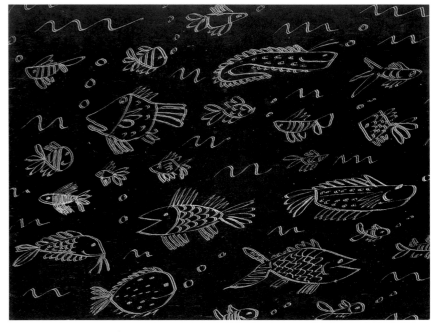

This illustration by M. Àngels Comella was made by engraving lines in a layer of black pastel spread over a composition of bright colors, which are revealed by the engraved lines.

Mixing oil pastels directly on the paper produces interesting effects. However, the result can become too smudged if you use too many colors.

Oil pastels cannot be mixed with watercolors. They can be used in the same work, though, by first drawing with the pastels and adding the watercolor after. The pastel lines will remain visible amid the watercolor.

SUPPORTS

Oil pastels adhere to all types of surfaces regardless of their texture (unless they are extremely rough), because their thick trace smears over to cover the grain of the support. This versatility makes them a good medium for experimentation. They can be tried on supports like metal, glass, or plastic. Paper, though, is the best support to use, and one with which it is possible to achieve very interesting results.

TECHNIQUES AND EFFECTS USING OIL PASTELS

Since oil pastels cover the support very thickly and are also easy to handle, they can be used to obtain interesting effects through superimposition and scraping. One can paint over an area of color with another color until the first area is completely covered, and then scrape away at the top layer so that the color of the base appears through the scraped lines. To achieve this effect, it is important not to press too heavily while applying the second color, otherwise the two colors will mix. The best results are obtained by superimposing a dark tone over a lighter one, since darker colors cover lighter ones more efficiently.

Oil pastels are not soluble in water, so they can be used to create interesting effects by combining them with other, water-based media such as watercolor or gouache. If a wash of watercolor is painted over a line of oil pastel, the line will stand out against the painted area because the pastel is impermeable to water. These effects are obtained using wax crayons.

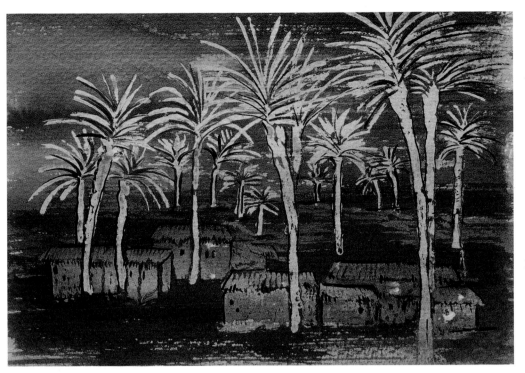

COMBINING WITH OTHER MEDIA

Wax crayons can be combined with oil-based media, such as oil paints, and also with non-oil-based media, provided a specific effect and not a perfect blend is desired. Oil pastels repel water and cannot be mixed with media such as watercolors, gouache, or acrylics. Similarly, conventional pastels or colored pencils are not, in general, very compatible with wax crayons, since wax crayons have much stronger colors. Even so, it must be noted that experimentation with oil pastels in combination with other media can give unexpected results, which, in theory, do not seem likely.

If few colors are used, they can create effects like this one in which oil pastel colors are diluted with white spirit and spread over the paper. The white areas were obtained by scraping off the diluted color. Illustration by Cristina Picazo.

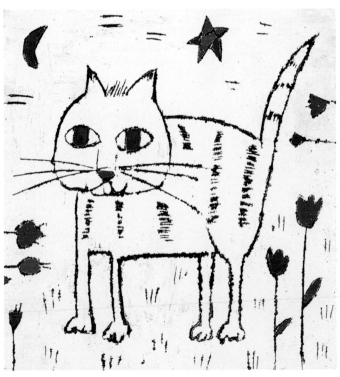

In this illustration by M. Angels Comella, oil pastel outlines are combined with areas of watercolor.

Here the technique of scraping has been used to create a multicolored illustration. Oil pastels were used, both for the white covering and the underlying colors. Illustration by Montserrat Llongueras.

A Narrative Illustration Using Pastels

In the last few years, pastels have become one of the most popular media among illustrators, especially those illustrators who work in a very colorful, personal style. With pastels, it is possible to achieve very graphic results on small art works, without the need for special accessories or apparatus. High-quality pastel sticks are available that provide colors and very saturated tones, even to the point that a finished pastel work can be confused with an oil painting. Furthermore, the texture of these colors can be even more noticeable when the support is particularly coarse. Here we show the process of creating a narrative illustration on normal drawing paper.

CHARACTERISTICS OF THE PROJECT

The editor has commissioned the painter and illustrator Yvan Viñals to create a narrative illustration for a detective novel. Although nowadays this type of illustration is much less common than it was several decades ago, some major publishers still publish special series for subscribers. These books are carefully produced and include illustrations of some key scenes. The choice of scenes can be made by either the editor or the illustrator, who, in any case, must become familiar with the plot of the book.

It is very important for the details in the illustration to be faithful to the text, since readers will immediately spot any discrepancy in the characters' clothing or inconsistency in the scene, precisely because they will have formed a very clear image of the details in the plot.

The illustrator can make up details only if they do not appear in the text and provided they do not contradict any information that is in the text. Here the illustration is in a realistic style and shows the moment when the hero arrives at a nocturnal rendezvous at the St. Sebastian Gate in Rome.

MATERIALS

Sticks of soft and hard pastels are used (the hard ones for outlines and details) on light gray Canson Half-Tint paper. The paper is mounted on a drawing board and held in place with strips of paper tape. In this way the support will be held firmly in place throughout the entire process, allowing for clean, firm lines.

REFERENCE MATERIALS

Narrative illustrations usually require very specific reference materials, since they must correspond as closely as possible to the information in the text. In this case, the editor has provided the illustrator with a nocturnal view of the St. Sebastian Gate. However, it is the illustrator's responsibility to properly characterize the human figure. The narrative only says that the hero is wearing a raincoat and a hat. These elements are not difficult to represent. The problem lies in finding a static model for the hero that can be copied easily. With the help of two friends, the illustrator takes various photographs of the "character" in a pose that would be logical for someone walking out on a stormy night. When the help of a mirror is not enough, many

The illustration does not require much reference material, but it has to be very specific. The editor has provided a photograph of the location and the illustrator has obtained a photograph that characterizes the human figure along with images of stormy skies.

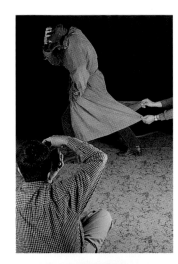

illustrators use photographic pictures as reference material when other means are impractical. Finally, painting stormy skies will help make the scene more realistic.

It is not unusual for the illustrator to ask a few friends to help reconstruct the scene to be depicted. In this instance, the character's clothing has come from the illustrator's own wardrobe.

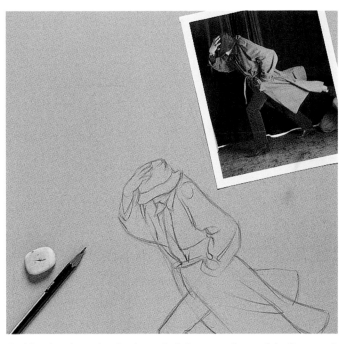

1. *After drawing a few sketches to find the proper frame of the figure and the scene, the illustrator chooses the best-photographed image taken with the help of his collaborators, and begins to draw the scene in pencil.*

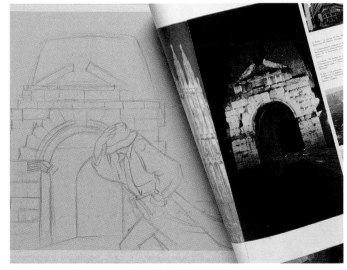

2. *This image shows how the two elements that comprise the scene, the human figure and the historical monument, fit together.*

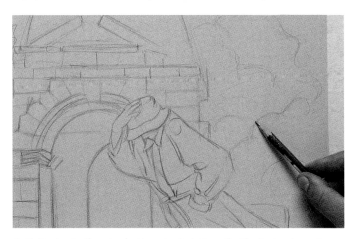

3. *Referring to the reproduction of a painting, the illustrator draws in the basic lines that depict the clouds and lightning across the stormy sky.*

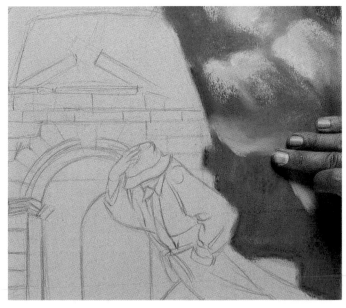

4. *The intense contrasts in the cloud-filled night sky are given shape using black, white, and blue pastels, while the outlines of the figure and the monument remain untouched.*

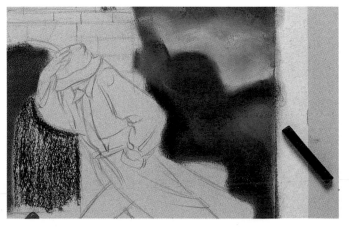

5. *The sky is practically finished. The clouds have been created by smudging with the fingers, while in the left-hand corner an intense unblended blue has been added to emphasize the yellow lightning clearly.*

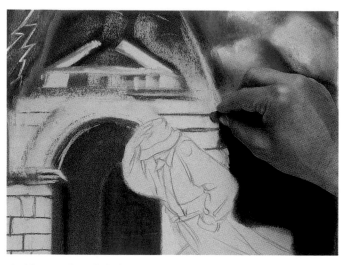

6. After covering all the lit surfaces of the monument with a layer of yellowish white, the shadows and outlines of the stones and the molding of the Roman arch are drawn using a dark brown.

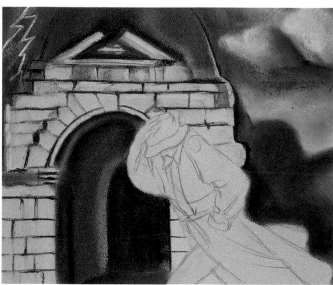

THE PROBLEM OF LIGHT

When trying to reconstruct narrative scenes, the space, scene, and layout of each element must be coherent. Above all, the light source that illuminates the scene's elements must be correctly situated. These factors are all fundamental. In this illustration, the illustrator has chosen to have the Roman arch's nocturnal illumination duplicate that in the reference photograph, and to depict the light and shadow falling on the figure accordingly, trying not to create any lighting inconsistencies, which would be immediately apparent.

7. Here you can already see the strong, dramatic contrast created between the illumination of the arch and the dark, stormy background.

8. To further reinforce the effect of nocturnal illumination, the shadows, which show the relief in the stones and the molding of the arch, are emphasized even more.

HARD AND SOFT PASTELS

Soft pastels are the most suitable for covering large areas with thick, saturated color. These layers cover the paper without having to go over it too many times. Hard pastels, in contrast, are particularly useful for showing detail, outlines and profiles, and to add nuance to slight variations in color within large areas covered by soft pastel.

9. The shadows of the hat and the creases in the raincoat that the figure is wearing are added, using a hard stick of earthy green pastel.

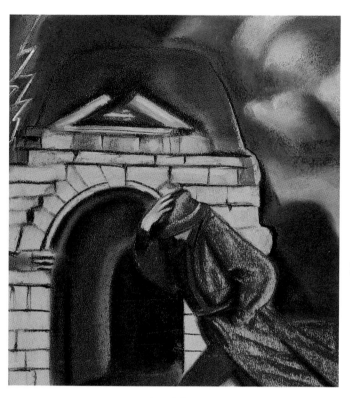

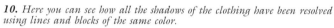

10. Here you can see how all the shadows of the clothing have been resolved using lines and blocks of the same color.

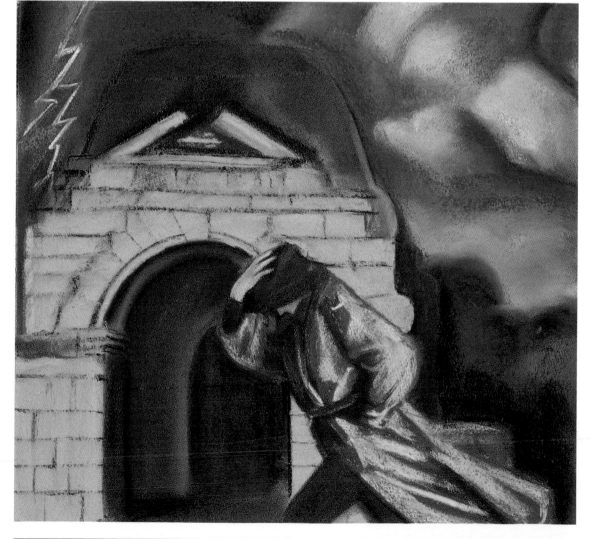

11. The illustrator goes over the whole raincoat with an ochre stick of soft pastel, including the areas of shadow he has already colored. He then blends these two colors using his fingers to achieve a good balance between light and shadow.

12. To emphasize the volume of the folds in the raincoat, a few strokes of white have been added to the areas exposed to the light. Finally the illustration is finished.

A Decorative Illustration Using Colored Pencils

Colored pencils are among the easiest and cleanest medium to use. As a complement to other media, they are almost indispensable for adding occasional details to large-scale illustrations. When used in illustration, they offer far greater possibilities than one could imagine. For the following illustration, colored pencils will be used as the principal medium along with watercolor and a somewhat unusual tool, an engraver for scoring the paper. The use of watercolor is minimal and only affects the background color. It will become apparent how colored pencils are a medium that can be used to produce a high degree of subtlety in the drawing.

CHARACTERISTICS OF THE PROJECT

The painter and illustrator Myriam Ferrón will make a decorative illustration to accompany a text on art and customs in Ancient Egypt. The book in which this illustration will appear is a text with wide circulation, aimed at a very broad public, making the visual appeal of the illustration a fundamental criterion. This type of work usually requires illustrations that, while not adding factual information, contribute to the overall appearance of the text and highlight its content. The illustrations should be directly related to the text, even if they do not illustrate a particular event described in it. The editor has to specify the format of the illustration (in this case vertical), the size when reproduced, and the subject matter of the text it relates to. It is important for the editor to show the illustrator a sketch or layout of the page so that the illustrator can adjust the style and color of the illustration to it.

MATERIALS

The materials for this illustration consist of different color pencils, with both soft and hard leads. Hard lead is very useful for drawing outlines and delineating shapes, while soft lead yields more intense, saturated tones in illustrations. The colored pencils are complemented by a small metal engraving tool for scoring the paper without scratching it (tools with very sharp blades or edges should not be used). For this reason the paper must be sufficiently thick (around 200 grams) and with a very light grain. A watercolor (ochre) will be used to color in the background of the illustration and a little white gouache for some final highlighting.

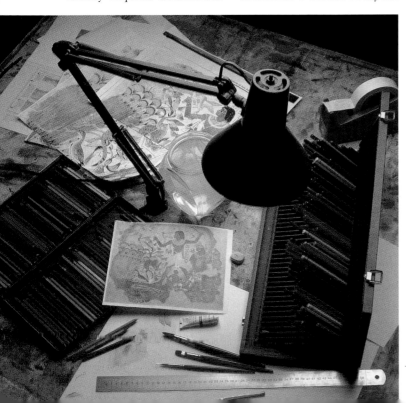

Here you can see two sets of color pencils, hard and soft ones, a color photocopy of the reference image, and some black and white photocopied enlargements of it. These items, along with the watercolor that will be used as background, constitute all the materials needed for the illustration.

The reference materials required for this illustration are easy to obtain. Being a text on art and customs in Ancient Egypt, one can find many reproductions of Egyptian paintings in any art book or illustrated encyclopedia. It is necessary to choose an interesting, attractive model that can be easily reproduced, and that fits the size requirements of the commission. In this instance, a color photocopy of an Egyptian fresco has been used (as chromatic reference) along with some black and white enlargements to facilitate reproduction.

COLORED PENCILS ON SCORED PAPER

Using colored pencils on paper that has first been scored is a well-established illustration technique that many professional illustrators still use. The layer of color laid down is relatively faint compared with other painting media. The lines scored in the paper remain entirely visible after they have been covered with color and the scored designs enrich the final result.

1. First of all, a large block of ochre-colored watercolor (diluted with a lot of water) is spread over the entire surface of the paper. The visible brush strokes do not create a problem. On the contrary, their texture will be part of the illustration.

2. *To speed up drying time, a hair dryer can be used, while kept at a safe distance from the paper.*

3. *A light box can be used to trace the outline of the drawing from the fresco, or the photocopy and the paper can be attached onto the glass of a window. In either case, the photocopy will show through even if the paper is relatively thick.*

4. *To go over all the lines, a sanguine pencil (which is a brick red color) has been used. This tone integrates naturally with the chromatic harmony of the whole.*

5. *The engraving tool is used like a pencil to score the drawing of the birds' plumage and the texture of the plants. However, it is necessary to work carefully to avoid scratching or perforating the paper.*

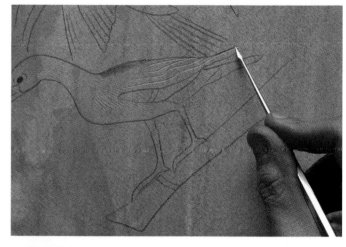

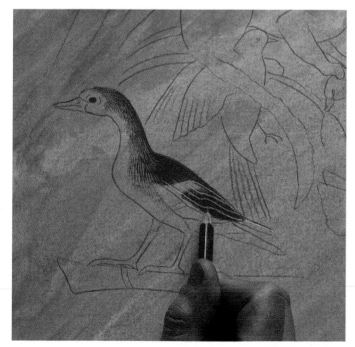

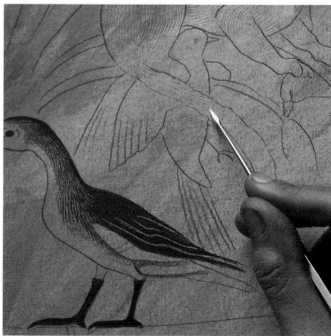

6. *When the areas that have been scored with the engraving tool are colored over, the scored lines show up in negative, as light lines against a dark background.*

7. *When engraving and coloring the paper, the color photocopy must be used, at all times, as a reference.*

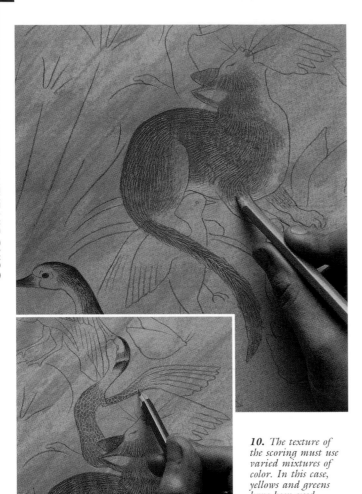

8. *It is important not to score all animals in identical fashion. The cat's coat is characterized by scoring deeper, thicker lines than those on the previous animal.*

9. *The plumage of this bird is also scored differently than that of the duck. Instead of long, wavy lines, intermittent circles are engraved on the animal's neck.*

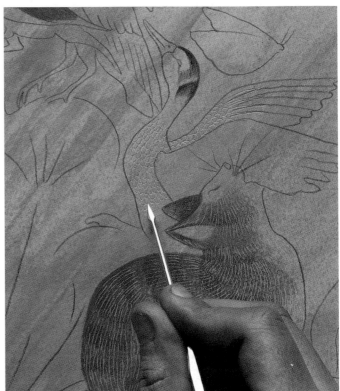

10. *The texture of the scoring must use varied mixtures of color. In this case, yellows and greens have been used.*

11. *Here you can see how the engraving tool has been extremely useful in enriching color and varying texture.*

12. *To achieve the straight lines of the stalks of the plants, a metal ruler should be used since the engraving tool would scar the plastic edge of a normal ruler.*

13. *The details and fine lines shown in this illustration would be difficult to achieve with just colored pencils. The engraving tool enhances the impression of fine detail in all of the figures.*

14. *A graphite pencil is used to highlight some of the edges and details of the birds. It should be extremely sharp to avoid smears or variations in the thickness of lines.*

15. *It is important to use dark lines to emphasize outlines that otherwise would not be distinguished from the background color.*

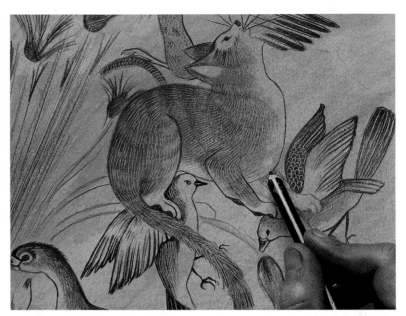

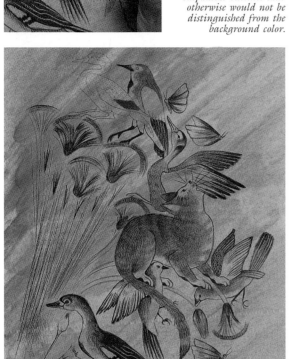

16. *As can be seen in the almost completed illustration, when engraving is complete, the only thing left to do is add a few details and highlights.*

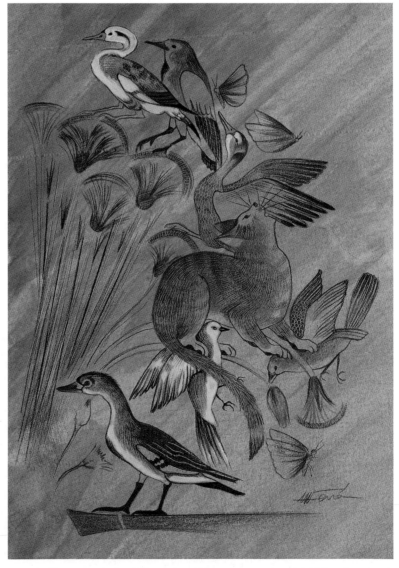

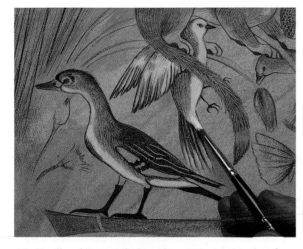

17. *Finally, white gouache is used to emphasize the color of the animals and to give them a little volume. This medium enhances the contrast between the forms and adds to the brightness of the whole composition.*

18. *The illustration is clearly decorative and, at the same time, faithful to the style and characteristics of Egyptian art. For this reason, it meets the two requirements of the commissioned work.*

An Illustration Using Acrylic Paint

Acrylic is the most modern of all painting media. It was first used around 1930. Since then the number of artists who use it has increased to the point where the medium is now as popular as oil paint. Illustrators use acrylic to paint with an airbrush, creating illustrations that are rich in texture and display original visual effects. However, there are still plenty of possibilities for professional illustrators to experiment with this medium.

CHARACTERISTICS OF ACRYLIC PAINT

There is a huge variety of acrylic paint available, and almost every year new products appear on the market, providing new options. Acrylics differ in their drying time (if not applied too thickly, acrylic paint dries as quickly as watercolor), the permanence of their color, the degree to which their colors change under differing light or atmospheric conditions, and in their impermeability. Once dry, acrylic colors are insoluble in water and form an elastic, almost unalterable film, similar to plastic. Acrylics are available in a wide variety of colors and are sold in tubes and bottles that come in different shapes and sizes.

Among the colors available from manufacturers are matte, gloss, sparkling, phosphorescent, and refractive tones. Also available are additives that give body to the paste and make it more fluid, textured, matte, or transparent. Other additives accelerate or slow down the drying process. All acrylics are soluble in water and the technique for using them is practically the same as for gouache.

Acrylic colors can be used in a thousand different ways. They yield particularly good results if they are used for transparent and opaque washes, as shown in this illustration by Ramón de Jesús.

Acrylic paint can be manipulated in all sorts of ways while it is still wet (scrubbing, scraping, printing with a sponge, etc.). Its consistency can be anything from fine transparent washes of color to thick layers of solid paint.

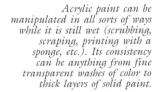

SUPPORTS

Acrylic paint can be painted on any type of support, except those that have an oily surface or are highly glossy. The best results come from slightly absorbent supports, such as card, cardboard, prepared canvas, sealed wood, smooth paper, and so on. All acrylic manufacturers make a base white color (called gesso), which can be used to prepare supports that are too absorbent. Colors stick well to this base and acquire solidity and luminosity.

TECHNIQUES AND EFFECTS USING ACRYLIC PAINT

The popularity of acrylics is due in large part to the fact that they can be used to create all sorts of finishes—opaque, transparent, gloss, textured, earthy, etc. They can be made to produce all kinds of effects, from the purest realism to much more expressionist and imaginative results. They can by applied in smooth layers of homogenous color or in patches of color. Their quick drying time and the capacity to cover initial areas of color with subsequent, opaque layers means that the artist can correct and improvise coloring the work, although, as with all types of illustration, it is important to conform to the work's defined tracings.

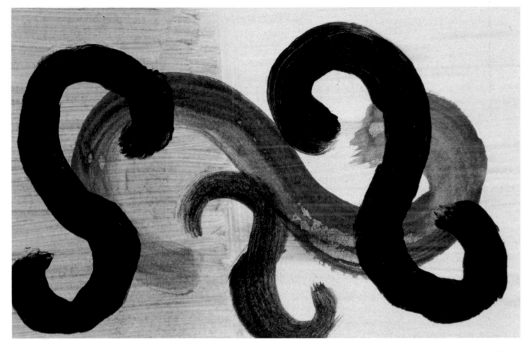

Acrylic can be used in a way similar to watercolor, with the added advantage that it allows for interesting contrasts between transparent washes and opaque color.

Acrylic can yield very personal finishes, depending on whether it is used to build up transparent or semi-transparent layers or to lay down solid colors. Illustration by Judit Morales.

Acrylic paints are available in both matte and gloss. New varieties offer the illustrator the possibility of working with metallic colors. In this illustration, a shiny, metallic gray has been used.

COMBINING WITH OTHER MEDIA

Acrylic paint can be combined with all media that use water as an agglutinate, as well as with dry media such as pastels or colored pencils. When using mixed media with acrylics, enough water must be added for the layers of paint to be sufficiently thin, so that other media may not be overshadowed by the acrylic paint. Most professional illustrators use acrylics in combination with other media, since the intrinsic possibilities of acrylics and the large number of additives available can generate all possible effects of color, quality, consistency, or texture.

A Children's Illustration Using Acrylic Paints

Acrylic paints are extremely versatile, which makes them suitable for varied types of illustration, from extremely realistic to the less figurative, from exuberantly colorful to somber and almost monotone. The medium also offers different possibilities in terms of appearance and quality of finish. Acrylic colors cannot be compared to any other pictorial medium. They allow a huge variety of effects, including textures, transparencies, impastos, variation in thickness, washes, and so on. In the following illustration the medium will be used in a straightforward manner, similar to gouache, without building up its thickness or superimposing opaque layers of images on top of transparent bases.

CHARACTERISTICS OF THE PROJECT

This illustration is designed for publication in a children's book aimed at children between seven and ten. It is a work in which text is predominant, which implies a relatively high reading level. For the most part, the narrative is written, though the illustrations are a key element in the book. The editor has commissioned Judit Morales to create ten illustrations of different sizes (a page and a half, a page, or half a page) and has left her the task of scattering them throughout the book. The illustrator has also received a copy of the text and will be responsible for creating a layout showing where each illustration will appear and how large it will be.

SKETCHES

In cases like this one, it is common for the illustrator to first read the text and to mark the scenes that seem most suitable for illustration, either because of their importance in the story or their compatibility with the illustrator's personal artistic style. The illustrator then makes sketches for each of these episodes and decides on the format for each illustration. This will be decided by the spontaneous composition of each sketch (whether vertical, horizontal, a general view, a small detail, a close-up, etc.). Once the illustrator has determined the different sizes based on the requirements of the commission, she will proceed with the layouts.

THE MOCKUP

The mockup shows the layout of each sketch on the assigned double page. The mockup should be a double page (as if the book were open) and full size, so that the appearance of each illustration can be viewed as it will appear in the text. As reference, she can use photocopies of other books in the same series or other similar works (the editor can easily provide this material). Adjusting the size of the sketches to the double-page format, by either enlarging or reducing photocopies of the sketches, the illustrator and the editor can decide together on the book's final appearance.

MATERIALS

A large selection of acrylic paint tubes will be used. These colors are available in a number of tones, depending on the manufacturer, but are similar to the tones on the color charts available for oil paints. Because acrylics spread less easily than oil paints, both painters and illustrators

To get the right color, it is sometimes necessary to make numerous mixes. For this reason, the illustrator uses plastic palettes with several cups.

always use medium or large tubes. To make mixes, large palettes with cups are used to enable proper mixing of all the shades the work requires. Round paintbrushes of different thickness and natural hair (sable or ox tail) are used, as well as a flat, medium-sized paintbrush with synthetic hair. Two pots of water (one for cleaning paintbrushes and the other for adding clean water to the mixtures) complete the selection of work tools.

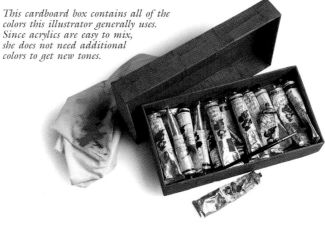

This cardboard box contains all of the colors this illustrator generally uses. Since acrylics are easy to mix, she does not need additional colors to get new tones.

2. A sketch, or mockup, of the double page where the illustration is to be placed. The size of the mockup must be the same as, or proportional to, the actual size of the pages. To adjust the format of the illustration, she has used a reduced photocopy. The text is a photocopy taken from another book with similar typography.

1. This is the first sketch of the illustration. It was made using a felt-tipped pen, and given its characteristics it needs to be reproduced in the book as a full-page illustration.

3. The previous drawing is traced on paper, which will be the support for the illustration. As seen in previous examples, it is easy to trace using a light box or by leaning against a windowpane in good light.

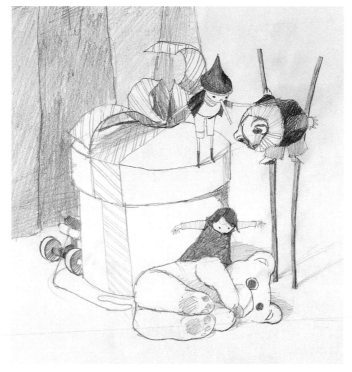

4. Using the first sketch as a model, a more detailed drawing is made that includes contrasts of light and shade.

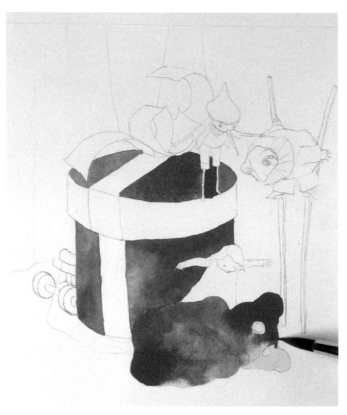

5. *The first layers of color are very fine and transparent. In fact, they are laid down in the same way as watercolors, with the color diluted in plenty of water. The paintbrush is a round, ox-hair brush of the type also used for watercolors.*

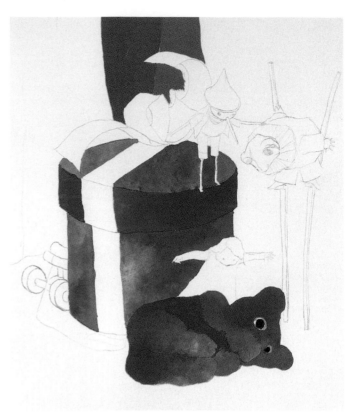

6. *In this image you can compare the contrast between the areas painted with very dilute color, which are therefore transparent, and other areas (the green tones in the background) painted with thicker color that give a more opaque finish.*

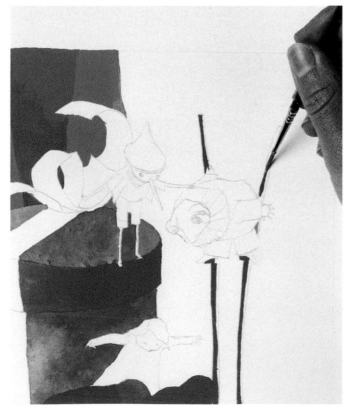

7. *Areas of same color are painted one by one, leaving the adjacent areas white. Details, like these two long sticks, are painted with a fine, round sable brush.*

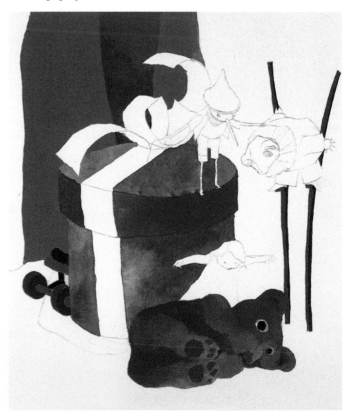

8. *Little by little the objects acquire volume, using darker and more opaque tones in the same range for each object. To provide contrast to the illustration, each object stands out against the colors of the ones surrounding it.*

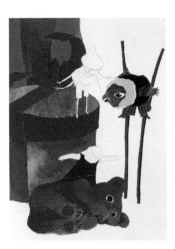

9. In this fragment, you can see the meticulous care with which the illustrator paints each of the details, without overemphasizing them or digressing from the spirit of the illustration.

10. After applying the initial layers of fine color to the surface of the ribbon, the illustrator now adds detail, painting in the white and yellow bands.

THE WHITENESS OF THE PAGE

When illustrating books nowadays, the illustrator must not only create an interesting and well-drawn image, but must also consider its overall effect on the page. When an illustration is not framed, its white spaces play a fundamental role, not only in its own appearance but also in that of the book as a whole.

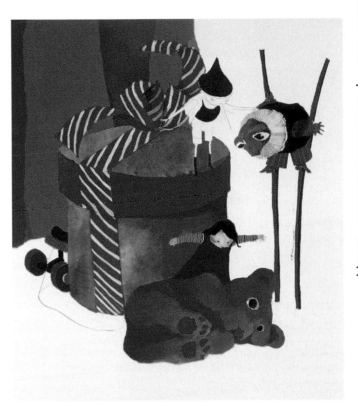

11. The illustration is now almost complete. Notice the subtle interplay of white spaces, which are so important to the visual appeal of a book's illustration.

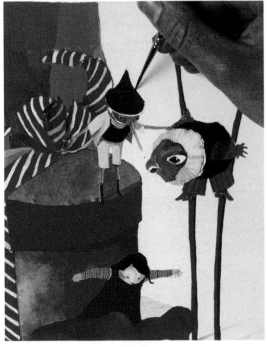

12. It is important to include small areas of bright, saturated color to liven up large areas of broken and grayish tones (a grayish green in this case).

13. The tiny shadows that appear at the bottom of the stilts and the string attached to the tricycle add a three-dimensional effect to the illustration by highlighting the surface on which these objects stand. In this way, the white spaces are integrated into the overall work.

Illustrating with Oil Paints

Oil paints have always been the traditional illustrating medium for professional artists who are also art painters. What they look for and find in oil paints is, above all, a medium that can yield highly realistic results. This is why oil paints have fallen into disuse as a medium for illustration and have been substituted by new techniques, such as the airbrush or computer drawing and design, which offer cleaner, and less work-intensive, results. Nevertheless, oil paints are still used by more demanding professionals who seek to convey a high degree of craftsmanship in the final appearance of a work.

SUPPORTS

The most universal support for painting with oil paints is cotton or linen canvas, correctly prepared with a white or colored sealant and stretched on a wooden frame. Many artists use boards backed with canvas or prepared with a special sealing paste designed for painting with oils. You can also use suitably sealed card or paper so that the oil is not absorbed too quickly.

In general, oils are used in illustration for works that require a high degree of realism and detail. Illustration by Miquel Ferrón.

Oil paints require various auxiliary materials—a palette, solvent, and special supports (canvas or prepared boards), as well as special brushes made with bristle.

CHARACTERISTICS OF OIL PAINTS

Oil colors consist of pigments in an agglutinate of linseed oil. This gives them their smooth texture, and their unparalleled visual power (a small amount of color goes a long way). Their consistency is diluted using turpentine, petroleum essence, or white spirit.

Oil is a slow-drying medium. The thicker the colors used, the longer it takes them to dry. This means there is plenty of opportunity for retouching a work. The painter can modify a color or add nuance to tones hours, and even days, after painting them. Thanks to this capacity, artists can create works that are highly realistic and meticulously detailed.

Oil colors mix together well and can be blended into highly subtle and complex tonal gradations that are not possible with any other medium. They can be used in transparent washes or as thick impasto. Between these two extremes there is every degree of intermediate possibility. Sufficiently dilute, oil paint can be used with an airbrush, although, because it is so slow to dry, few professional illustrators use it this way.

TECHNIQUES AND EFFECTS USING OIL PAINTS

Illustrators who use oil paints do so for realistic effects, and, consequently, the most impressive results are precisely those that show a detailed naturalism. However, as is clear from the work of the great painters of the past and present, oil paint can be used to convey a wide range of transparencies and textures. These effects, though, are much more time consuming to achieve than with acrylic paints and require a lot of experience. There are a lot of additives that can alter the consistency of oil paints, the speed of drying, and their final appearance, but they affect this medium far less than similar-purpose additives for acrylics.

Oil paints are suitable for making transparent washes and for combining opaque areas with transparent ones. Their slow drying time allows for all types of modifications and corrections. Illustration by Anna Ricart.

COMBINING WITH OTHER MEDIA

The multifaceted quality of oil paint enables this medium to produce all kind of effects or pictorial and visual results. Hardly any professional artists use other media to achieve special effects. Even so, oil paints can be combined with other oil-based media, such as wax crayons, and can also be superimposed over water-based media, such as acrylics or gouache, once these are completely dry. Some painters and illustrators begin a work by applying thin layers of gouache or pastel to check the chromatic effect, before going over the whole work with oil paints.

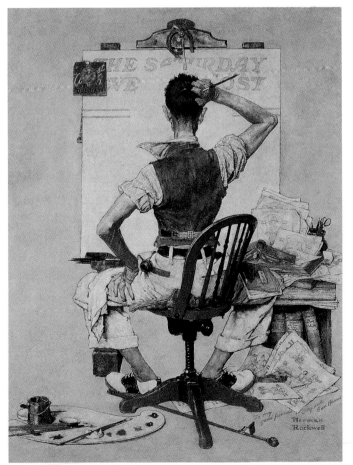

Norman Rockwell, Artist in Front of a White Canvas. *Illustration for the magazine* The Saturday Evening Post. *Rockwell, the most famous North American illustrator, did all of his illustrations in oil, creating realistic depictions of everyday life.*

Frederick Remington, Cavalry Charge on the Southern Plains. *Metropolitan Museum of Art, New York (USA). Remington's illustrations are from real life, and are perfectly realistic oil paintings.*

A Book Cover in Oils

The appearance of book covers (especially of novels and other general types of narrative) has gained importance over the last few years. The large number of new publications, increased competition between publishers, and the short shelf-life of publications have forced editors to look for striking book covers that stand out from the masses. This is a very competitive field for illustrators, and also a very profitable one. Illustrators who create successful covers are guaranteed further commissions. Also, most editors who use illustrated book covers will often hire the same illustrator on an exclusive basis to provide original works for a whole series. In this way, the publishing house strives to create an unmistakable brand for itself.

This is the palette the illustrator will use. Ten colors are enough to create all the tones needed to illustrate the cover in oil.

CHARACTERISTICS OF THE PROJECT

The project is to create a cover for a novel set in the Far East. The editor has provided the illustrator with an excerpt from the story to guide him in his work and to give him a general idea of the plot and, in particular, of its ambiance. Apart from this, the illustrator is completely free to interpret the work as he wishes, using any images or other references that he chooses. Naturally he has the complete trust of the client, for whom he has worked satisfactorily on previous occasions.

Illustrator Yvan Viñals took this photograph to use as a visual reference for the illustration.

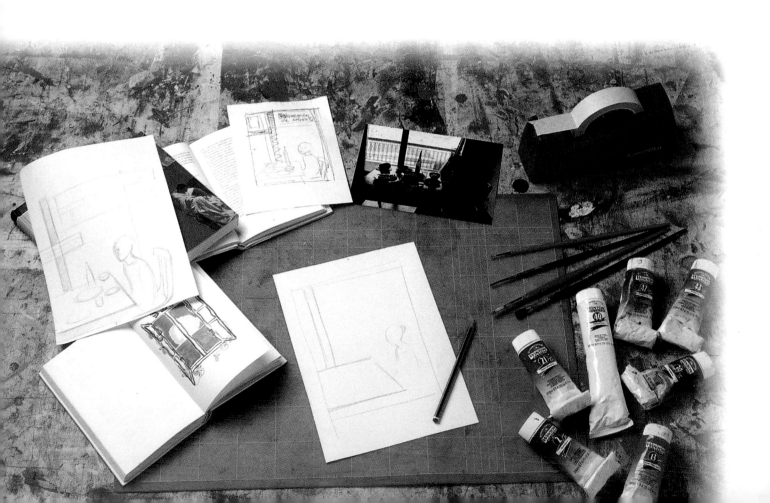

REFERENCE MATERIAL

The reference material used by illustrator Yvan Viñals consists of a photograph that he himself took at home. It shows a figure sitting at a table beside a window. The photograph serves only as a general reference. It is useful because it shows a composition that fits the illustrator's idea of the work's configuration: a composition with long vertical lines of a window against which the objects and the figure are silhouetted. This verticality suggests a contemplative calm which, having read excerpts from the story, is the basic feeling the illustrator wants to convey.

MATERIALS

The materials used here are the usual ones for oil painting: paints, bristle brushes, and dissolvent (turpentine essence). Ten colors will be used on a conventional palette: two yellows, an ochre, carmine, red, burnt umber, three different blues, and white. This range can produce all types of nuances, including black, or at least a tone dark enough to be used in place of black. The illustrator also uses various sheets of paper for making pencil sketches before starting to paint.

A STUDY OF THE COMPOSITION

Using the photograph as an initial model, the illustrator draws various studies of the composition in pencil. With these the illustrator creates an aesthetic arrangement of the forms in the composition and works out the spaces required by the cover's layout, all the while keeping the integrity of the illustration intact. This is a precaution that one must always take when creating illustrations that will include text.

1. This sketch is an initial attempt at establishing the composition of the illustration. It is intended to work out possible ways of distributing spaces, so as to allow room for the book's title.

2. In this second version, the figure sits much lower and the window looms larger in the illustration.

3. Once the composition has been decided, it is sketched on the canvas with a few general strokes, without details but outlining the most important spaces and forms.

4. The illustrator has used very dilute blue and carmine tones to go over the general lines of the composition.

5. The first areas of color belong to the landscape in the background that can be seen through the window. Two large areas of blue and mauve are enough to establish the horizon line.

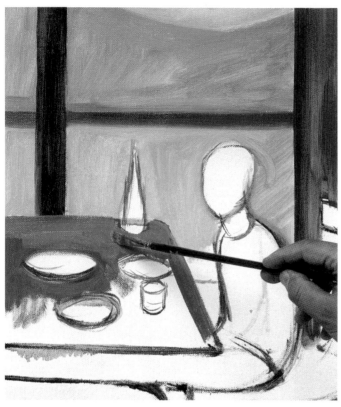

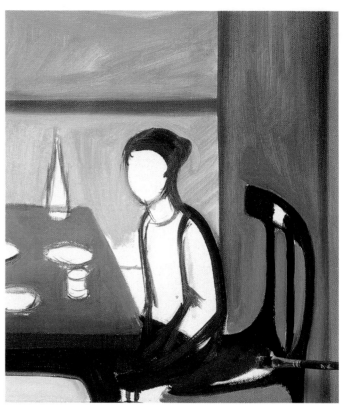

6. *The coloring continues with a range of greens and blues that unify the tones in the composition, giving them a gentle luminosity that fits in with the atmosphere in the book.*

7. *Aside from the figure, the entire composition is covered in relatively dilute blocks of color that unify the whole design. Proceeding from the overall image to particular details is common in most pictorial techniques and particularly when painting with oils.*

8. *The figure is colored in, with blocks of color that give shape to the volume of the head. This will be one of the few areas in the composition with warm colors and one of the undeniable points of interest.*

9. *The fine detail of the figure's facial features are painted onto the background coloring of her face. These tones must harmonize with the distribution of light and shadow on the face. Here you can see how the illustrator has started painting the figure's clothing.*

10. *For the moment, the foreground has enough detail, but a little more detail is needed in the background. These areas of color belong to a building that can be seen through the window.*

11. At this stage, the only thing left to do is add detail to the figure and the objects in the room, giving them solidity and volume. You can see how the sky is no longer a simple plane of color, but is full of nuances that give it an atmospheric quality.

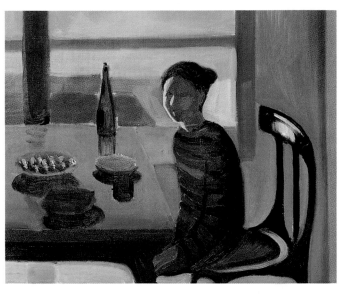

12. Little by little, the details of the objects on the table have been filled in to balance and enliven the large areas of color swept by the paintbrush. The figure and the seat have now been completely shaped.

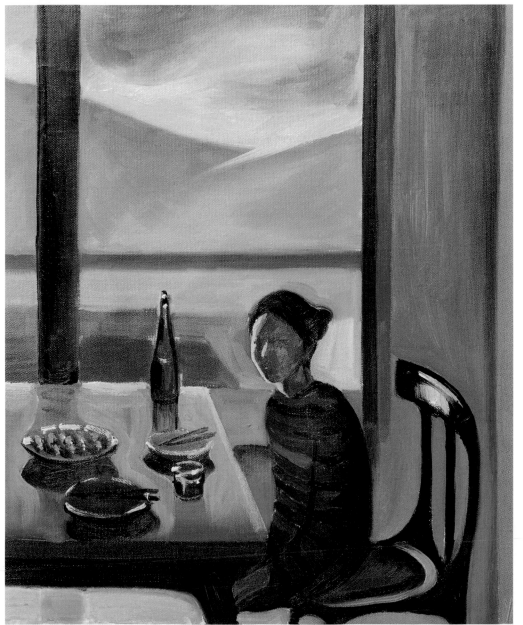

13. The final touches have softened the tones in the facial features in order to integrate them with the overall modeling of the face. A few reflections and bright points have been added to the surface of the table to reinforce its early-morning brightness, which is the exact tone that the illustrator wanted to achieve with this book cover.

Collage, Photomontage, and Illustration in Three Dimensions

No other technique shows the close relationship between illustrative styles and pictorial creativity more clearly than collage. Collage was an invention of the avant-garde artists at the beginning of the twentieth century (particularly the Cubists) which had an immediate impact on all of the other forms of creative expression. Photomontage (introduced by the Surrealists) is another version of the same visual concept. Besides these two techniques, three-dimensional illustration has been one of the most modern and enriching contributions of contemporary illustration.

collage is to juxtapose surfaces that, because of their distinctive color, texture, shape, and size, create an interesting and suggestive overall visual effect. With this in mind, the illustrator can use all types of paper, including scraps, in composing works.

Indispensable materials are scissors, an artist's knife, a metal ruler (to use with the knife), and glue, which can be one of various kinds depending on the size and thickness of the paper. The most common type is white glue, or synthetic latex, which can be lightly diluted with water if the paper to be glued is too thin.

It is also necessary to have on hand different-size hand bristle brushes for applying the glue. They should all be washed after use so that the bristles do not stick together. It is also useful to have a large variety of different kinds of paper—colored paper for drawing (such as Canson paper), newspaper, wrapping paper, smooth paper, rough paper, film, rice paper, and so on.

TOOLS AND MATERIALS

Rather than being just illustrative techniques, collage and photomontage are graphic products that encompass all types of techniques. The basic principle of

M. Àngels Comella uses alternating shapes of suitable colors all in the same tonal range to give this work its bright unity.

This photomontage by Ramón de Jesús combines photographic images with strips of paper. What gives this image its unity is the free, clearly visual pictorial approach.

Three-dimensional illustrations usually consist of a relief with multiple components. This work by David Sanmiguel was made with pieces of colored card.

COLOR AND FORM IN COLLAGE

Although the illustrator might color the collage paper bits, the most interesting aspect of this technique lies in using the material's original colors. This way the origin of the collage components can be recognized, while at the same time the overall composition can be appreciated. Chromatic harmony is much more interesting when it is provided by pieces of colored paper of different origin that are all pulled together by the artist. What is important is the illustrator's visual ability and talent in combining colors. The same is true for shapes, which should contrast one another and at the same time preserve similarities in order to avoid an overall effect of the work being incoherent and disjointed.

MATERIALS FOR PHOTO-MONTAGE

Photographs from magazines, newspapers, or books can be used in photomontages. The illustrator should have available a large archive from which to extract suggestive images that can suit a variety of subject matters. It is important that the photomontage be a true, original creation that does not rely on other artists' or photographers' works in creating the message that the illustration is to convey.

COLOR PHOTOCOPIES

Often the most suitable images for photomontages come from printed books that would be a pity to tear apart. Rather than do this, most professional illustrators use color photocopies that nowadays are of very high quality.

The appeal of figurative collages lies in the variety of forms, colors, and textures of the different papers chosen, as well as in the visual synthesis of the overall effect. Illustration by Anna Sadurní.

SUPPORTS

The larger the size of the image and the thicker the pieces of paper used, the stiffer the support should be. It is customary to use card or mounting board. For small-sized collages made with thin types of paper, thick paper or card should be used that is either white or in a color that suits the overall chromatic effect. The glue and the support should be compatible so that the paper sticks firmly and does not detach.

Collage made with real leaves stuck onto ridges of paper that imitate tree trunks. The effect is very graphic and has great visual appeal. Illustration by Anna Sadurní.

THREE-DIMENSIONAL IMAGES

Three-dimensional images are another type of illustration made possible by modern reproduction techniques. The illustrator's composition must be photographed to produce the final product. Consequently, in this type of illustration the quality of the photograph is very important, especially the quality of the lighting that makes the relief of the forms stand out clearly.

In creating the relief, the illustrator can use all kinds of solid and rigid materials, as well as malleable materials (clay, plasticine, plaster, etc.) which can be used to make three-dimensional elements that stand out against the background. It is impossible to list all the materials and all the methods that could be used to make three-dimensional illustrations. The field is entirely ruled by personal creativity, since no dominant trends prevail.

PHOTOGRAPHY IN ILLUSTRATION

Photography of three-dimensional illustrations is extremely important as it constitutes the key creative element in the illustration. The choice of objects, the way they are arranged, and how they are lit bridges the gap between illustration and still-life photography art. This is an ever-changing field, whose limits are always being stretched by contemporary illustrators. The results can have a very intense visual power and, from the point of view of form and color, are as creative as any other type of illustration.

Photographic illustration made by Joan Soto. It is a magnificent collage of natural elements in which everything has been carefully chosen to achieve an effect that is both decorative and realistic.

The shadows cast by the reliefs of the figures in this illustration integrate naturally with the nature of the whole and become a part of it. Illustration by M. Àngels Comella.

SUPPORTS

Supports for illustrations in three dimensions should be rigid and strong and should be suitably prepared so that the work's different components can be easily attached to them. Sometimes it might be useful to assemble the collage pieces in boxes. In any case, the support for this type of work rarely shows through and only serves as a sufficiently stable backing for the work.

A three-dimensional illustration made with plasticine by M. Àngels Comella. Here the plasticine has been used as a pictorial medium to create a relief that casts its own shadows.

The presence of shadows adds extra interest to illustrations, no matter how simple they are in conception or execution. Illustration by M. Àngels Comella.

POP-UP BOOKS

Pop-ups are folding three-dimensional illustrations that appear on double pages of a book. When these pages are opened, the pop-up stands up like a house of cards and folds down again when the book is closed. Pop-ups are used almost exclusively for children's books. They require great care to produce and are quite expensive to publish, so they are not commissioned very often. Making pop-ups requires close coordination with the publisher, since the creative spirit of the illustrator is constrained by construction limitations in building the pop-up within assigned budgets. The illustrator would normally produce several mockups to test the folding mechanism. These are constructed with thick paper similar (or identical) to the paper that would be used in the book itself.

Making pop-ups involves a lot of ingenuity to make flat surfaces unfold in a way that creates an interesting sense of volume. The style of the illustration wholly reflects the illustrator's individual style. In general, the most effective illustrations have little detail, thus enabling the outlines of the figures to create an interesting, harmonious effect.

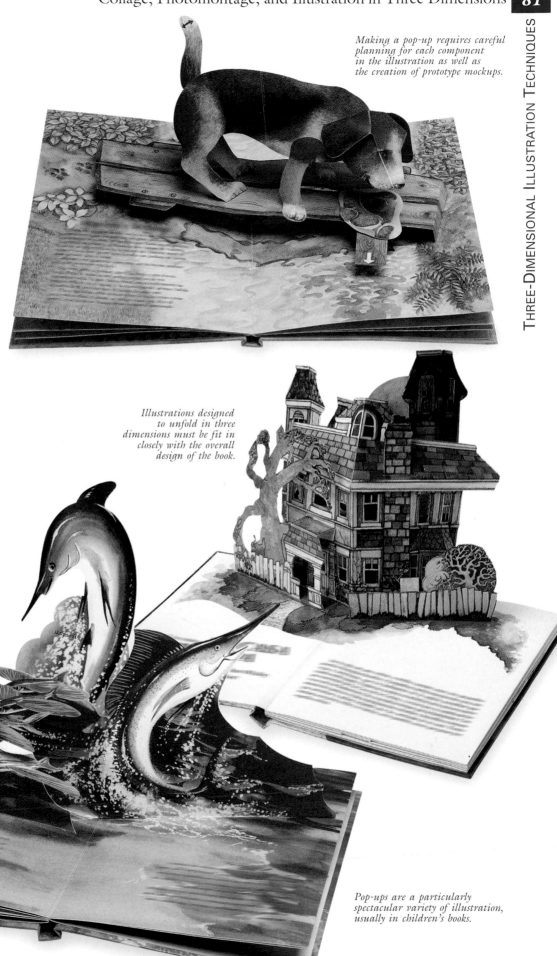

Making a pop-up requires careful planning for each component in the illustration as well as the creation of prototype mockups.

Illustrations designed to unfold in three dimensions must be fit in closely with the overall design of the book.

Pop-ups are a particularly spectacular variety of illustration, usually in children's books.

An Illustration in Relief

Three-dimensional illustrations can be made of different materials and in many different ways. Rather than a single technique, the process involves a combination of very different methods whose common factor is the interplay of three-dimensional forms. The characteristics and techniques for making such an illustration depend on the type of materials used. In this case, the illustration uses different-colored strips of card. The relief is achieved by superimposing the strips and having them stand up. The challenge in this technique lies in envisioning beforehand each of the three-dimensional shapes and exactly how they will fit together. As you will see, these calculations always involve a margin of error and, depending on the problems that arise in building the pop-up, an option for making final adjustments.

The materials used in this illustration are not really different from those used by school children in making handicrafts. Here the result will depend on the design outlines and the way the strips of paper are stacked together. The malleable plastic is the blue strip that lies under the stick of glue.

CHARACTERISTICS OF THE PROJECT

This project entails creating a conceptual-type illustration in three dimensions for an article on the evolution of women's fashion. As usually happens with this type of illustration, the editor has given the illustrator only general guidelines for its theme and format (in this case vertical), leaving all other choices open for the artist. Except in very exceptional cases (such as, for example, in making pop-ups), three-dimensional images are not a genre commonly used by editors, as there is no particular requirement for commissioning this type of work. Instead, their use is dictated by the nature of the publication, the editor's trust in the illustrator's creativity, and prevalent graphic trends. David Sanmiguel is the illustrator who has been commissioned to carry out the project.

MATERIALS

The basic material for this illustration is colored card. In order to give the relief its greatest visual impact, it is best not to use too many different colors, since their contrast can detract from the effect of the shadows. In general, the greater the shadows cast by the three-dimensional elements, the fewer colors should be used. The basic tone is set by a bone-colored card, combined with yellow, orange, and grayish green. To cut the card out, you need a good pair of paper scissors and several artist knives with different blades (for cutting straight lines and curves.) You also need a stick of glue, paper adhesive tape, and a malleable plastic similar to plasticine, called Blu-Tac, which will hold the strips of paper up.

SOURCES

There is no real reference material for this type of illustration. Only inspiration can help the illustrator decide which idea to pursue. In this case, the illustrator has reviewed reproductions of women from the end of the nineteenth century and the beginning of the twentieth, the specific period featured in the article to be illustrated. After consulting art books and catalogues, the illustrator has conceptualized a visual solution based on decorative forms inspired by the sumptuous dresses of the Victorian era. In his illustration, chromatic richness will be kept to a minimum in accordance with relief technique requirements. These are the criteria on which this illustration will be based.

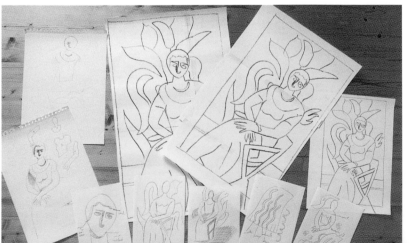

1. It is important for the theme of the illustration and the art technique to fit together. Clothing during this period consisted of multiple overlapping fringes and shapes. In the picture you can see the initial sketches, the final drawing (enlarged to two different sizes), and diagrams that show how different parts and basic cuts will link together.

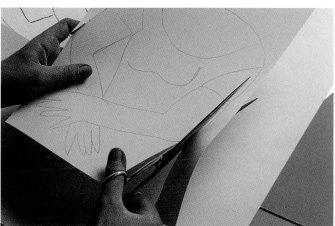

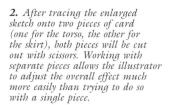

2. *After tracing the enlarged sketch onto two pieces of card (one for the torso, the other for the skirt), both pieces will be cut out with scissors. Working with separate pieces allows the illustrator to adjust the overall effect much more easily than trying to do so with a single piece.*

3. *With the exception of the large pieces, which have been cut out with scissors, all the cuts are made using an artist's knife with a revolving head that is especially designed for cutting curves. The picture shows how the hollows of the eyes and the outline of the nose have been cut.*

4. *To give volume to the breasts, their lower edge is cut out to create a flap that can be raised slightly.*

5. *After completing the cuts in the upper half of the figure, the piece of card is turned over and the different incisions are held in place with adhesive tape so that they don't break accidentally while work proceeds. To avoid tearing the paper when the tape is removed, the tape can be made less sticky by pressing it against a piece of cloth or wool several times before applying it to the card.*

6. *Once all the cuts have been made, the pencil lines are erased carefully, making sure not to bend the flaps that will give the figure its volume.*

7. *To differentiate the area of the dress from the rest of the torso, "bows" made from small strips of rolled yellow card are stuck around the neckline. These are easy to roll up by rubbing them against the side of a pencil.*

GLUE

When working with paper, it is advisable to use a stick of glue. This type of glue is clean and quick drying and, unlike aerosol glues, it can be used to bond very small areas together. The only disadvantage of these sticks is that the glue dries out and loses its stickiness over time (after about two or three months). To achieve a permanent bond, white glue can be used when the original glue deteriorates.

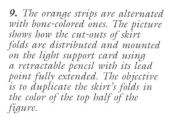

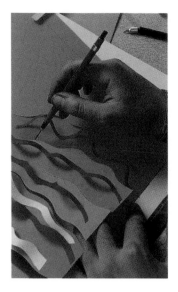

9. The orange strips are alternated with bone-colored ones. The picture shows how the cut-outs of skirt folds are distributed and mounted on the light support card using a retractable pencil with its lead point fully extended. The objective is to duplicate the skirt's folds in the color of the top half of the figure.

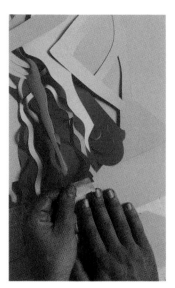

8. The bottom piece of the figure, the skirt, has been traced onto yellow card that has then been cut out into flowing, vertical strips suggesting the way clothing hangs. On top of the skirt, various orange-colored strips are added and cut in the same flowing shapes. These strips are then separated on the support and glued, so that they stand up in relief. The glued strips are held in place with a clothes pin until the glue dries.

10. After cutting out the different leaf shapes that surround the figure (using the bone and green card), the pieces are laid out on the support which, in this case, is a large sheet of bone-colored paper. This is the most laborious part of the task because it must ensure that all of the component parts of the work have been given sufficient relief. This is achieved by shaping the card strips to give them volume and by raising the flaps.

LIGHT

Light is a key factor in all three-dimensional work since relief illustrations are always photographs of original art. When creating the work of art, the illustrator must consider the light conditions that will highlight the volumes and relief of the piece. These light conditions, adjusted to give the correct degree of detail, will later be reproduced in the photographer's studio.

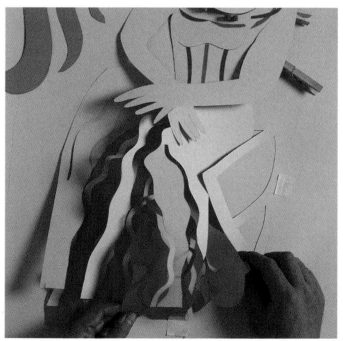

11. With the help of clothes pins and other small objects, the areas that require most light are raised. Each adjustment must be checked using lighting that is as close to the actual lighting that will be used for reproduction in the photographer's studio.

12. To give volume to the large leaves that surround the figure, these are curved outwards and held down at each end. The ends are then glued to the support.

MALLEABLE PLASTIC

Malleable plastic is known by its commercial name, Blu-Tac. Besides supporting the surfaces that have to be photographed in relief, it can be used instead of adhesive tape to stick different strips of paper (invisibly) together. While other small objects can be used to create relief effects, none is as easy and straightforward to handle.

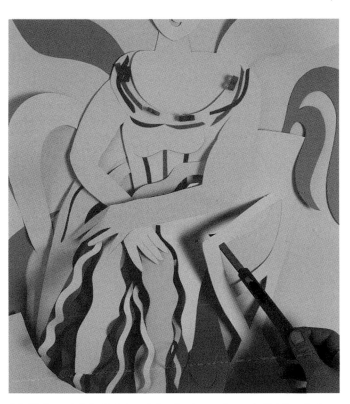

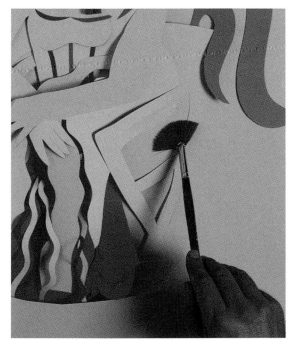

13. This is one of the final adjustments made in the photographer's studio once all the pieces are in the correct position and held in place temporarily with adhesive tape. Small balls of malleable plastic are used to raise the strips of paper to different heights.

14. Strips and flaps that do not stand out enough can be lightly raised with the help of an artist's knife. As these final adjustments are made, the illustration should be viewed and checked out through a camera's viewfinder.

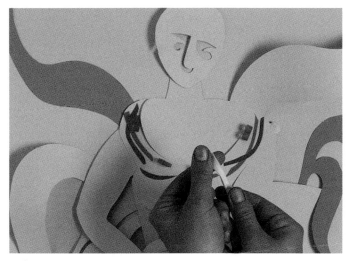

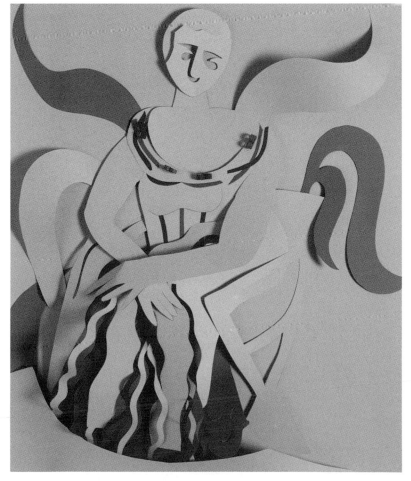

15. Finally, the whole illustration should be cleaned with a soft, fan-shaped paintbrush. This will get rid of all traces of eraser shavings and specks of dirt that might have stuck to the surface of the paper.

16. Making sure the lights are positioned correctly is as important as the illustrator's manual work. The shadows should be soft but sufficiently intense to give the sensation of relief. When the work is lit, the illustrator should follow the instructions of a photographer who is an expert on the subject and alter only those elements that diminish or increase the intensity of the shadow that is cast.

The Technique of Photomontage

Rather than consisting of a single technique, photomontage is a combination of graphic techniques that use photographic images and collage. Even such a broad definition cannot cover the whole range of illustrations possible with photomontage. Bearing in mind that artistic works are reproduced by photographic means, and that a photograph can be used both as figurative detail and to provide colored form, any printed image can be used in a photomontage. In fact, this technique involves a very interesting and gratifying creative process, whereby every work has the potential to yield new visual combinations.

Colored paper, cutting tools, aerosol glues, felt-tipped pens, colored pencils, and, above all, a lot of graphic material constitute the basic materials for any kind of photomontage.

CHARACTERISTICS OF THE PROJECT

The illustration featured on the next pages was made by David Sanmiguel. Intended for a music magazine, the project will illustrate a text about hi-fi systems and sound reproduction. Like most conceptual illustrations, the artist has been given complete freedom since the editor has commissioned him precisely because of his particular style. In this case, the illustrator is also free to choose the format of the illustration.

MATERIALS

As was the case with the three-dimensional illustrations in the previous chapter, the materials that are usually used for photomontage are paper or card supports, cutting tools (scissors and various artist's knives), and glue. For this task, conventional knives and knives with square or triangular blades will be used to make straight incisions. A scalpel (with a curved blade) will be used for curved incisions and a knife with a revolving head will be used for both straight and curved incisions that demand particular accuracy. The glue used will be non-permanent aerosol glue (spray-mount), which allows the pieces of paper to be stuck down and removed as often as necessary, as well as permanent aerosol glue (spray-ment) for sticking down parts once their placing is definitively set. Felt-tipped pens and colored pencils will also be used to retouch the images. The illustrator has chosen to use colored Canson Mi-Teintes paper, which is usually used with pastels. And since the work involves cutting tools, it is useful to have a cutting

1. Color photocopies are today almost exact reproductions of their models. This means that good color reproductions from art books can be used in photomontages.

2. Only the top part of this reproduction of a Rubens painting will be used: a group of angels descending on the Nativity, carrying a banner with an angelic text.

board to protect the work desk and keep the blades sharp.

HANDLING PICTURES

The basic material used by a photomontage illustrator consists of different pictures. Any professional illustrator working in this genre will have a large selection of usable pictures from magazines, newspapers, catalogues, calendars, advertising, and so on. Experienced professional illustrators will save all kind of prints in case they are needed in the future. The best material comes from well-illustrated magazines (fashion, interior design, specialist magazines, etc.) in which the pictures take up a whole page and, often, even a double page.

Nowadays, the excellent quality of color laser photocopies means that good reproductions of works of art can be used without damaging the books they appear in. Color photocopies can even be made of original paintings and drawings that no illustrator would dream of using as material for photomontages.

4. A pair of paper scissors can be used to cut out larger figures whose borders do not require the same accuracy in cutting. This piece (from a furniture advertisement) can be used to create a flowery background against which the figure will stand out.

THE INITIAL IDEA

Before starting a project, the illustrator always starts with an initial visual idea that may be sketched out on paper or fixed in his/her mind. In this case, the idea consists of a person listening to music from a stereo system. The challenge of depicting music visually does not just depend on technical ability but also on inventiveness. The solution adopted as a starting point consists of representing music (in this case classical music) by means of a double bass and a group of baroque figures. Form and composition will become more specific when the combinations of images and colored areas are chosen.

A PICTURE ARCHIVE

When photomontages are an illustrator's usual line of business, it is almost essential to have an archive of graphic material (folders, archive drawers, boxes, etc.) filed by categories. These can be filed according to general categories such as "Nature," "Machines," "People," "Animals," "Cities," etc., or can be more specific, reflecting the illustrator's normal line of work. The files facilitate archiving different images or graphic documents that may come into the illustrator's possession.

3. To cut out the intricate group of angels, the artist uses a knife with a rotating head. The illustrator then goes over the edges of the piece of paper with a dark felt-tipped pen to prevent any white from showing when the cut-out is glued to the illustration.

5. This picture shows how easy it is to make curved incisions with a knife that has a revolving head.

A QUESTION OF SCALE

One of the problems to be dealt with in a photomontage is adjusting the sizes of the different parts so that they form a coherent whole. There is no point in using high-quality images if they do not produce narrative unity when placed together. To achieve this unity, it is necessary to work to scale, adjusting the size of each cutting so that each one contributes to the overall effect without losing its individuality or standing out too much on its own.

6. Once the needed pieces have been cut out, various compositions can be tried out to convey the illustration's general idea. The collage cuttings are laid out on a black background to determine which configuration best expresses this idea.

7. The possibilities are not endless but, with a limited number of cut-outs, different layouts can be experimented with by changing formats, the color of the background, and the way the collage cuttings are arranged.

8. One of the most challenging and gratifying aspects of photomontage is laying out the collage cuttings, each of a different color and size, with the aim of creating new images, very unlike the originals. Playing with cuttings of facial features can create many new and different faces and expressions.

9. Slowly, the composition options narrow. Here the illustrator has decided on the format of the illustration (vertical) and the location of the elements in the top part (the musical instrument, the angels, and the loudspeaker), as well as on some of the colors that will appear in the final composition.

10. *After several attempts, the illustrator arrives at a layout configuration that will clearly and graphically convey the general idea in the text. Appropriate adjustments can then be made to reinforce this central idea.*

11. *Now it's time to concentrate on details. The Latin text being carried by the angels could confuse the message the illustration has to convey. One solution is to substitute this text with music notes. To do this cleanly, a piece of white paper will be glued over the banner. But first, the banner is traced onto tracing paper.*

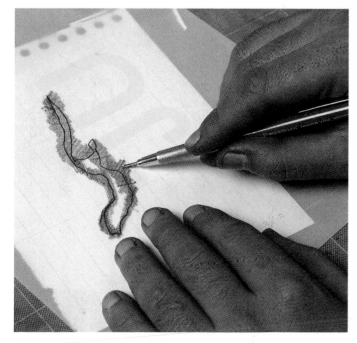

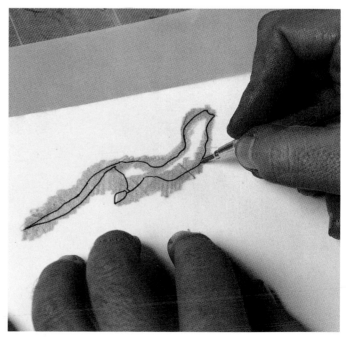

12. *Once the outline of the banner has been traced, the tracing paper is turned over and the banner's outline is shaded over with a graphite pencil.*

13. *The tracing paper is placed on a sheet of white paper and the banner's outline is gone over again with a pencil. The pressure of the pencil point will transfer the graphite to the white paper along the contours of the banner.*

THE IMPORTANCE OF SIMPLICITY

One of the problems sometimes found in photomontage is that illustrators are swamped with material and their visual images get lost in a sea of multiple options. When this happens, it is necessary to set aside most of the images and try out solutions that may not be the most spectacular but that are better suited to the subject. By experimenting with a smaller range of elements, it will be easier to find a desired solution.

14. *The banner traced onto the white paper is cut out and glued over the original one so that the text is completely hidden. Then a line of music is drawn on it and the shadows of the banner added.*

15. *To reinforce the idea of music "falling" from the speaker, the illustrator has decided to include another double bass. But instead of using a duplicate cutting of the first bass, some graphic variation is added by creating a new instrument with pieces of colored paper.*

16. *When the pieces have been glued together, the illustrator draws in the characteristic details of the musical instrument with a felt-tipped pen, copying them from the original cutting.*

17. *To achieve a more convincing effect of volume, the curved surfaces of the double bass are shaded using felt-tipped pens and colored pencils.*

18. *Before gluing down the cuttings on the support, it is a good idea (if they are cut from card) to sand down the edges lightly so that these stand out when glued.*

19. *When aerosol adhesive is used, care must be taken not to spray the furniture or other objects. It is a good idea to use a cardboard box as a protective screen that will prevent hands from becoming stained.*

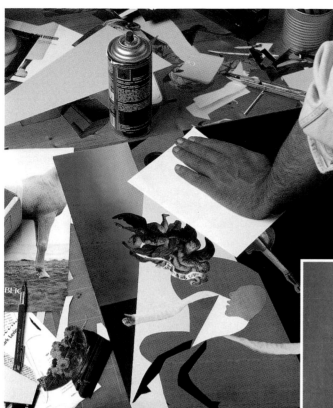

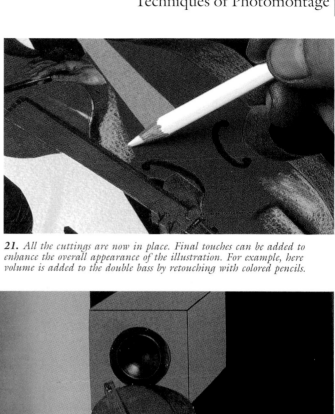

21. *All the cuttings are now in place. Final touches can be added to enhance the overall appearance of the illustration. For example, here volume is added to the double bass by retouching with colored pencils.*

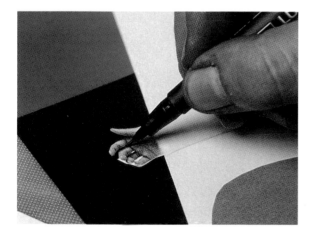

20. *After mounting each of the cuttings in place, they must be pressed down to be sure they stick. Covering the photomontage with a sheet of paper when pressing will ensure that this is done cleanly.*

22. *The final touch consists of darkening the white areas between the figure's fingers with a felt-tipped pen. This is easier and more practical than trying to cut out such small-sized contours with an artist's knife.*

23. *As can be seen, the illustration is finished. Final retouches and changes in form and color are applied almost up until the last minute. The creative freedom that photomontage offers makes it one of the most gratifying genres in illustration.*

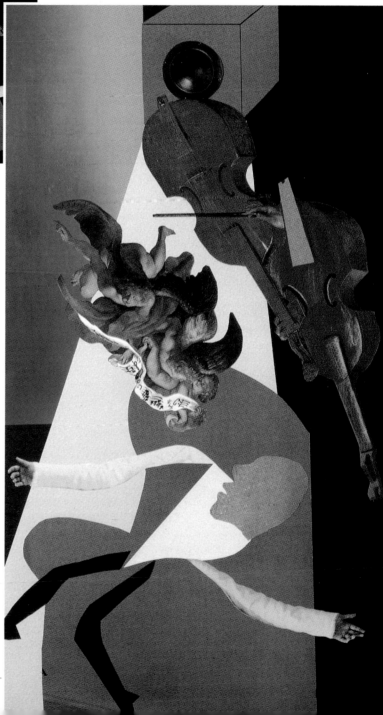

VARIETY OF COLORED STRIPS

Using different tones of each color yields best results in this type of illustration. In this case, it is essential to have various blues at hand, such as ultramarine, cerulean, cobalt, Prussian, and so on, as well as violet tones that can give a darker, deeper tonality to the range of blues. Such variety in color would be almost impossible to obtain if using standard paper colors. This is why it is worthwhile to create your own strips by coloring sheets of paper with gouache or acrylic paints.

4. This picture shows how useful it is to rely on the drawing as a guide when cutting out the strips of paper. The main outlines of the drawing mark the separations between different tones of the cuttings that make up the motif. To determine the shape of each piece, a strip of paper in the appropriate color is placed onto the corresponding area and its approximate outline drawn on it.

5. Seen here are a number of cuttings placed where they will be glued. It is a good idea to check how well they fit together before gluing them on. This helps avoid mistakes that would be difficult to correct later.

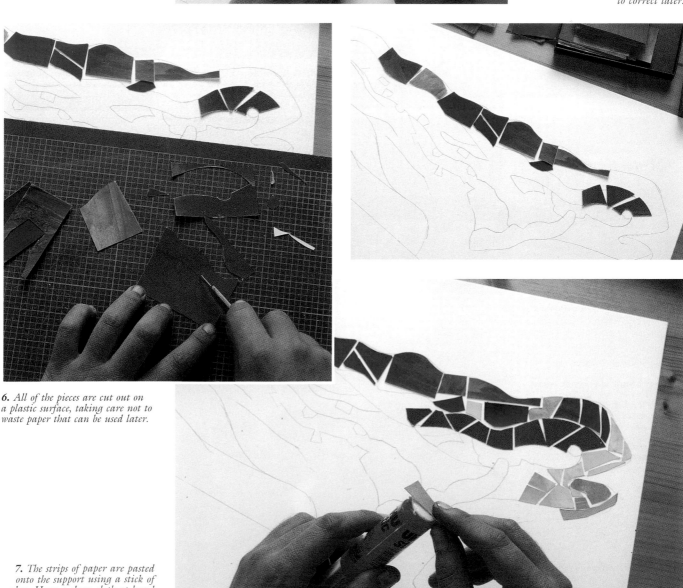

6. All of the pieces are cut out on a plastic surface, taking care not to waste paper that can be used later.

7. The strips of paper are pasted onto the support using a stick of glue. Have a clean cloth at hand to wipe the glue from the fingers to avoid dirtying the original while handling it.

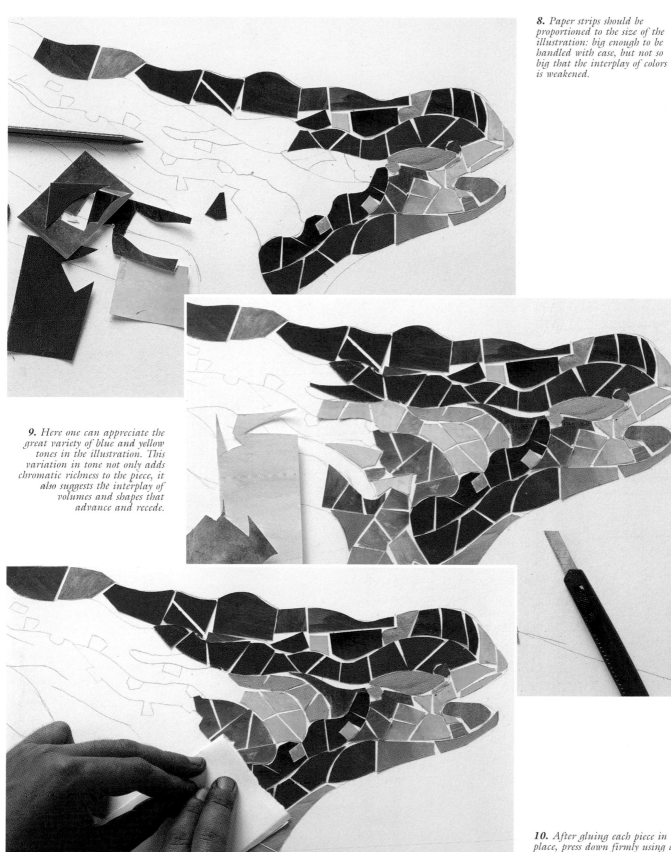

8. *Paper strips should be proportioned to the size of the illustration: big enough to be handled with ease, but not so big that the interplay of colors is weakened.*

9. *Here one can appreciate the great variety of blue and yellow tones in the illustration. This variation in tone not only adds chromatic richness to the piece, it also suggests the interplay of volumes and shapes that advance and recede.*

10. *After gluing each piece in place, press down firmly using a piece of clean paper rather than fingers. This will help prevent traces of glue on the fingers from contaminating or sticking to the strips that have already been glued.*

ORDERING AND FITTING THE PIECES

The strips of paper should be laid out following the contours of the initial drawing. As work progresses, it is possible, and even inevitable, that the size of individual pieces will be adjusted, depending on their density in each zone. It is advisable to alternate small pieces with larger ones, so that there is an overall variation in density. In this way, the sizes of each piece and the spaces separating them avoid monotonous patterns.

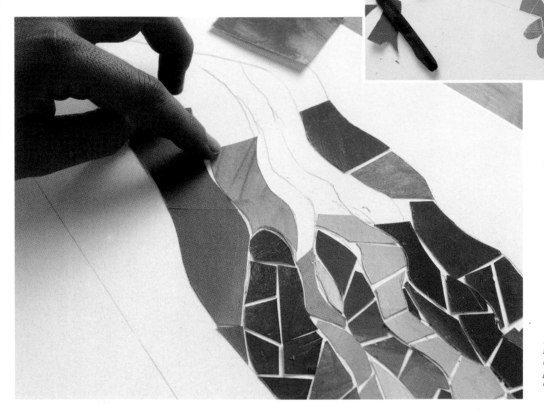

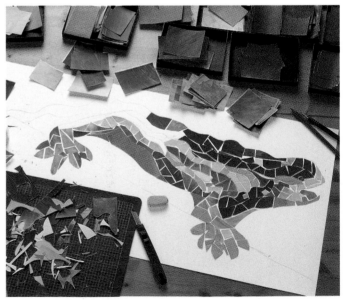

11. *The work is already in an advanced stage. Here it can be clearly seen how the illustration is not filled in randomly, but follows instead the outlines of the initial drawing, progressing in a single direction (from right to left) to ensure continuity in the layout of the pieces.*

12. *This picture shows how the pieces are fitted into their corresponding spaces. The colored paper is cut out first in the shape of the area filled by a single color.*

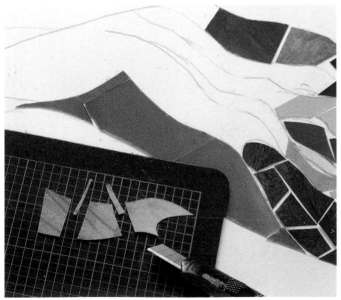

13. *The piece above is then cut into various smaller pieces, which are then placed down, separated by empty white spaces. To make sure that these fit correctly, small slivers are cut from each piece before they are glued onto the support.*

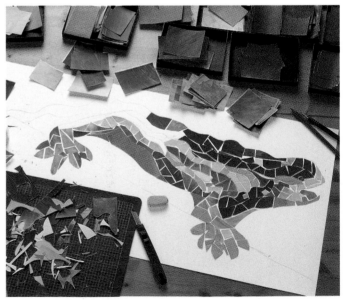

14. *In the final stages of work, the large number of small cut-outs set aside will make it easy to identify the remaining pieces to be glued, by relying on paper pieces left over from earlier cuttings.*

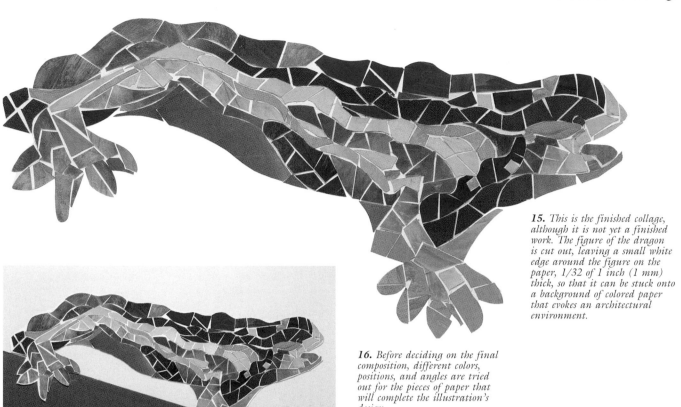

15. *This is the finished collage, although it is not yet a finished work. The figure of the dragon is cut out, leaving a small white edge around the figure on the paper, 1/32 of 1 inch (1 mm) thick, so that it can be stuck onto a background of colored paper that evokes an architectural environment.*

16. *Before deciding on the final composition, different colors, positions, and angles are tried out for the pieces of paper that will complete the illustration's design.*

17. *The paper in the lower portion of the illustration has been cut out in the same ways as the mosaic covering the creature's skin, for a final effect and to create a visual impact reminiscent of the spirit of the magnificent piece designed by Antoni Gaudí.*

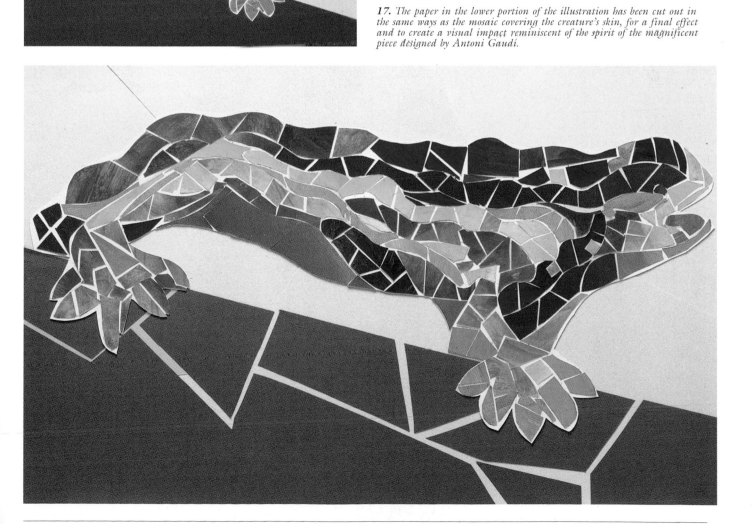

Scientific and Technical Art

Scientific and technical illustration is one of the most effective means of displaying precise and detailed information about topics that require powerful visual support. It is an area in which the work of the graphic artist has not been displaced by advances in photographic reproduction. In general, new developments in science and technology demand clear illustrations that faithfully reproduce a mechanical device or components and specific functions of machines, organisms, or natural systems. While nowadays computers provide incalculable help to professional illustrators, traditional media continue to be used and the skill of the illustrator is far more important than the power of a computer.

CHARACTERISTICS

The essential characteristic of scientific and technical illustration is the clarity and exactness of the information it conveys. No matter how highly complex and detailed the illustration is, the reader has to be able to identify each important element. All of the details should occupy their exact, correct place in the overall illustration and must be represented in proportionately correct sizes and shapes. In addition, since an illustration of this type must be visually attractive and interesting, its graphic qualities (form, color, and contrast) must be of the same high level as the information it conveys.

HISTORICAL DEVELOPMENT

Illustrations intended for reproduction were traditionally engraved in wood (in the case of figurative images) or copper plates (in the case of cartography and exact, documentary images). Sometimes these printed images were then colored with watercolors.

In the eighteenth century, scientific and technical illustration developed rapidly thanks to the work of encyclopedia publishers who needed a lot of visual material to illustrate their large-scale reference works.

Advances in reproductive techniques, and particularly the arrival of photomechanical reproduction at the end of the nineteenth century, allowed the dissemination of all types of illustration. It was then that technical illustration reached one of its peaks with the so-called "presentation drawings" of mechanical or architectural structures. These works were highly detailed engravings, meticulously colored in by hand, and were intended to provide a precise and appealing depiction of a particular project, rather than serving as a reference for engineers.

The arrival of airbrushing and computer illustration in the twentieth century, as well as an improvement in photomechanical reproduction techniques, have made it possible to achieve extremely accurate, top-quality color reproductions of original illustrations.

MASTERING TECHNIQUES

Scientific and technical illustrations demand complete mastery of realistic drawing, as well as of the different techniques of drawing to scale or in perspective. To these basic skills must be added a rigorous and methodical nature and a certain visual talent for finding the most suitable and attractive way of presenting a subject. Most technical illustrators begin working in professional studios and it is there that they gain the experience and knowledge that are vital for later developing a career as independent illustrators.

REFERENCE MATERIAL

Technical illustrations are the result of thoroughly accurate handling of the reference material received by the illustrator. While the illustration must never lack visual appeal, in this type of work the main concern is precision. It is not always possible to obtain the necessary reference material from reference books. For some special tasks the illustrator will have to take on-site notes or photographs (in an operating room, a factory, or any other place where there is no existing graphic information).

Attributed to Birtferth de Ramsey, illustration for the treatise The Quadripartite System of the Macrocosmos and the Microcosmos, *c. 1080. Saint John's College, Oxford (United Kingdom). Medieval scientific illustrations have the same decorative aesthetic as purely narrative ones.*

Jakob Ignaz Hittorff, The Temple of Empedocles in Selinunte. *Illustration from the work* The Restoration of the Temple of Empedocles or Polychromatic Architecture in Greece, *1851, Paris (France). This is a hypothetical reconstruction of a Greek temple, based on archeological data. With large scientific illustrations, precision is never compromised for the sake of aesthetic concerns.*

Illustration for the book by J. J. Scheuchzer, The Formation of the Rainbow, *1771, Augsburg (Germany). Scientific illustrations reached a new peak during the Enlightenment. It is from them that modern technical illustration grew.*

Albrecht Dürer, Aquilegia Vulgaris, *Albertine Library, Vienna (Austria). Dürer's passion for nature made him one of the greatest botanical illustrators of all time. This wonderful piece is a good example of how scientific illustration can be fully considered a work of art.*

Engraved page by Nicolas Bion in the Treatise on the Construction and Principal Uses of Mathematical Instruments, *1723, The Hague. Science Museum, London (United Kingdom). Nowadays, this type of illustration would be substituted by photography. Nevertheless, there is something that photography cannot do: discriminate between the significant details contained in images like this one.*

SCIENTIFIC IMAGES

Scientific illustrations require a precise interpretation of the subject, both in terms of the specific information conveyed and of the style it represented. It is also very important to take into account the type of publication in which the illustration will appear. Illustrating for a general interest magazine is not the same as illustrating for a specialized one. In the latter case, readers do not want spectacular images, but accurate visual descriptions of what is explained in the text. General interest publications and school textbooks demand a high level of visual excellence and allow the illustrator greater creative freedom.

RECONSTRUCTION

Many scientific illustrations are imaginary compositions rooted in reality (atlases, animal life, geology, space travel, the life of primitive man, architectural reconstructions, etc.). These illustrations require conducting a great deal of research in their construction. A clear, attractive result that conforms to the various elements in the reconstruction depends entirely on the style and skill of the illustrator.

REPRESENTING THE INVISIBLE

Often an illustrator must produce a clear graphic version of subjects that cannot be photographed (viruses, atoms, magnetism, physiological processes, etc.). In this case, other illustrations can serve as reference material, unless the illustrator can interpret the scientific subject correctly and portray it in accurate and scientifically correct fashion. Because in most cases it is impossible to compare the relative accuracy of similar illustrations, the illustrator has relatively wide discretion in his or her rendition.

TECHNICAL IMAGES

Technical renditions are highly specialized illustrations that usually must abide to far more specific graphic norms than other types of illustrations. They almost always require specific scale drawings and particular views of the subject matter represented. Examples are renditions of exploded cross-section views, such as illustrations of a mechanical object showing different views of the correct location of all of the components.

Other examples are orthographic views or ground plans, elevations, and views in perspective (for architecture, interiors, vehicles, machinery, etc.), sequences or illustrations that show different internal components of the same object, and, finally, schematic representations of how machinery operates, which rarely uses three-dimensional representations.

TECHNIQUES

Until recently, airbrushing was indisputably the most important technique used for scientific and technical illustrations. Its speed and accuracy could not be matched by any other traditional media since the quality of airbrush finish is often almost indistinguishable from photographs. However, nowadays computers have demoted the airbrush from its preeminent position. Computers offer results that are just as accurate as those obtained with airbrushes and take less time to produce the illustration. Above all, they avoid the need to deal with airbrushing tools.

Albinus, illustration for the anatomical treatise Tabulae Sceleti et Musculorum Corporis Humani, *1747. The Victoria and Albert Museum, London. Anatomical illustrations demand the utmost documentary accuracy. Many modern representations follow the masterful examples of the seventeenth and eighteenth centuries.*

George Stubbs, engraving of the anatomy of a horse. The Royal Academy of Arts, London. Stubbs was a specialist in painting horses. His anatomical illustrations have never been surpassed in either accuracy or compositional grace.

Perspective view in watercolor of an interior design project for a house, made by the interior designer Helena de Canal. Some interior designers are often excellent illustrators. One of the key features of this work is the assured manner in which the perspective has been represented (slightly "corrected" to show the space more clearly).

Jean Dubreuil, engraving for the book La Perspective Practique, *1642, Paris (France). Perspective illustration requires illustrators to be experts in systematic representation. One of the tasks of the illustration is to precisely teach this type of representation, which, as the image shows, demands a high degree of precision.*

Illustration by Marcel Socias. Reconstruction from a textbook on animal life.

VISUAL SYNTHESIS

Most medical, anatomical, botanical, or geological illustrations synthesize a large amount of information. This synthesis has to be graphically clear and avoid anything that is either redundant or unintentional. The balance between realism and clarity is the key to success in this type of work. A high degree of realism may make it difficult to differentiate significant details from less significant ones, while too much abstraction can reduce the realism of the objects being illustrated.

Illustration by Miquel Ferrón. A cross-section view of a camera which is remarkable because of its high degree of detail and the well-executed perspective of the illustration.

Airbrush Illustration

Historically, airbrushing was limited to retouching photographs and to commercial art. However, as the realm of visual media has expanded, particularly advertising, creative ideas that were introduced in mass media have spread to the world of fine art. Nowadays, airbrushing has become a common tool in art, although the technique is not fully accepted in the so-called "serious" painting circles.

Man Ray, La Volière. Roland Penrose Foundation, Chiddingly (Great Britain). This is one of the first works ever done with an airbrush. Strangely enough, it is the work of an artist who was not an illustrator.

THE ORIGINS OF THE AIRBRUSH

The origin of the airbrush dates back to 1893, when North American Charles L. Burdick founded the Fountain Brush Company in London, the first airbrush manufacturer. Burdick was an accomplished watercolorist who initially used the new tool for painting in watercolors. He sent some of his works to the annual exhibition at the Royal Academy of Art where they were rejected for having been produced with a mechanical tool. It took a long time for airbrushing to be accepted as an artistic medium in its own right.

The moment of greatest glory for the airbrush came in 1972 at the Paris Biennial, which presented an exhibition of hyper-realist painters. These painters exhibited large-scale canvases painted with absolute realism that was cold, mechanical, and photographic. They created neatly delineated art works, giant portraits, enlarged details of motorcycles and cars, and urban landscapes, all with the utmost detail. The airbrush proved to be irreplaceable in this type of work and capable of achieving a degree of detail that was impossible with any other medium.

Today the airbrush is widely accepted in the world of fine art and is used by illustrators and avant-garde experimentalists.

In the world of illustration, the airbrush continues to be an indispensable tool for producing highly accurate images, retouching photographs, or producing advertising art.

Illustration by Marcel Socias. Perfect finishes, precisely delineated areas of color, and an array of options for reproducing texture have made airbrushing an important medium in illustration.

CHARACTERISTICS OF AIRBRUSHING

Airbrushing enables the illustrator to paint using a jet of atomized liquid color similar to aerosols, but far more precise. Control of the liquid jet depends on air pressure, the consistency of the paint, and the distance of the airbrush from the support. Air pressure can be controlled in several ways depending on the airbrush model. An airbrush is essentially a tube with a hole at one end through which pressurized air is blown. On its way through, the air drags with it paint contained in a reservoir located near the nozzle of the tube. The paint is atomized by the air and blown onto the support. A trigger allows the airbrush user to control the amount of air blown through it. When the trigger is pressed, air is forced through the airbrush. The air sucks out paint from the reservoir. The paint mixes with the air, is atomized, and then ejected through the opening of the tube. Airbrushes differ in their control of air pressure and thickness of the spray.

SINGLE-ACTION AIRBRUSHES

In single-action airbrushes, the trigger controls the flow, of air. When the trigger is depressed, it takes air in, which mixes with the paint either inside or outside of the airbrush, depending on whether the tool has an internal or external atomizer.

Airbrushes with external atomizers are simple mechanisms. Because in most of these airbrushes pressure cannot be regulated, they are used to paint large areas of flat color. Some models have a needle located at the mouth of the tube which enables the spray of atomized paint to be regulated. However, spraying must be interrupted when doing this.

In airbrushes with internal atomizers, the air and paint are mixed inside the instru-

The airbrush mechanism is based on the same principle as a mouth spray. The jet of air draws out the paint and atomizes it onto the support.

The jet of air can be precisely regulated, allowing users to vary the thickness of the spray.

ment. When the trigger is pressed, a valve opens to let air in. This atomizes the paint and forces it out of the tube. The thickness of the spray is controlled by the position of the regulating needle. The needle can be adjusted by turning the screw located at the back of the handle. The looser the screw, the thicker the paint will be.

DOUBLE-ACTION AIRBRUSHES

Fixed double-action airbrushes, which use a double-action trigger, allow the artist to control the air-intake valve and the position of the needle. The more complex models (and those used by professional illustrators) have an independent double action which allows the user to control the volume of air and flow of color separately. When starting to work, it is advisable to eject a stream of air first and then to slowly start the spray of paint. This keeps the colors from splashing, as is likely to happen with single-

This model has a simpler mechanism. Its external atomizer does not have a regulating needle, meaning that the stream of paint it emits is always the same thickness.

The independent, double-action airbrush is the type most widely used by professional illustrators. It allows the flow of air and amount of paint to be controlled separately.

This is one of the most versatile models which can be used for all types of jobs. It is an independent, double-action airbrush with a top-mounted reservoir.

CHOOSING AN AIRBRUSH

When choosing among the many different airbrush models available today, a beginner might be drawn to a variety of sophisticated designs that have several interchangeable opening parts or different types of paint reservoirs. Buying one of these models is as big a mistake as purchasing a cheap, low-quality airbrush. The best option for a beginner is to buy a high-quality, reliable airbrush with a simple design (preferably one with an independent, double action).

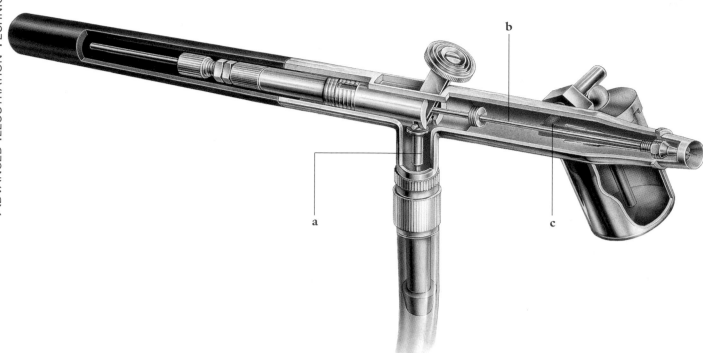

The internal workings of an airbrush consist of three essential mechanisms: air intake (a), the needle that regulates the flow of paint (b), and the paint intake (c).

action or fixed double-action airbrushes.

WORKING MECHANISM OF THE AIRBRUSH

Airbrushes have actually not changed much since they were first developed, although their design may have improved and become more stylish and they may look sleeker and more attractive. However, the basic components—a trigger that precisely controls and regulates the amount of air released which, in turn, atomizes the paint by means of a needle, and the nozzle through which the expanding jet of paint is expelled under pressure—were already part of Burdick's original design in 1893.

Whether we are dealing with single-action or double-action airbrushes, the basic components are always the same. The airbrush has a body with a valve for air flow, and a paint reservoir. In the case of gravity-fed airbrushes (which have a top-mounted paint reservoir), the reservoir can be incorporated within the instrument or it can be

externally mounted. A sleeve, which protects the needle inside, makes the instrument easy to grip. The trigger that regulates airflow and the intake of paint is on top of the instrument.

With suction-fed airbrushes, the paint receptacle is located on the side or under the body of the airbrush. These models have the advantage of holding much more paint than gravity-fed airbrushes. Cartridges holding different colors can be replaced quickly and are easy to clean. On the other hand, suction-fed airbrushes are bulkier and more cumbersome, which impairs somewhat the user's movement.

AIRBRUSH COMPONENTS

Most airbrushes operate and rely on the same principle of operation. Whether they are gravity-fed or suction-fed, they share similar mechanisms consisting of a system for blowing air through a pipe and an adjustable needle which regulates the release of a jet of atomized paint.

The airbrush nozzle is one of its most delicate parts. A light tap can alter the needle's position and impair control of the stream of paint.

It is necessary to test the trigger's pressure regularly. If the action is weak, air flow cannot be accurately controlled.

The screw that holds the needle in place should be screwed tightly to keep the needle from moving during work.

USING AN AIRBRUSH

When using an airbrush, it is important to follow certain basic steps. The tool should be held in the same way as a pen or pencil, between the thumb and middle finger, with the forefinger resting on the trigger. The entire airbrush should fit in your hand the same way a writing instrument does. Beginners usually try to find the most comfortable way of holding the airbrush and often pick up bad habits. This should be avoided from the very start.

When ready to paint, the action of the trigger should be first tested. This is done by pressing down on the trigger to produce a flow of only air. If paint is ejected during this test, the needle and the paint-release control should be adjusted. To release a stream of color, the trigger is pushed back and down at the same time. To help keep the airbrush in good condition and prevent it from dropping accidentally, manufacturers provide special holders that can be mounted on work tables. Some of these can accommodate two airbrushes to enable the artist to alternate between them with ease.

MAINTAINING AN AIRBRUSH

To keep the airbrush in perfect working condition, special care must be taken not to damage the nozzle, which is very delicate and sensitive to any type of bumping. The nozzle should be kept completely clean so that the needle can easily move inside the sleeve.

The trigger must be in perfect working condition. For this to happen, the positioning spring must exert the right amount of pressure. If the spring is not strong enough, it will not exert enough tension. This will affect the accuracy of the trigger response and the airbrush will not operate effectively.

It is also important for the screw that holds the needle in

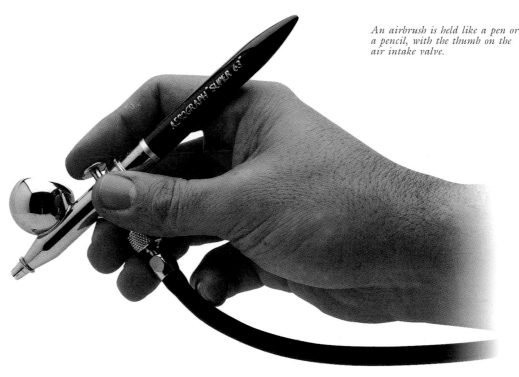

An airbrush is held like a pen or a pencil, with the thumb on the air intake valve.

place to be screwed in tightly so that the needle does not move while work is in progress.

CLEANING AN AIRBRUSH

An airbrush that is not properly maintained will be impossible to use. Meticulous care is the key to keeping the airbrush in good condition. Caring for an airbrush is a tedious but necessary task.

Airbrushes must be cleaned after each use, even when the use is brief. This is a golden rule that must always be observed. Second, it is important to ensure that the paint being used is of the right consistency. Airbrushes cannot discharge or expel specks of dry paint. Third, the air pressure must never exceed the levels indicated by the manufacturer. Lowering the air pressure to achieve a specific effect will not damage the airbrush, but raising it too high will make the airbrush behave erratically and can cause leaks in the joints and washers of the air valve.

To keep the airbrush in good condition, all of its parts should be washed with alcohol after each use.

A tank compressor can store compressed air in its air tank, ensuring a constant supply of compressed air to the air gun.

AIR SUPPLY: COMPRESSORS

Air compressors are pumps that compress the air to a particular pressure and then force it out through a nozzle. Air compressors are distinguished by their air intake capacity measured in gallons per minute or liters per minute (L/m), and by the maximum air pressure they can produce. Air pressure within the air tank is measured in pounds per square inch (psi), kilograms per square centimeters, or atmospheres. The flow of air that a compressor is capable of achieving—which is measured in gallons per minute—is in direct proportion to its intake capacity. In addition to compressors, there are other supply sources for pressurized air. These are compressed air containers which, while useful for emergencies, are not very long lasting, and compressed air bottles, which yield good results but need to be recharged by special suppliers.

COMPRESSOR MAINTENANCE

All compressor manufacturers provide specific instructions on the correct use and maintenance of their compressors. It is extremely important to check the oil level of the compressor on a regular basis.

If this is not done properly, the compressor could freeze up and then require major repairs by the manufacturer. Controls for oil maintenance can be found on the side of the compressor and consist of an oil inlet and an oil level gauge. The oil level should never be allowed to fall below the prescribed minimum. The oil in the compressor should be changed at least once a year. The moisture filter should be emptied from time to time. If the compressor has a reserve tank or chamber, the drainage tap should be used to drain any moisture that might have accumulated.

COMPRESSOR ACCESSORIES

One advantage of airbrushing is that the artist can control and create special effects without the need for many different accessories. However, some accessories are crucial. These are an air pipe, an adapter for connecting the air pipe to the air supply, a moisture filter, and a manometer for checking air pressure.

The air pipe connects the airbrush to the compressor. It usually measures between three and six feet long and is made of different materials. Plastic air pipes are cheaper and more delicate since they can be cracked or crushed accidentally. Rubber pipes with a protective sleeve are

A diaphragm compressor does not store air. Instead it channels the air under pressure directly to the airbrush, making this type of compressor less reliable in maintaining a constant pressure.

Table-mounted stands are important for holding the airbrush while not in use. Some stands have another support for the air filter and the compressor's pressure regulator.

Different types of air pipes for supplying compressed air to the airbrush. These pipes should be both strong and flexible.

*Illustration by Antonio Muñoz
Tenllado. Most illustrators combine
opaque colors with transparent
ones to achieve a variety of effects
in their work.*

from light colors to darker ones and bearing in mind that the effects of both chiaroscuro and color saturation are achieved by applying successive layers of color. Second, working with transparent colors means that white cannot be used. White will always be the color of the support, either itself or as a base tone that enables the artist to lighten the work's colors with transparencies. In either case, however, a very precise initial sketch with carefully planned areas of color and white is required. Transparent media fall into the following categories: traditional tubes of watercolor, liquid watercolor, liquid inks, and special fluids for airbrushes.

more durable but not as light as plastic ones. Pipes made of articulated rings are light, strong, and durable.

The air pipe is connected to both the airbrush and the compressor by means of threaded adapters. Single adapters for working with one airbrush or multiple adapters for working with several airbrushes at the same time are available. Though sometimes used by professional artists who work with two airbrushes at the same time, multiple airbrushes are most often used by advertising and graphic design studios.

OPAQUE COLORS

Opaque colors are solid colors that are used to completely cover a support or to cover up other colors so that they do not show through. Gouaches are the most commonly used opaques. If the gouache is too runny, it will not cover the support well and will leave streaks. If it is too thick, it will clog the nozzle of the airbrush. There is, however, a special type of gouache that has a fine pigment that prevents lumping. It is important to clean the airbrush after each use. Water is

all that is needed to clean after a gouache.

Acrylic paints are widely used by airbrush professionals. There are two types of acrylic paint which vary in viscosity. Low-viscosity acrylics are diluted with water, whereas high-viscosity acrylics need the addition of another medium.

TRANSPARENT COLORS

Regardless of the medium used, there are two standard techniques for painting with transparent colors. First, it is necessary to gradually darken the composition, proceeding

MASKS

Masks are protective covers used to mark off the areas to be painted. Masking is the process of protecting and keeping certain areas in the illustration free of color and is an important part of airbrushing technique. An art in its own right, masking requires advance planning of the work and its division into

Colors can be opaque (gouache, acrylics, etc.) or transparent (watercolors, anilines, inks, etc.). It is important for the paint to be totally liquid and free of lumps so that the nozzle does not become clogged.

different stages. The degree of accuracy aimed for in airbrushing could not be achieved without masking. Masks can be classified into different types: fixed, removable, suspended, and liquid.

FIXED MASKS

Fixed masks are attached to the support. The most common material for a fixed mask is self-adhesive film which is specially made for airbrushing. Available in single sheets or in rolls, self-adhesive film is sold with a protective cover that needs to be peeled back slowly as the film is applied to the support. Despite its strong adhesive quality, which keeps the paint from seeping through to the support below, the film comes up easily so that the mask can be removed after it has served its purpose. Self-adhesive film makes a very fine mask which prevents the paint from building along the edges and ensures a clean border. Another important characteristic of this type of mask is its transparency, which allows the masked area to show through and be painted over. Another type of fixed mask is one made of polyester paper which is attached to the support with rubber glue.

REMOVABLE MASKS

Removable masks are put on the support and are held in place by a hand or other heavy object placed on top of them. Alternatively, they can be held above the support to produce diffuse edges. Removable masks can be made with any kind of material, from paper, poster board, and cardboard to rulers and stencils. They can also be made by using fingers or hands.

LIQUID MASKS

Liquid masks are used to protect small details. These masks consist of a dilute rubber solution that is applied with a paintbrush. This type of mask dries quickly and leaves a film that can be removed by rubbing with a finger or a soft eraser. It is not wise to apply liquid rubber with a sable paintbrush because the rubber dries at the base of the bristles. This makes removing the mask difficult and can also ruin the brush. A better idea is to use a synthetic paintbrush, which should be washed in water immediately after use.

PAPER FOR AIRBRUSHING

Paper is, without a doubt, the most common support used by airbrush artists, especially high-quality, smooth Bristol paper and papers with a stucco surface (matte art paper). Also worth mentioning

AERIAL MASKS

Aerial masks are suspended above the support or held in place with pieces of rubber or balls of rolled-up adhesive tape. Cotton wool is one example of a suspended mask. When it is sprayed, the paint filters down through the mask and produces gradations of color that are very suitable for painting cloudy skies.

Shown here are different types of masks, from adhesive masks designed for airbrushing to removable masks of all kinds.

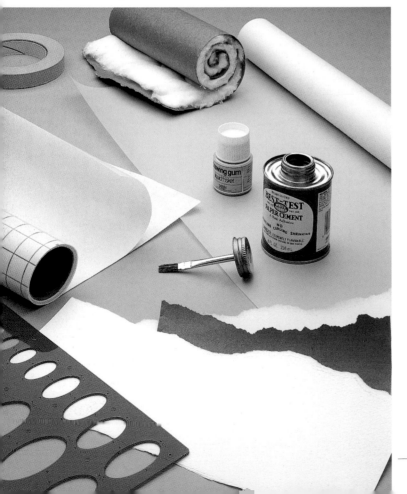

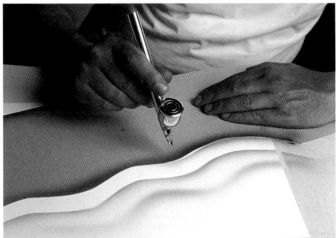

Use of a mask allows the artist to achieve clear outlines and borders and to create clearly defined contours around tonally graded areas.

Self-adhesive masks are indispensable for most airbrush work.

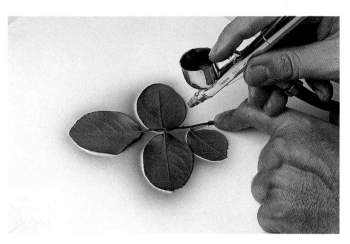

A removable mask can be a customized paper cutout, a piece of posterboard, or any other flat object placed over the support.

Paper cutouts allow the artist to create masks that meet the demands at hand.

Rubber glue is particularly useful for attaching non-adhesive masks.

ADHESIVE FOR REMOVABLE MASKS

When working on rough paper, self-adhesive masks can sometimes damage, as they are being removed, the base paint over which they have been applied. The solution lies in using a removable mask that is attached with rubber mounting glue. After the work is finished, the mask can be lifted easily and any glue that sticks to the paper can be removed with a soft eraser, without any damage to the paper or paint.

Here a plastic template is used as a mask.

Here pieces of a cotton wool are used as a mask to achieve special effects.

are the specially manufactured airbrush papers, such as Studio Grattage and Studio Aero by Canson, or smooth Schoeller paper for technical drawing.

All papers should weigh at least 300g so that they keep their shape. It is recommended that paper in sizes greater than DIN A4 be mounted on a wooden board. Some types of paper are available pre-mounted on board (50 × 60 cm), which prevents creasing and enhances their appearance. However, the board makes it more difficult to use a scanner (the most common form of reproducing an illustration) to copy the original. Some scanners require supports that can be rolled up without folding or creasing their surface.

It should also be mentioned that, for special art works, fine-grained or medium-grained papers can be used (provided they are relatively heavy), as well as papers that imitate the texture of canvases used in oil painting. In any case, the artist should always be aware of the results he or she can achieve with the different-texture papers. The types of paper described above are suitable for artistic works where freehand airbrushing is predominant and where the illustrator wants to achieve textured results.

The grain of the paper dramatically affects the final appearance of an illustration. Works which require greater detail and accuracy should be made on smooth paper.

PAINTBRUSHES

Paintbrushes are indispensable when painting with an airbrush. They are used for painting details on the finished work, for refilling the airbrush's reservoir with paint, and even for cleaning off remnant traces of paint. For adding final details to the work, a sable paintbrush is best. These paintbrushes are of top quality and their hairs always form a perfect tip.

Templates in the shape of curves, signs, circles, or geometrical forms of all types save time cutting out very small masks.

They are very flexible and can be used to make very detailed strokes. Sable paintbrushes are the most expensive, but last much longer than other kinds, provided they are properly cared for. When painting with acrylics and applying liquid rubber masks, synthetic paintbrushes should be used since these substances often stick to the brush bristles when they dry.

KNIVES

Artist's knives, cutters, and scalpels are also important tools for making masks for airbrushing. The most common type of cutter has a ceramic blade and an interchangeable head. These cutters are easy to use because they

are so light and their blades stay sharp almost indefinitely, not needing replacement unless broken. To make curved cuts, it is best to use an artist's knife with a rotating head. Modern cutting knives are indispensable for cutting paper and cardboard supports.

TEMPLATES

These are pieces of plastic with holes that are used for drawing geometrical forms and shapes without needing rulers or compasses. There is a wide range of templates available in all shapes and

There are different knives for different types of cutouts, from highly precise types to types that can be used on card and thick paper.

sizes: circular, square, oval, triangular, arrow-shaped, for numbers, letters, etc. There are special types, called French curves, which are ideal for cutting all types of regular or irregular curves. Templates and French curves are used for both drawing and cutting out removable masks.

OTHER TOOLS

Artists also need transparent and opaque adhesive tape, large scissors for cutting out paper, an eraser, graduated rulers and metal rulers to use as edges for cutting, square and triangle rules, removable

glue for mounting masks, adhesive masks and polyester paper for making movable masks, a magnifying glass for working on the small details, technical pens, a set of compasses, a technical drawing pen, a crepe rubber eraser for removing traces of rubber glue, and liquid masking fluid for masking out.

An airbrush artist is likely to need a large number of additional tools, ranging from compasses for making curved incisions to a face mask for working on large-scale works in enclosed spaces. Other needed materials include adhesive tapes, erasers, glues, and rulers.

FELT-TIPPED PENS

Felt-tipped pens can be used for retouching and adding detail to an illustration. Felt-tipped pens come in transparent colors, and most brands offer very extensive ranges of tones. Depending on their use, it might be useful to have felt-tipped pens of different widths, with both water-soluble and alcohol-soluble inks.

COLORED PENCILS

Colored pencils are usually used for testing different combinations of tones, but they can also be used for retouching and adding color to the final details of an illustration. Watercolor pencils allow the color to be diluted and tones to be blended together, by diluting the color with a paintbrush dipped in water.

An illustration by Marcel Socias. Illustrations as complex and highly detailed as this one usually need a lot of touching up, which involves using a paintbrush to apply gouache and colored pencils and felt-tipped pens.

An Airbrush Illustration

Because airbrushes have been discussed in detail in the previous section, it is not necessary to repeat their characteristics and potential uses here. In the process of creating the illustration that follows, you will see how this tool lends itself particularly well to illustrations that need to depict the shine, reflections, and textures of metal surfaces. The illustration is taken from a photograph, but includes imaginative additions that demonstrate another aspect of this technique, and one that is freer and more spontaneous.

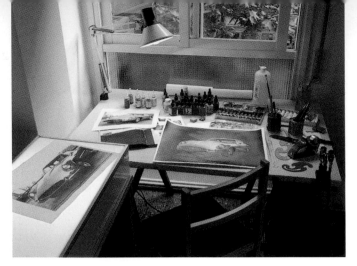

The illustrator's studio is a small room that is perfectly suited for airbrush work. The room is well lit with both natural and artificial light, and the work surfaces are well set up.

CHARACTERISTICS OF THE PROJECT

The illustrator, Myriam Ferrón, is going to work on a project that involves painting a sports car for a catalogue. The catalogue shows old (but not antique) models of cars, and is particularly aimed at car enthusiasts and collectors. The illustration has to be extremely faithful to the model in question, although its ultimate aim is decorative rather than technical: the commission is to create an accurate reproduction of a car that is highly appreciated and sought after by collectors. The illustration must convey the fast, aggressive, sporty spirit of the car, while at the same time faithfully showing all aspects of its technical specifications and design that makes it instantly recognizable to experts.

REFERENCE MATERIAL

The illustrator has been given various high-quality photographs of the car, and has chosen the one that fits the criteria that a good airbrush illustration must fulfill. First of all, the car has been photographed clearly and in perspective, in a position that suggests movement and energy and which is common in car advertisements. Secondly, the distribution of bright points and reflections over the metallic surfaces is obvious and sharp and does not affect the overall coloring of the illustration. The details stand out clearly and the shadows help highlight the design without masking any of its characteristic details. The illustrator is responsible for finding additional reference material needed to create an imaginary environment for the illustration that fits in with the spirit of the project. For this, she will search through catalogues of photographic images to find inspiration in vistas of cloudy skies.

MATERIALS

The illustrator will use a Hansa Aero-pro 301 airbrush, which has an independent double action, a top-mounted reservoir, and is connected to the compressor by a rubber pipe. She is using a tank compressor with a quart capacity of 1.5 L and a flow of 15 L per minute. She will paint the illustration using anilines, which are also known as airbrush inks or liquid watercolors. She will use adhesive masks and a wide range of other tools, including an artist's knife, watercolors for drawing sketches, acrylic paints, felt-tipped pens and colored pencils for retouch-

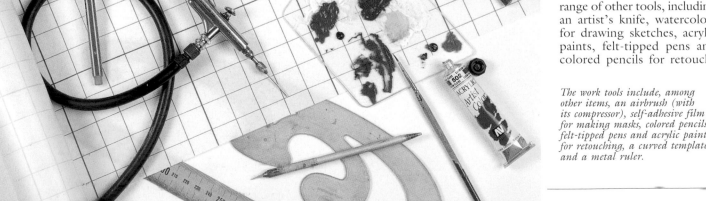

The work tools include, among other items, an airbrush (with its compressor), self-adhesive film for making masks, colored pencils, felt-tipped pens and acrylic paints for retouching, a curved template, and a metal ruler.

ing, an eraser, a curved template, and a metal ruler for cutting.

SKETCHES

For airbrush work, preliminary sketches are a must. Airbrush painting is labor intensive and methodical, and should be carefully planned from the beginning. The illustrator should know exactly which colors he is going to use and in which order he will use them. He also needs to identify the background areas and the areas that will stand out against the background. Here, the combination of two different reference sources (the photograph of the car and the images of the sky) makes it necessary for the illustrator to calculate in advance how the two will fit together.

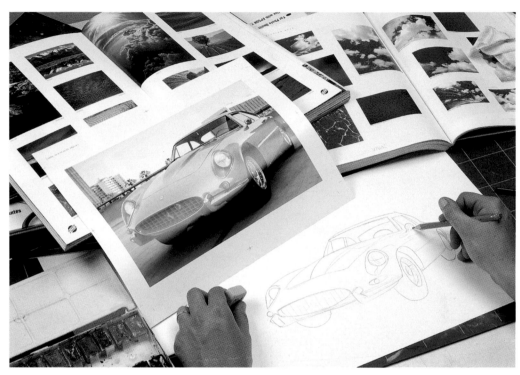

1. Before beginning work, it is very important to make a series of preliminary sketches to check the chromatic effect of the illustration and the link between the form of the car and the imaginary environment of the background.

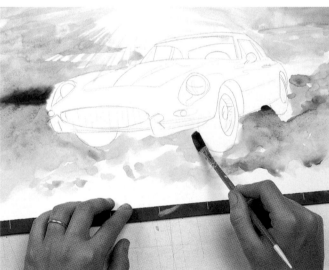

2. Watercolor is a fast, handy medium for checking the visual effect created by various combinations of both composition and coloring. These combinations are based on the reference material.

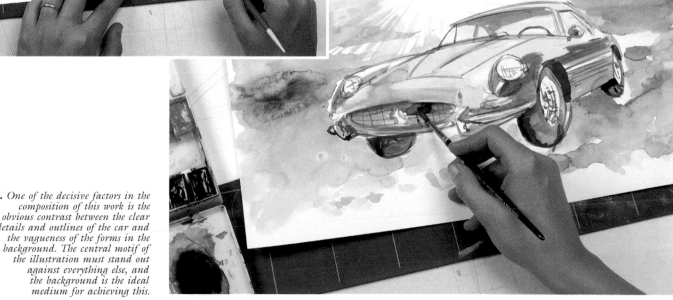

3. One of the decisive factors in the composition of this work is the obvious contrast between the clear details and outlines of the car and the vagueness of the forms in the background. The central motif of the illustration must stand out against everything else, and the background is the ideal medium for achieving this.

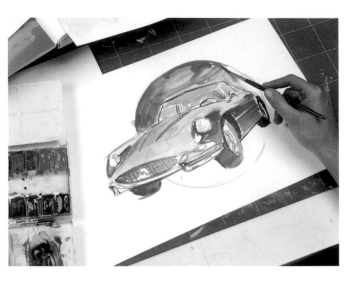

4. *You can experiment by changing the color of the car to see what effect it will have. Making these changes to the original requires a lot of practice and confidence, since the color you have invented must seem as real as the original color.*

THE LIGHT BOX

A light box is an important tool in any illustrator's studio, especially when working with an airbrush. Here all of the sketches have been done using a light box to trace the outline of the car. The light box has also been used to trace a blown-up copy of the vehicle. The box does not have to be very large, since large-scale originals can be traced in sections using an A4-sized light box.

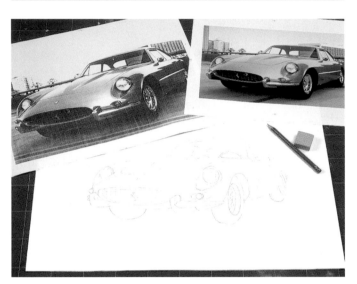

5. *The illustrator has drawn a total of three preliminary sketches in significant detail, combining different solutions for the background and the color of the car. Finally she has opted for a dark background in warm colors, which will sharply contrast with the cold, bright color of the car.*

6. *The first step in making the final illustration is to trace a blown-up copy of the original photograph onto the paper support. The support should be fine-grained (but not glossy) and thick enough so that it is not easily nicked by the edge of the knife. A hard-lead pencil is used to draw clear, strong lines.*

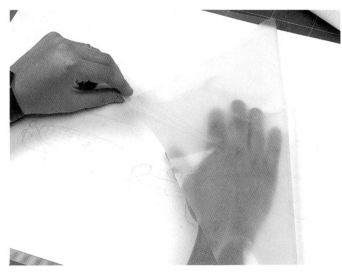

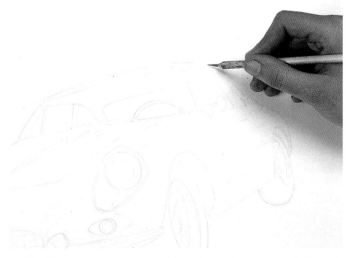

7. *Now the illustrator covers the entire sheet of paper with an adhesive mask. Experience dictates that the size of the mask (which is always standard) should be proportionate to the size of the paper to avoid wasting material through unnecessary trimming.*

8. *The illustrator goes over the outside outline of the car with a knife and cuts out its silhouette. The mask is very fine and easy to cut, so it is not necessary to apply too much pressure to the knife. This will help prevent damage to the paper underneath.*

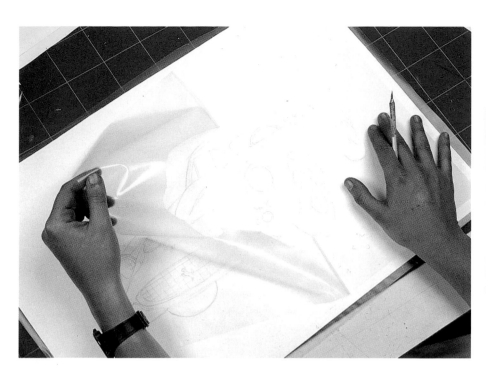

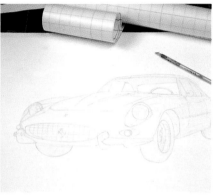

9. *The illustrator now pulls away the mask so that only the part covering the shape of the car remains stuck to the paper. The adhesive on the mask is specially designed to make this task easy.*

10. *This picture shows the car completely covered by the mask. It is customary to start airbrush works by painting the background and leaving the main image blank.*

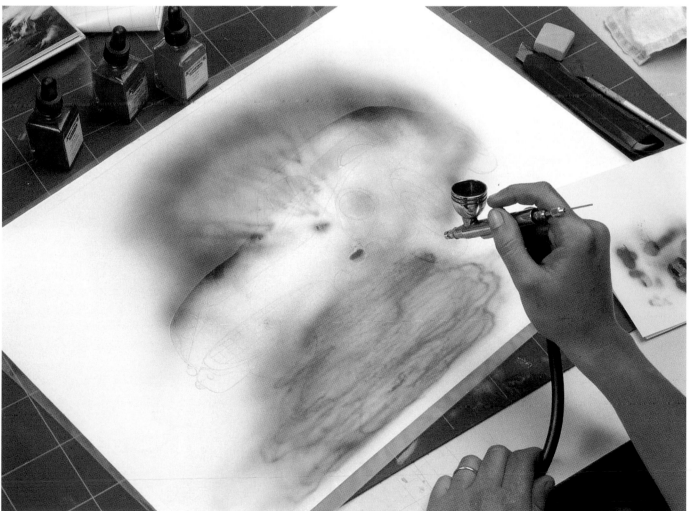

11. *This picture demonstrates the first applications of color, sprayed on with very little pressure and with the mouth of the airbrush valve opened wide, so that the spray covers a wide area. As with other techniques, light colors should be painted before dark ones.*

SAVING THE MASKING

As each part of the illustration is painted, more pieces are cut from the mask (each major detail needs to be covered with its own mask). All of the masks should be saved until the illustration is finished, since they need to be used for painting over the area that has been removed (which is now exposed to the spray of paint) and for painting over the mask, when the rest of the masking is removed leaving a small patch covering the detail in question.

12. *The background is painted without using masks (except for the mask that covers the car). Even the most detailed parts of the bottom half of the illustration can be painted freehand, holding the airbrush steady with both hands to keep it from moving.*

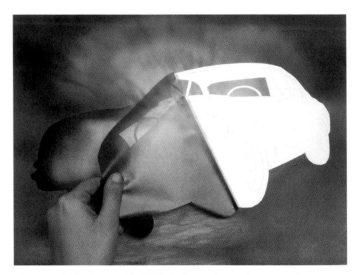

13. *Once the background is finished, the mask over the car can be removed, and the mask over the background is put back in place to protect it from subsequent layers of paint.*

14. *Notice how the illustrator paints the wheels. The illustration is protected by a mask covering the background and a new mask covering the car (though just the lower half). The wheel areas are cut out so that they are the only parts of the car that are exposed to the spray.*

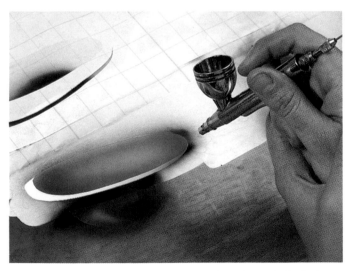

15. *Another important detail in the bottom half of the car is the dark area of the radiator grille. As with the wheels, this area is painted after cutting out a mask that follows its outline. The illustrator is careful to protect the edge of the bodywork around the mouth of the radiator grille, which will be a lighter color.*

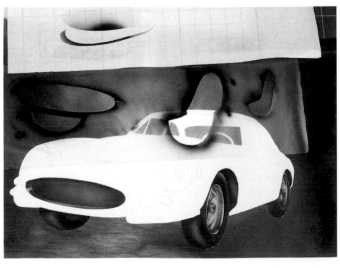

16. *Here you see the result of painting in the first details of the car. In the upper part of the picture, you can see the mask that was used for painting the wheels and the radiator grille. The hubcaps (the metallic pieces inside the wheels) have been painted using a curved template as a masking device.*

17. *The mask for the bottom half of the car has been used again to outline the edges of the headlights and the bumpers. The artist has also begun to work on the upper part of the car, using a new mask, from which the interior of the car and the rearview mirror have been cut.*

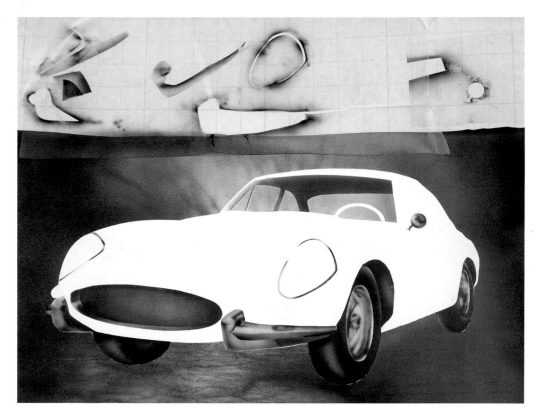

18. *The illustrator now has to use a new mask to add certain details to parts of the car, since the previous masks have had too many parts cut out of them already.*

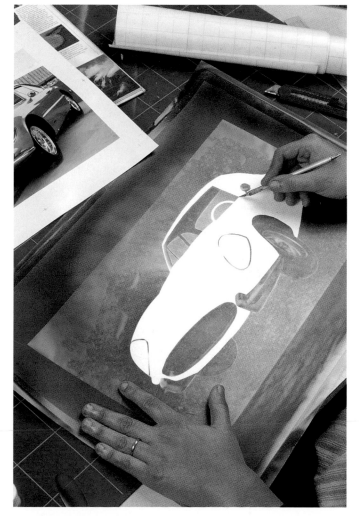

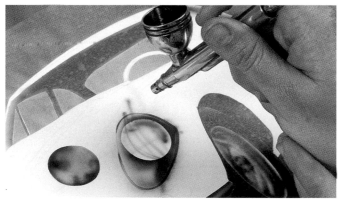

19. *The central part of the headlights are cut from a new mask, and are now sprayed with a dark color that is exactly the same as the one used for the other details of the body work.*

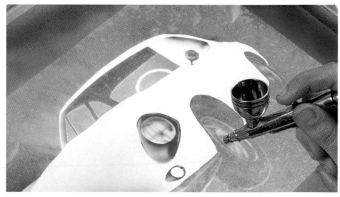

20. *The large panels of the body work are sprayed once the mask has been removed. However the mask covering the small details (headlights, radiator, wheels, interior, etc.) are left in place. The paint is first sprayed on very lightly because the idea is to achieve an initial general shading.*

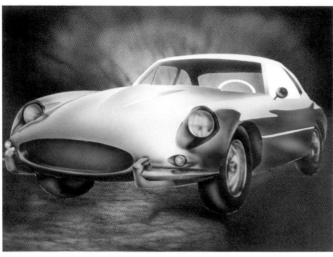

21. *The bright points and reflections of the bodywork have been achieved by cutting out their corresponding masks. The tonal gradations in the darker areas are achieved easily by spraying more strongly along the edges that are masked over. The full range of color is not totally applied to the middle section part, since these areas require a lighter tone.*

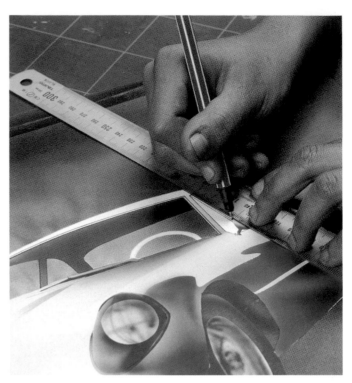

22. *You can add details to the windows on the right-hand side by using a ruler and a fine felt-tipped pen. This method is much easier than trying to get straight lines with the airbrush.*

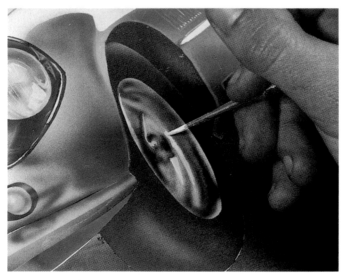

23. *The tiny reflections on the hubcaps are filled in using light touches of white gouache, applied with a very fine, round sable paintbrush. You should try to be sure that the paintbrush keeps a perfect point to achieve the greatest degree of accuracy possible.*

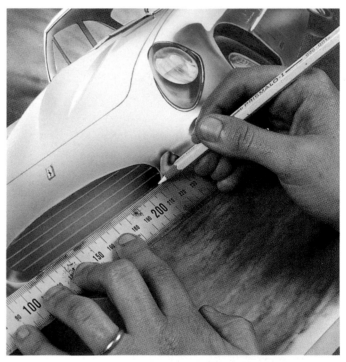

24. *As with the right-hand windows, the details of the radiator can also be drawn in with a white pencil. All of these retouches with media other than the airbrush are what give the finished illustration its fine details.*

25. *The basic work of the illustration is now almost complete, including the most important details of the car. All that remains to do are the general nuances of the bodywork and the background, which can be completed by using masks and by retouching with a gouache, felt-tipped pen, or colored pencil.*

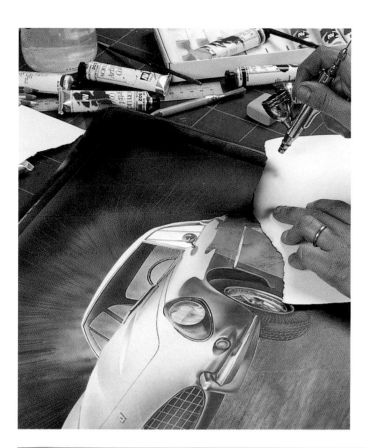

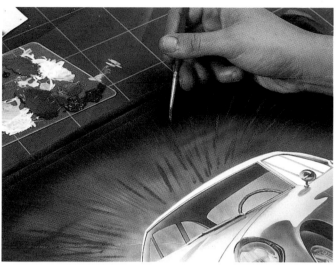

26. *By this stage, adhesive masks are not necessary. The final retouching can be completed using masks made from strips of paper. Notice how the rear wing of the car is retouched using a cut-out card mask.*

27. *The final details of the background can be finished with a paintbrush. For details like these, the airbrush is not accurate enough, and it would be much more complicated trying to create these small details correctly with an airbrush than with traditional methods.*

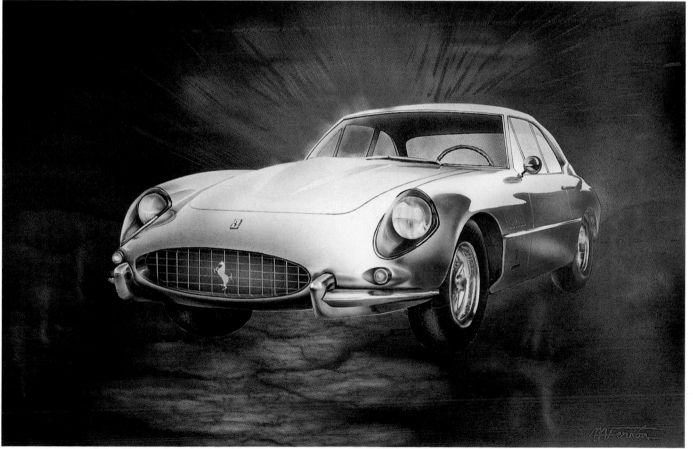

28. *This is the final result of the process. The combination of airbrush and traditional techniques is common for illustrations that require a high degree of detail. The final product is an illustration that fits the chosen* *theme perfectly, fulfils the requirements of the project, and contains all of the necessary detail.*

Computer Illustration

One of the areas in which the technological revolution in computers has had the most wide-ranging effect is in the world of publishing and everything that surrounds it, such as photographic manipulation, design, layouts, photo-setting, printing, and so on. The work of the illustrator has not been unaffected by the technological revolution: computers are increasingly being used to create images, and to a large extent have proven themselves to be a powerful challenger to methods such as airbrushing. On the following pages, the illustrator Antoni Vidal shows some of the possibilities of this new technology, a technology that is in such a constant state of evolution that, even if it does not supplant traditional methods entirely, is opening up new areas which are only accessible to professional artists familiar with the new equipment and software.

Illustrator Antoni Vidal sitting at his computer. A professional-grade computer needs to have a very high memory capacity and a powerful processor that allows the illustrator to work quickly.

The mouse is a vital tool: a mouse is to a professional computer illustrator what a pencil or paintbrush is to a painter.

HARDWARE

Everything related to computers is involved in a dizzying process of change and innovation. After only a few months, new innovations are no longer cutting-edge, and hardware specifications become more advanced with each season. Inevitably, by the time this text is published new developments will have appeared on the market that surpass the capabilities of the equipment mentioned here. However, the general concepts and ways of using software programs will remain essentially the same.

Optimum working conditions for using a good-quality image-manipulation program can only be achieved with top-of-the-line equipment. The specifications of Antoni Vidal's computer (an Apple Macintosh) are as follows: 200 Mb of RAM memory, 4 Gb of hard disk memory, and a 400 MHz processor. Although some illustrators work with a light pad (a flat surface over which a pointer is moved), Vidal still uses a conventional mouse, with which he achieves exceptionally precise, flowing lines. In this respect, the illustrator's familiarity with the work tool is more important than its theoretical degree of precision.

SOFTWARE

There are two types of drawing and image manipulation software available: those using vectors and those using bit-maps. The former allow the illustrator to create much lighter images (which take up much less memory), but their resolution does not change, so they lose quality when enlarged.

The work tools explained below, as well as the illustrations shown on the following pages, correspond to bit-map software (*Adobe Photoshop* version 5.0), which is the software most commonly used by professional illustrators. As the following pages show, using this software is very similar to the technique of using

an airbrush, and the results give maximum quality and accuracy.

MAIN WINDOW

The main window is the support on which the illustrator works, in the same way that a painter works on paper or canvas. It is a frame with a ruler along the top and down the left-hand side: both rulers allow the illustrator to alter or adjust the dimensions of the illustration.

As with any other type of computer software, the menu bar appears across the top of the screen, and has the following options:
· Save Menu, for operations involving saving, printing,

and opening and closing documents, among other tasks.
· Edit Menu, for copying, pasting, choosing, etc., part or all of the image in use.
· Image Menu, for altering the size, position, RGB or CMYK color treatment, etc., of the image.
· Layer Menu, for creating, adding, or deleting layers, views of layers, combinations of layers, etc.
· Selection Menu, for isolating one or more areas of the image, combining selections, creating masks, etc.
· Filter Menu, for effects of color, texture, focus, distortion, etc.
· View Menu, for revealing or hiding borders, guides, rulers, and increasing or decreasing what is seen on screen.

· Window Menu, for opening or closing the windows for different options, palettes, and tools.
· Help Menu, for accessing the program's help manual.

SIZE SPECIFICATIONS

This window is opened by means of the Image Menu mentioned above. It shows a box which enables you to establish or modify the dimensions and resolution of the image. These two factors influence the size of the image or, in other words, how much

memory it will take up (expressed in the usual units of kilobytes or megabytes), which this window also specifies.

Before starting to work, the height and width of the image are entered. A box will immediately calculate how much memory this image takes up. These dimensions can be specified in pixels (the dots which make up the image) or in centimeters. Similarly, the resolution can be specified in pixels per inch or pixels per centimeter. One of the boxes (Keep Proportions) allows you to specify a new height or width, and automatically calculates the

You can access all of the program's menus and tools from the main window.

This is the window that enables you to specify the size of the image.

Frame	**Move Tool**
Selects rectangular segments of the image.	*Moves the selected areas.*
Lasso	**Magic Wand Tool**
Selects an area of the image by freehand.	*Selects areas of the image.*
Airbrush	**Paintbrush Tool**
Uses an airbrush technique (very soft-edged lines).	*Gives a paintbrush effect.*
Rubber Stamp Tool	**Art History Tool**
Copies a point or fragment of the image.	*Paints using pre-established paintbrush preferences.*
Eraser Tool	**Pencil Tool**
Deletes any mark.	*Draws homogenous outlines.*
Blur Tool	**Burn Tool**
Blurs marks or areas of color.	*Darkens areas of the image.*
Pen Tool	**Type Tool**
Various tasks, from going over shapes with a high degree of accuracy, to correcting lines.	*Inserts text into the document.*
Measure Tool	**Linear Gradient Tool**
Measures distances, locations, and angles.	*Creates a gradation of one, two, or more colors.*
Paint Bucket Tool	**Eye Dropper Tool**
Colors in pre-selected areas.	*Measures the parameters of a color in a given point or area.*
Hand Tool	**Zoom Tool**
For moving the image within the window.	*Enlarges or reduces the view of an image.*
Viewing Options	**Foreground and Background Colors**
Selects the type of view onscreen: standard, full screen with menu bar, or full screen without menu bar.	*Reverses or changes foreground and background colors.*
	Mask Modes
	Creates different masks.

Tool bar.

ADVANCED ILLUSTRATION TECHNIQUES

new height or width in proportion to it.

BRUSH WINDOW

This window shows the different paintbrush strokes, airbrush sizes, and pencil and paintbrush widths. The program offers a series of standard sizes, to which any that the illustrator chooses for each task can be added. To make this choice, you just have to click twice on the one you want to change.

SIZE AND SHAPE WINDOW

This window has a list of options for working with airbrush effects. You can alter the pressure of the spray (just as you would if you were pressing the trigger of a real airbrush) by varying the percentages that appear in one of the boxes (from 1 to 100%). There is also a box entitled Transition, in which you can specify the steps or interruptions in the flow of color as you are spraying. The normal value (for an experienced illustrator) for Transition is 0, or in other words without interruption.

COLOR SWATCHES

Color swatches constitute the illustrator's palette. The program has a range of standard colors that the illustrator can increase at will by accessing a separate window which enables the user to choose the specific tones he or she requires, by altering the parameters for the amounts of yellow, cyan, magenta, and black in each tone.

COLOR CURVES

This window allows the color of the image to be manipulated by means of the slide controls along the side and bottom of the central box. The interior of the box shows a

color curve, which appears as a straight diagonal line before adjustments are made, and only begins to curve when the parameters are changed, altering the percentages of red, green, and blue (for the RGB system) or yellow, cyan, magenta, and black (with the CMYK system).

LAYERS, STROKES, AND CHANNELS

These are the basic tools used in computer illustration.

In the Paintbrush window, the thickness of the work tool is chosen.

Using the Airbrush Options window it is possible to alter the air pressure and the flow of color of the Airbrush tool.

The Samples window shows an illustrator's palette. The illustrator can either choose the default colors or can create new ones.

Thanks to these tools, the illustrator can divide the work into separate actions which can be deleted or modified at any stage in the process without altering the previous work. For example, it is possible to alter the background of the image (the background layer) while keeping everything that has been painted on it. Layers can be copied, deleted, or combined in several ways. Once the work is finished, they should be linked together to create a single image file.

This window gives information about all the layers that have been used in the work so far.

Creating lines is like cutting out masks to isolate areas of the illustration. A work may require lots of these strokes, and all of them will be included in the relevant option of this same window, which means that they can be accessed at any time.

The Channel option provides the possibility of modifying the parameters of each color: cyan, magenta, yellow, and black. This is similar to changing the nature of the colors by means of their basic components. Manipulating these channels requires a certain degree of experience, since it is possible to irreversibly ruin several hours of work .

HISTORY

The History window shows all the steps taken during each work session. Thanks to this history of actions, it is possible to return to an earlier stage to correct errors or to retouch previous actions. Each time the image is saved, the previous history is deleted

RGB AND CMYK MODES

These are systems for adjusting colors. The former is an acronym of the names of the colors red, green, and blue. These are the basic colors that a computer screen works with. By changing the proportions it is possible to modify the coloring of an image. The second group of letters corresponds to the colors cyan, magenta, yellow, and black, which are the basic colors used in four-color printing. Changing these colors not only changes the colors of the image on the screen but also, later on, determines the proportions of these colors to ensure the correct colors for printing.

The Curves window allows you to vary the parameters of color for each image.

Layer options, including the relationship between each layer of the image, are controlled from this window.

This window saves the strokes made during each stage.

The History window shows the steps that have been performed so far and allows you to go back and correct or alter any aspect of the illustration.

This example shows the effect of manipulating different channels in the same image. From left to right and from top to bottom: a box in which cyan has been eliminated; a box in which black has been removed; a box in which the yellow channel has been increased; the largest box shows an area without any yellow; in the bottom box magenta has been eliminated.

and a new one begins, starting from that moment

AN ILLUSTRATION FROM A PHOTOGRPH

The software program used for this and the following illustrations *(Adobe Photoshop)* is used to create illustrations and to retouch and manipulate photographic images. Some illustrators use a scanner to upload photographs, which they then retouch to give them a finish similar to airbrushing. Antoni Vidal prefers to draw and color each illustration as if he were really using traditional tools: first drawing the image and then coloring it in. This method of working gives very personal, less photographically conventional images, but it requires a good level of drawing ability and a lot of

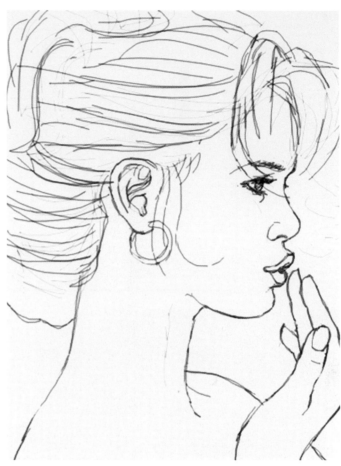

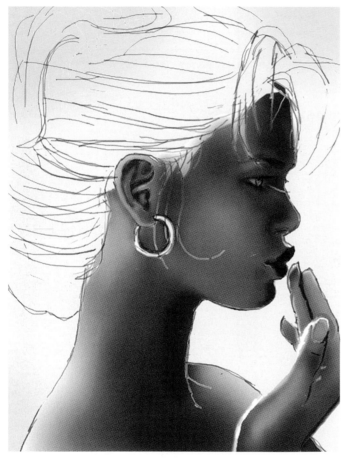

1. The illustrator makes a freehand drawing from a photograph, to make the first layer of the illustration. Apart from the obvious skill needed to create a drawing like this one (demonstrating a masterful technique that no computer program could provide), the illustrator must also be able to manipulate the mouse with great dexterity in order to achieve results that are so accurate and flowing. The line corresponds to a number 2 airbrush thickness, with 100% pressure, using a dark color, but not black; instead, a sepia from the default palette is used.

2. The drawing has enclosed areas that can be selected separately. Coloring begins with the selected area of the face. In airbrush terms, this selection corresponds to cutting out the central part of a mask to leave the area of the face and neck exposed, and then performing a similar operation with the hand. Coloring is done using different diameters of spray (with values that vary between 30 and 200) and very gentle pressure (12%) so as not to create areas of color that are too thick. The colors being used have been created by combining different amounts of yellow, cyan, magenta, and black. Once these colors have been chosen, they are incorporated into a palette that will be used throughout the work session. Burnt tones (flesh tones) of different intensities are used. This coloring constitutes a second layer of the illustration.

3. Little by little the details are made more specific. Color is painted on in different thicknesses, transitions from one tone to another are made more gentle, highlights are added with very fine strokes, and lines of different colors representing the woman's blonde hair are laid over the top. In this image you can see the high degree of realism and the subtlety that the software's tools can create in the hands of an expert illustrator.

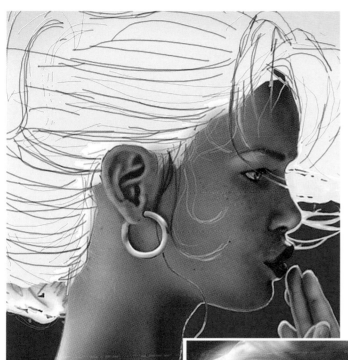

5. Here you can see how the hair has been painted using an initial background of dark tones, onto which have been superimposed stokes of different colors and widths which give a perfect sensation of strands of hair. Some of these strands have been painted using the Dissolve option of the Airbrush tool, which gives them a more transparent appearance. All of the hair was painted on a new layer.

LINKING LAYERS

Only when the illustration is finished and the illustrator is entirely certain that the entire work has been correctly completed can the different layers be linked together and saved as a single file, although they can be saved as often as necessary without being linked. From this moment on, it will no longer be possible to work on it by breaking it down into different parts; you will only be able to retouch it by adding new layers, manipulating the parameters of the colors, adding filters to give special effects, or adjusting the channels (the different basic colors that make up the image).

4. For illustrating the background, a new layer is added. This is so that you can go back and correct the background without having to alter the form and color of the figure, in the event that you should need a different color to give better contrast. The green used here is a modification of one of the greens of the default palette (already available as part of the software). It does not cover the whole of the background. This is because the lines of the hair create areas that behave like brush strokes or borders for selected areas. Before painting the top part of the background, the illustrator makes sure that the area is closed off and that when it is selected, the figure's hair will not be selected as well.

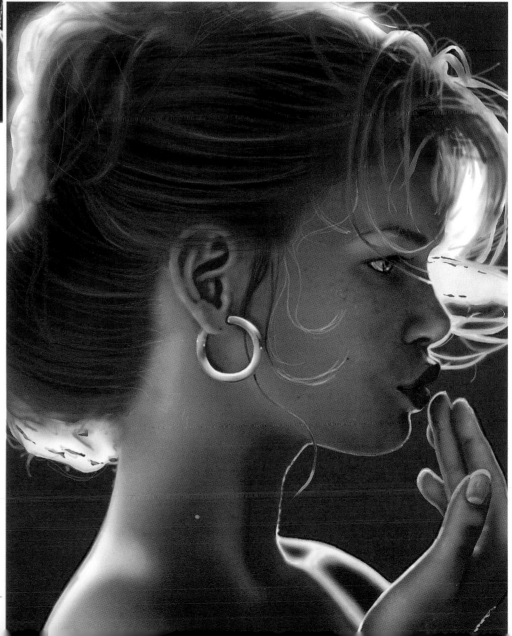

6. The finished illustration shows a much higher degree of detail than the original photograph. This is possible thanks to the software's capability for enlarging the image. The light points of the wisps of hair against the light were achieved by drawing fine lines of a very light, somewhat transparent tone against the green of the background.

skill and practice using a mouse.

AN ILLUSTRATION WITH A GRADED BACKGROUND

This illustration was not taken from a photograph or any other initial visual reference source. The illustrator invented it entirely. Although it has a high-quality finish, it is based on a very simple drawing: an outline that perfectly delineates the physiog-

1. For the initial drawing the Airbrush tool was used, with a thickness of 3 and 100% pressure. It was made on a very pale background that avoids the excessive hardness that white produces. For this reason, the background and the lines of the drawing are created on different layers. The illustrator has imagined the position of the head and the outline of the facial features. This also forces him to imagine the coloring and volume of this African face, in accordance with the initial drawing. The outline has been created with the magnetic Pen tool so that it fits the outline and length of each curve exactly.

2. Work continues by selecting the upper half of the face with the Magic Wand. The volumes of the face are created using the Airbrush tool at 100% pressure, with a width ranging from 30 to 200. The colors used are modifications of the reddish browns of the standard palette, which are then added to the program's standard palette. They can also be saved, if you want to be able to use them in the future. The same operation is repeated for the lower half of the face. The band that divides the two halves is a ritual design, common among some African tribes.

3. In this detail you can see how the dark lines of the initial drawing are naturally integrated with all the colors that make up the volumes of the face. Thicker strokes are alternated with finer ones, and the Dissolve option has been used in places to blend them together. One of the main advantages in working with this type of software is that you can obtain any intermediate tone between two colors almost instantly.

4. The line of the chin, which before had been masked out, has been painted in using a gentle tonal gradation that clearly shows its red tone. It is important that these tones are integrated coherently with the other colors of the face. To do this requires not just a mastery of the graphic resources of the software, but also solid experience creating images, colors, blends, tonal values, and contrasts. Illustration software does not provide any solutions that the illustrator is not already capable of imagining and which he or she, if necessary, could not reproduce with other media. For this reason, before working with this type of software, the illustrator should have a solid background in drawing and painting.

5. To create the color of the background, it is necessary to return to the first layer. For this luminescent effect, the Mask option is used, which allows the illustrator to create circular and elliptical tonal gradations, having first chosen the colors to be graded. He also uses the Airbrush tool, with a value of 300. The colors chosen for the gradation are a very dark tone created from a strong saturation of the proportions of the basic colors; an intermediate tone with lower proportions; and a very light third tone, which contains no black, barely 6% yellow and small quantities of cyan (16%) and magenta (20%).

RESOLUTION

The resolution of all these images is 120 pixels per centimeter, which is the equivalent to 302.8 pixels per inch. This is the ideal resolution, since it is exactly the same resolution that is used for the copy-transparencies used in four-color printing. A higher resolution in the illustration would not improve the quality of the image (but would increase its size). A lower resolution would compromise the quality of the printed image.

6. This image shows the minute detail with which some parts of the face have been handled. The dots, which represent the tiny curls where hair starts to grow, have been made using a very wide aperture with the Airbrush, and using very weak pressure. In this way the spray falls in small drops which create an interesting transparent effect. Some disappear into the background, while others stand out from it.

7. The final touches are made by opening the Curves window and adjusting the parameters of color. This is not done color by color (as would be the case if the Channels window were opened) but all together, varying the tonality lightly until it is left at exactly the right point. Once the work is finished, all the layers are linked together, and the illustration is ready to send to the editor.

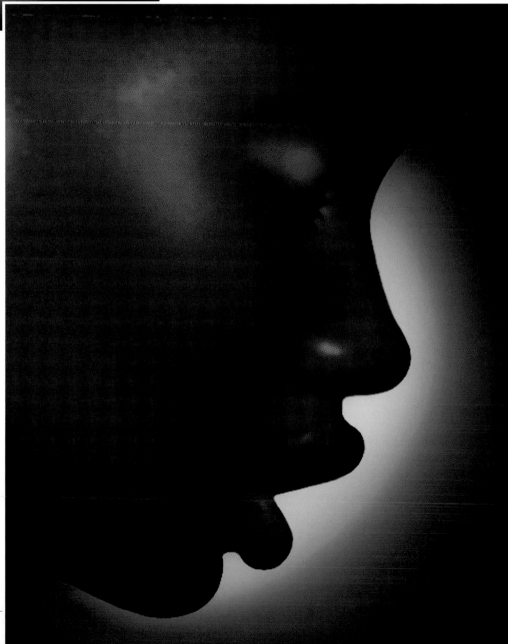

nomy of an African face. One of the interesting elements of this project is the effect achieved with the background: an elliptical tonal gradation achieved using a special tool.

AN ILLUSTRATION ON A TEXTURED BACKGROUND

This illustration is entirely invented. In fact, the idea of the illustration was to create a work inspired by the popular art of American Indian villages. For this reason, a detailed, realistic handling is overlooked in favor of a more rustic feel to the work. One of the most interesting aspects of this illustration is the appli-

cation of a special texture, which gives a particular quality to the coloring that is very different from its usual nature (in other words, it is very different from the characteristic airbrush effect). The

1. Before starting work, the illustrator has made a few pencil sketches to decide on the composition and linear style of the drawing. Although it is simple, it must be very abstract and economical in its strokes. Once the general composition has been decided upon, a freehand drawing is begun. The illustrator is interested in creating thick, imprecise lines, similar to the effect of charcoal on a rough support. The color of the drawing is completely black, with a thickness of 8 and 100% pressure. To achieve an irregular line, the illustrator uses the Dissolve option, which makes it possible to make the edges of the lines dissolve into small dots.

2. In this enlargement of a fragment of the previous drawing, the irregular texture of the lines can be appreciated. This is very similar to the effect of using charcoal on a thick-grained paper (such as watercolor paper, for example) or on canvas. This quality of line is perfect if you wish to add a textured effect to the finished work. The texture of the finish must always fit in with the other elements of the illustration.

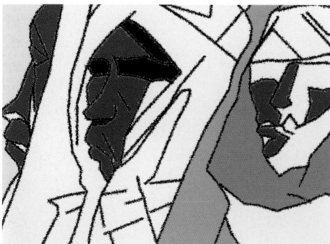

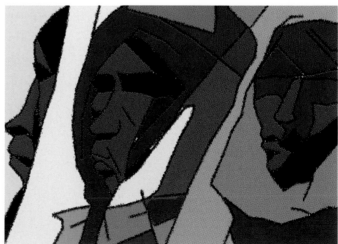

3. The initial drawing has created certain well-delineated areas that are perfectly enclosed between lines and are easy to color in without making tracings (special selections of areas of the illustration). By selecting specific areas with the Magic Wand tool, and using the Paint Bucket tool it is possible to fill each area with a different color. The result is a patchwork of areas of color, each of which is uniform and monotone, and free from effects of any type, as would be the result of working with monotone gouache, acrylic, or oil paints.

4. All of the different areas of color are filled in with the required color. Adjusting and changing colors is very straightforward in this work. All that is necessary is to select one of the areas and substitute the color for another one, modifying it by using the options offered by the palette of colors. These alterations can be made until the desired coloring is achieved.

5. *In this detail of the finished illustration you can see how certain colors have been added with the Airbrush tool to create slight effects of volume without altering the fundamental flatness of the image. These effects are also integrated into the final texturing of the image.*

CLEANING YOUR MOUSE

For illustrators who do not use a light pad, it is essential to keep the cursor mechanism of the mouse clean. Any traces of dust that stick to the internal moving parts of the mouse will affect the accuracy of each line and will complicate the work to the point that it becomes impossible. The illustrator must clean the mouse before each session. To do this, the central ball is removed, and any foreign bodies are cleaned off it, no matter how small they are, using a hard bristle paintbrush.

6. *This is the finished illustration after the texture has been applied to it. This is done by means of the Texture option in the Filter menu. In this case, the Hessian option has been chosen. The whole image takes on a textured appearance that really looks like the surface of a thick-woven canvas, complete with small shadows created by the irregularities in the texture, which affect the whole illustration. This work is an excellent example of the graphic possibilities of an illustration made on a computer which go beyond reproducing the typical effects of airbrushing.*

AN ILLUSTRATION WITH AN OIL FINISH

Among the many finishes that a computer can apply to an illustration, the oil effect is particularly surprising. Oil painting is, beyond doubt, the technique that is furthest removed from the antiseptic environment of computer manipulation to which the illustrator submits when creating illustrations on a computer. Real oil paint is a very solid medium, a paste pigment that is very difficult to control and which, in the end, gives dynamic, richly detailed results of layers and brush strokes. The final result is supremely artistic. Achieving similar results using the possibilities offered by a computer might seem an absurd idea. However, the following work gives a clear example of how it is possible to use a computer to achieve effects that show all the hallmarks of an oil painting.

1. The initial drawing is much freer than is usual when working with a computer. The free use of open, flowing lines is part of the illustrator's intention to create a work in which everything is based on the direct action of colored strokes. The shaded areas are made with the same tool (the Airbrush), but in Dissolve mode, which produces a gentle spray effect that allows the areas of shadow to be defined approximately. The result is not very different from the appearance of a charcoal sketch on canvas, before beginning painting a portrait in oils.

2. In this detail you can appreciate the fine spray clearly, achieved using the Airbrush tool in Dissolve mode. It is not necessary to give the work any greater precision. It is better to work rapidly and freely, so that the colors are more spontaneous than is usually the case with computers.

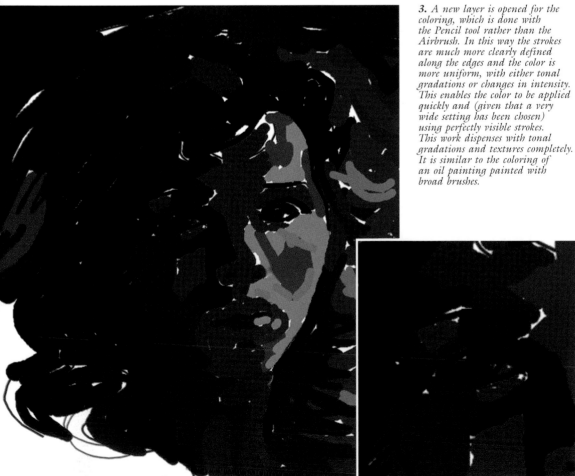

3. A new layer is opened for the coloring, which is done with the Pencil tool rather than the Airbrush. In this way the strokes are much more clearly defined along the edges and the color is more uniform, with either tonal gradations or changes in intensity. This enables the color to be applied quickly and (given that a very wide setting has been chosen) using perfectly visible strokes. This work dispenses with tonal gradations and textures completely. It is similar to the coloring of an oil painting painted with broad brushes.

4. In this enlargement, you can see clearly how the areas of color are superimposed on one another following the natural rhythm of the hand going over the forms, and creating light and shade at the same time as applying color. Inevitably, the border areas between the colors are very hard, and the colors do not mix together. These aspects are reserved for later stages in the work.

5. *You should choose the colors carefully, creating them from a combination of cyan, yellow, magenta, and black. The general range is more reddish, with quite a lot of black in the composition of the tones. Once all areas of the illustration have been covered, it is the moment to soften the areas where blocks of color meet, using the Airbrush tool. This softening should only be done where the contrasts between light and dark areas are strongest, so that they do not become just gentle changes of tone. In this work the effect of chiaroscuro is fundamental.*

6. *At the same time as the lines separating blocks of color are softened, you should also fill in details of the facial features so as to define the subject's expression clearly. Once all the chromatic areas have been softened, the illustrator opens the Filter menu, and chooses the Pixel option, and within this the Paintbrush option. This filter increases the number of details in each block of color, dividing them into two or more tones which show up as small differences in the color of each block. This creates the effect of an oil painting. In combination with strong chiaroscuro, the illustration is strongly reminiscent of the finished appearance of an oil painting.*

Professional Illustrating

I n this section we feature some of the important aspects of professional illustration that should be taken into account by anyone who wants to illustrate professionally. In the world of professional illustration it is not enough to be able to master the various techniques and to show a certain degree of originality. It is also important to display your work appropriately, negotiate commissions correctly, and present your original illustrations in a suitable form.

An illustrator should have suitably personalized business cards to give to any possible prospective clients.

PRESENTING A PORTFOLIO

The main problem a new illustrator has is getting him- or herself known. If you live in a large city where publishers are based, you should know who they are and what type of work they publish. It is a waste of time visiting publishers who specialize in books that do not include illustrations or who only use them occasionally to decorate book covers. The logical thing is to go to a well-stocked bookstore and write down the registered names and addresses of publishers who issue illustrated work in a

This is a portfolio specially designed for carrying and displaying original works, protected in plastic sleeves.

Leaflets, pamphlets, and presentation sheets are resources that give the editor a more complete idea of the nature of an illustrator's work.

style that is similar to your own. If these publishers are a long way from where you live, you will have to send them a portfolio with a curriculum vita and a selection of color photocopies of your best illustrations. In any case, it is always much better to arrange a time to go to visit them in person, taking with you a selection of your original works. The editor will take a closer interest in the work and the illustrator will gain more information about the requirements of the business by talking to one or more of the people in charge.

How you present your work is important. It should look organized and polished. If you have not had any work published before, a good idea is to make various illustrations that include typography (titles, texts, capital letters, etc.) to give the work a context.

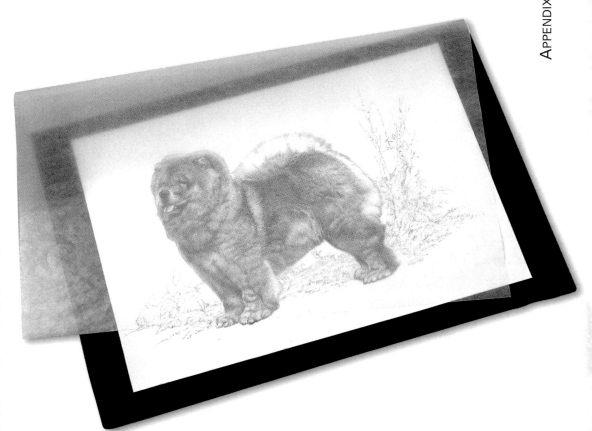

This is a good way of presenting an original illustration: the paper is less likely to be creased, and is protected by a sheet of rice paper.

PERSONAL PRESENTATION

Before visiting editors who might be interested in your work, it is a good idea to send out information to all the different publishing companies by way of a personal presentation. As mentioned above, this presentation will consist of color photocopies of your work, but it is a good idea to accompany it with business cards or printed sheets that give a more professional image of your work as an illustrator.

Business cards should have a certain degree of visual originality (in their typography, their general design, or the inclusion of an image) to make them stand out from all the others that the editor receives from other professionals in different fields. A personalized business card always suggests a personal creative style. Apart from these, it might also be a good idea to create a leaflet or pamphlet with a careful selection of your work, along with your personal details.

COMMERCIAL AGREEMENTS

The question of fees and reimbursement should be agreed on with each publisher individually. It is essential to find out approximately how much other illustrators charge so that your offer will be within reasonable limits. Remember that it is not the same to receive a commission for a single illustration as for a large series of them. In the latter instance, the price per illustration will be lower than for a single image. Similarly, when creating illustrations of different degrees of complexity for the same client, it is usual that the editor and the illustrator will agree on an average price for each one.

PRESENTING ORIGINALS

Originals should be presented sufficiently well protected. The best option is to mount them on a piece of rigid cardboard (mounting board), held in place with adhesive tape, and protect them with a sheet of rice paper or manila paper. In this way they will not be creased during transportation or postage.

COMPUTER SUPPORTS

Professional illustrators who work with computers usually present a printed copy of their work along with the electronic support, such as a diskette, a zip disc, an optical disc, or a CD, depending on how much memory the image takes up. It is useful to show the editor a good printed copy of the work before creating the computer file, in case it is necessary to retouch it or make any corrections to any aspects of the image.

AGENCIES

Agencies are intermediaries between the illustrator and the client. Each year they publish an extensive catalogue of high-quality reproductions of their illustrators' work. Agencies always represent a guarantee for the client, although they increase the price of the work because of commission charges. The unarguable advantage for the illustrator is that his or her work will receive much greater publicity than he or she could achieve alone (most agencies are international), and there is no need to negotiate prices with editors.

These are some of the most common computer supports: diskettes, zip discs, optical discs, and CDs.

ALL ABOUT TECHNIQUES IN ILLUSTRATION

Topic Finder

OVERVIEW OF ILLUSTRATION

**The Changing World
of Illustration** 6
The Origins of Illustration 6
Engraving: A Medium of Broad
 Dissemination 6
Satirical Illustrations 6
Illustrators in the 19th Century . . . 7
 *Impressionism and
 Symbolism* 7
The 20th Century 8
Popular Culture 8
New Directions 9
 *The Evolution of Graphic
 Design* 9

**Styles and Genres in
Illustration** 10
Conceptual Illustration 10
Narrative Illustration 10
Comics . 11
 Decorative Illustration 11
 *Illustrations in Black and
 White* 11
 Visual Humor 11
Children's Illustration 12
Cover Illustrations 12
 Poster Design 12
Illustration in Advertising 13
Fashion Illustration 13
 Packaging 13

Drawing in Illustration . . 14
Illustrator's Drawings 14
 Supports for Drawing 14
Drawing Media 15
Comic and Graphic Humor 15
 The Human Body 15
Drawing Styles 16
 Scale Illustrations 16
Drawing in Ink 17
 Technical Pen 17

USING DIFFERENT MEDIA
FOR ILLUSTRATION

An Illustration in Ink . . . 18
Characteristics of the Project 18
Reference Material 18
Materials . 19
Approaching the Subject:
 Notes and Sketches 19
 Importance of the Stroke 19
Method . 20

**Illustrating with
Watercolor and Gouache** 22
The Characteristics of Watercolor . . 22
 *Supports for Painting
 with Watercolor* 22
The Characteristics of Gouache . . . 23

*Supports for Painting with
 Gouache* 23
Working with Watercolor 24
Working with Gouache 24
 Drying Times 24
 *Transparencies Using
 Gouache* 25
Methods and Effects Using
 Watercolor 26
 *Compatibility with Other
 Techniques* 26
Methods and Effects Using
 Gouache 28

**A Historical Illustration
Using Watercolor** 30
The Characteristics of the Project . . 30
Reference Material 30
Materials . 30
Procedure 30
 Templates 32
 Technical Pens 34
 Keeping the Work Clean . . . 35

**A Naturalistic Illustration
Using Watercolors** 36
Characteristics of the Project 36
Reference Material 36
Materials . 36
 A New Paintbrush 37

**A Comic Drawn with
Ink and Gouache** 40
Characteristics of the Project 40
Materials . 40
Reference Materials 40
Page Layout 41

**Illustrating with
Felt-tipped Pens** 46
Types of Ink 46
Fine and Broad Tips 46
 Suitable Supports 46
 *Mixed Techniques Using
 Felt-tipped Pens* 47

**Illustrations Using
Felt-tipped Pens** 48
Characteristics of the Project 48
Materials . 48

**Pastels and Colored
Pencils** 50
Characteristics of Pastels 50
 Supports for Pastels 51
Characteristics of Colored
 Pencils 51
 Supports for Colored Pencils . 51
Techniques and Possibilities for
 Pastels 52
 *Combining with Other
 Media* 53

Techniques and Possibilities for
 Colored Pencils 54
 *Combining with Other
 Media* 55
Oil Pastels 56
 Supports 56
Techniques and Effects Using
 Oil Pastels 57
 *Combining with Other
 Media* 57

**A Narrative Illustration
Using Pastels** 58
Characteristics of the Project 58
Materials . 58
Reference Materials 58
 The Problem of Light 60
 Hard and Soft Pastels 60

**A Decorative Illustration
Using Colored Pencils** 62
Characteristics of the Project 62
Materials . 62
Reference Materials 62
Colored Pencils on Scored Paper . . 62

**An Illustration Using
Acrylic Paint** 66
Characteristics of Acrylic Paint 66
 Supports 66
Techniques and Effects Using
 Acrylic Paints 67
 *Combining with Other
 Media* 67

**A Children's Illustration
Using Acrylic Paints** 68
Characteristics of the Project 68
Sketches . 68
The Mockup 68
Materials . 68
 The Whiteness of the Page . . 71

**Illustrating with
Oil Paints** 72
Characteristics of Oil Paints 72
 Supports 72
Techniques and Effects Using
 Oil Paints 73
 *Combining with Other
 Media* 73

A Book Cover in Oils 74
Characteristics of the Project 74
Reference Material 75
Materials . 75
 A Study of the Composition . 75

THREE-DIMENSIONAL
ILLUSTRATION TECHNIQUES

**Collage, Photomontage,
and Illustration in
Three Dimensions** 78
Tools and Materials 78
Color and Form in Collage 79
Material for Photomontage 79
 Supports 79

Color Photocopies 79
Three-Dimensional Images 80
Photography in Illustration 80
 Supports 80
Pop-Up Books 81

An Illustration in Relief . 82
Characteristics of the Project 82
Materials 82
Sources 82
Glue 84
Light 84
Malleable Plastic 85

**The Technique of
Photomontage** 86
Characteristics of the Project 86
Materials 86
Handling Pictures 87
The Initial Idea 87
 A Picture Archive 87
 A Question of Scale 88
The Importance of Simplicity 90

A Decorative Collage 92
Characteristics of the Project 92
Reference Material 92
Materials 92
Colored Paper 92
 A Palette of Colors 93
Variety of Colored Strips 94
Ordering and Fitting the
 Pieces 96

ADVANCED ILLUSTRATION
TECHNIQUES

**Scientific and
Technical Art** 98
Characteristics 98
Historical Development 98
Mastering Techniques 98
Reference Material 98
Scientific Images 100
Reconstruction 100

Representing the Invisible 100
Technical Images 100
Techniques 100
 Visual Synthesis 101

Airbrush Illustration 102
The Origins of the Airbrush 102
Characteristics of Airbrushing 103
Single-Action Airbrushes 103
Double-Action Airbrushes 103
 Choosing an Airbrush 103
Working Mechanism of the
 Airbrush 104
Airbrush Components 104
Using an Airbrush 105
Maintaining an Airbrush 105
Cleaning an Airbrush 105
Air Supply: Compressors 106
Compressor Maintenance 106
Compressor Accessories 106
Opaque Colors 107
Transparent Colors 107
Masks 108
Fixed Masks 108
Removable Masks 108
Liquid Masks 108
 Aerial Masks 108
 Adhesive for Movable
 Masks 109
Paper for Airbrushing 110
Paintbrushes 110
Knives 110
Templates 110
Other Tools 111
 Felt-tipped Pens 111
 Colored Pencils, 111

**An Airbrush
Illustration** 112
Characteristics of the Project 112
Reference Material 112
Materials 112
Sketches 113
 The Light Box 114
 Saving the Masking 116

Computer Illustration 120
Hardware 120
Software 120
Main Window 121
Size Specifications 121
Tool Bar 121
Brush Window 122
Size and Shape Window 122
Color Swatches 122
Color Curves 122
Layers, Strokes, and Channels 122
History 122
 RGB and CMYK Modes . . 122
An Illustration from a
 Photograph 124
 Linking Layers 125
An Illustration with a Graded
 Background 126
 Resolution 127
An Illustration on a Textured
 Background 128
 Cleaning Your Mouse 129
A Hyper-Realist Illustration 130
 Advantages and
 Disadvantages of
 Scanning 130
An Illustration with an Oil Finish . . 132
An Anatomical Illustration 134
A Geographical Illustration 136

APPENDIX

Professional Illustrating . 138
Presenting a Portfolio 138
Personal Presentation 138
Commercial Agreements 139
Presenting Originals 139
Computer Supports 139
Agencies 139
The Editorial Process 140
The Mockup 140
High-Resolution Scanners 140
Lithographic Film 140
Plates 141
Digital Photo-Layouts 141

We wish to thank Marcel Socias and Pacmer, S.A., for their generous help and technical advice.

Original title of the book in Spanish: *Todo sobre la técnica de la Ilustración.*

All inquiries should be addressed to:
Barron's Educational Series, Inc.
250 Wireless Boulevard
Hauppauge, New York 11788
http://www.barronseduc.com

International Standard Book No.: 0-7641-5361-7
Library of Congress Catalog Card No.: 00-067467

Library of Congress Cataloging-in-Publication Data
Todo sobre la técnica de la ilustración. English
 All about techniques in illustration / [author, Parramón's Editorial
Team ; illustrators, Parramón's Editorial Team].
 p. cm.
 Includes index.
 ISBN 0-7641-5361-7
 1. Illustration of books—Technique. I. Parramón Ediciones. Editorial
Team. II. Barron's Educational Series, inc. III. Title.

NC960 .T6313 2001
741.6′4—dc21
 00-067467

Printed in Spain

9 8 7 6 5 4 3 2 1

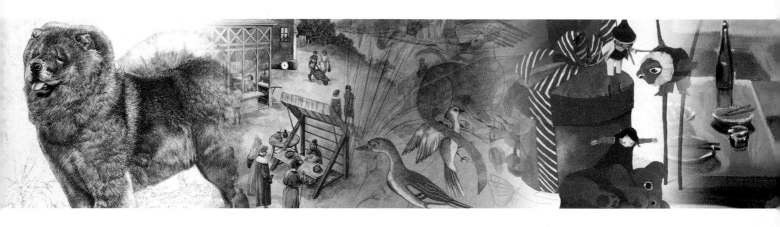